IMAGES
of America

LaSalle County

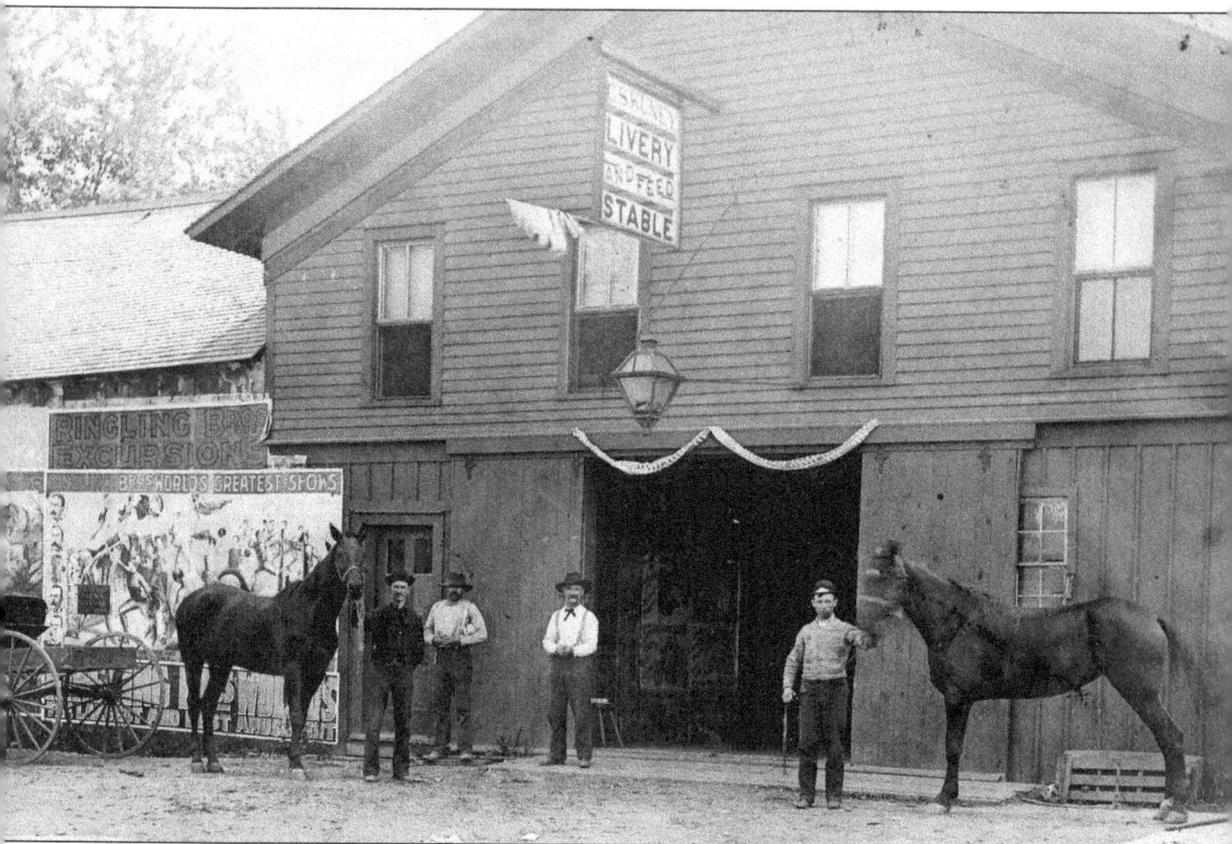

A LIVERY STABLE. This is G. S. Kuney's Livery and Feed Stable in 1895. There is a Ringling Brothers poster to the left of the photograph behind the horse and cart. The sign reads, "Ringling Brothers Excursions, Worlds Greatest Shows, The Largest and Best Amusement." The poster features acts with sword fighters, boxers, and horseback riding.

On the cover: Please see above. (Courtesy Earlville Community Historical Society.)

IMAGES
of America

LaSalle County

Susan Shaver Koller

ARCADIA
PUBLISHING

Published by Arcadia Publishing
Charleston, South Carolina

Library of Congress Catalog Card Number: 2006929839

For all general information contact Arcadia Publishing at:
Telephone 843-853-2070
Fax 843-853-0044
E-mail sales@arcadiapublishing.com
For customer service and orders:
Toll-Free 1-888-313-2665

Visit us on the Internet at www.arcadiapublishing.com

CONTENTS

Acknowledgments 6

Introduction 7

1. Historic Characters of the County 9

2. Moving Around the County 25

3. A Trip to Town 51

4. School Days, Holidays, and Sundays 79

5. Farming and Industry 93

6. Groups and Troops 111

Index 127

ACKNOWLEDGMENTS

This book was put together through the hard work of many individuals whose names do not appear in the courtesy under each photograph. Without them it would have been impossible to research this book, which also included many hours of scanning and so I acknowledge them gratefully here. My sincere thanks and appreciation go out to Dorothy Clemens; Shirley A. Sharpe, assistant director, Peru Public Library; Paul DePaoli research assistant, Reddick Library; Carol Bend, curator, Shabbona-Lee-Rollo Historical Museum; Peggy Schneider and Bridget O'Brien, Ottawa Visitors Center and Reddick Mansion; Bruce Etheridge, Susan Martyn, and Deborah Konya, LaSalle County Historical Society Museum; Dorothy Buck and Jennifer Bilyeu, Seneca Public Library District; Shirley Pierson, Steve Dancey, and Bill Greenwood, Mendota Museum and Historical Society; Dorothy Gemberling, curator, Marseilles Public Library History Room; Bob Jordan, fellow researcher and author; Patricia Breen, Rosemary Promenschenkel, and Joan Johnson, Streatorland Historical Society; Maureen Corrigan, Earlville Community Historical Society; Evelyn Moyle, Oglesby Historical Society; Graves-Hume Public Library in Mendota; Starved Rock State Park, especially Ranger Toby Miller; LaSalle County Genealogy Guild; Hume-Carnegie Museum and the LaSalle Public Library; Pamela Lange, museum director, Bureau County Historical Society Museum and Library; Jim Spanier and Mary Lou Leiser, who provided information and took my phone calls; and Dick Tinder, Mike Hyman, and Geoff Dobson, who were gracious through many e-mails.

Special thanks go out to my husband John and son John David. Without their technical support, maps, and know-how, I would not have known how to continue; and to Helen Crawford, who not only provided photographs and encouragement, but research help and introductions to others who value keeping history alive. To fellow Arcadia Publishing author and friend, Elizabeth Wallace (Images of America: *Colorado Springs* and *Kansas City in Vintage Postcards*), who gave me encouragement and advice. Last but not least to my parents, who without their love of history and family, I might not have taken an interest.

Every effort was taken to assure the accuracy of the information in this book; neither the author nor the publisher assumes responsibility for any consequences arising from the use of this book or the information it contains.

INTRODUCTION

It is a privilege to be a part of bringing this book to you. As a daughter of the pioneers of LaSalle County, a family historian, genealogist, and history lover, I wanted to show off the achievements of my ancestors who contributed to the development and success of LaSalle County. But this book is much more than one family's limited look at the county. What you will discover in these pages is the story of the county through many families; they bring their own flair to small business, industry, and transportation. The photographs were taken in the mid-1800s through the 1950s. They help to bring into focus the historic Lincoln-Douglas debates, one of which took place in Ottawa. Others show Du Pont's influence in the area. The Illinois and Michigan Canal, along with the Fox and Illinois Rivers, were major influences and equal to our highways of today. Proud business owners show off their successes, and some of the famous people of the area receive yet another chance to impress you. They include Wild Bill, Chief Shabbona, Abraham Lincoln, Clyde Tombaugh, and others. They all contributed to the county and inspire us still today. Buildings and architecture are shown through photos that may have been forgotten and buildings that no longer exist. The farming community is not forgotten here and is still predominate throughout LaSalle County, seen in market photographs that display a wide variety of produce as well as having influence in industry and shipping.

My love of doing research was another one of the motivators in working on this book. I was interested in what might be uncovered in each photograph. Hopefully they will inspire you to do further reading and research. What is uncovered, through the photographs, shows a county that was not only in the middle of events that shaped this nation and helped to change history worldwide, but that life in this county was rich and varied. For example you may not have known that Seneca was one of a few places in this country, during World War II, to make the Landing Ship Tanks. Normally these large ships would have been made at a seaport, but because of the attack on Pearl Harbor, secrecy was needed. Today a simple memorial can be found in the corner of the city's park, marking the great dedication to the support of our troops and the world in a time of need. LaSalle County had and has so much to offer that adds to the richness and diversity—rivers, forests, prairies, rolling landscapes, and rock formations, which were home to Native Americans and new Americans, explorers, and pioneers, wild and domesticated animals, ship captains, train engineers, racers, singers—and is a beautiful place for children to grow and discover.

I was able to achieve a better understanding of the county and its people through these candid photographs, which I hope will do the same for you. These are photographs that we might not have seen without the help of private individuals who opened up their collections.

The generosity of the people who let an unknown person into their homes and shared their love of history was remarkable and gave me an insider's look at the county that might not have been achieved through museums and libraries alone.

Every area of the county has a rich history, and many of those areas have historical societies and museums striving to keep that history remembered. I was not able to visit each and every town, nor take every road. Even though I discovered more than I had hoped to, I know that there is that much more left to discover. However, I am extremely happy to be able to bring you the remarkable photographs and history that is found here. I hope you will find as many surprises among these pages as I did in researching them.

—Susan Shaver Koller

One

HISTORIC CHARACTERS
OF THE COUNTY

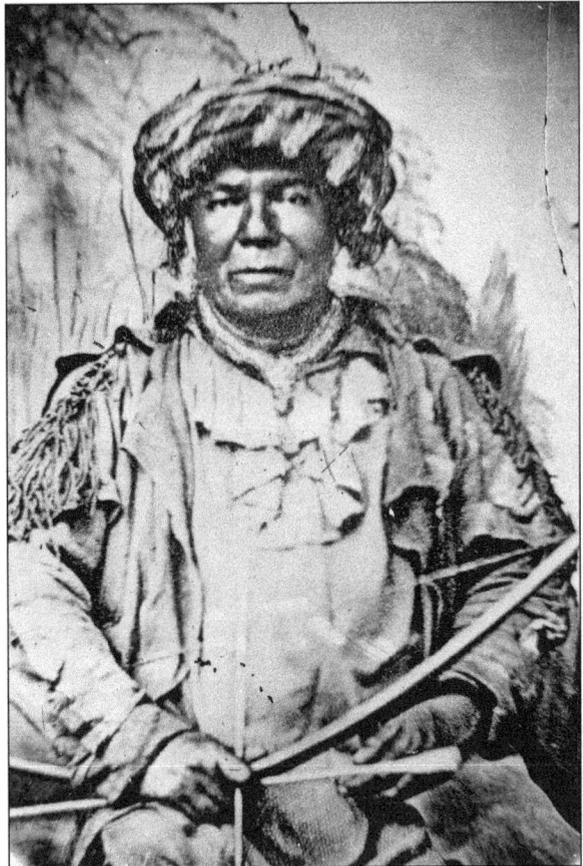

SHABBONA CHIEF OF THE
POTTAWATOMIE, MID-1800S. The Black
Hawk War was about to start. If it had
not been for Shabbona's warning to area
settlers of possible conflict, many more
may have lost their lives—the author's
family among them. It has been said
that these families "high-tailed it to
Fort Johnson," and many are thankful
that they listened to the chief of the
Pottawatomie. Shabbona, whose name
has been spelled over 20 different ways
over the years and treaties, was born
of the Ottawa tribe in 1775 and was
adopted into the Pottawatomie. He
became a chief and friend to the white
settlers, which was not a popular stand
for him to take among his people.
Shabbona did not work alone to warn
settlers of possible fighting in 1832. He
also dispatched his nephew Pyps to
the Fox River and Holderman's Grove,
and his son in still another direction.
Shabbona died in 1859, living out his
remaining days in LaSalle County
near Seneca. (Courtesy H. W. Immke
Archive, Bureau County Historical
Society Princeton, IL 61356)

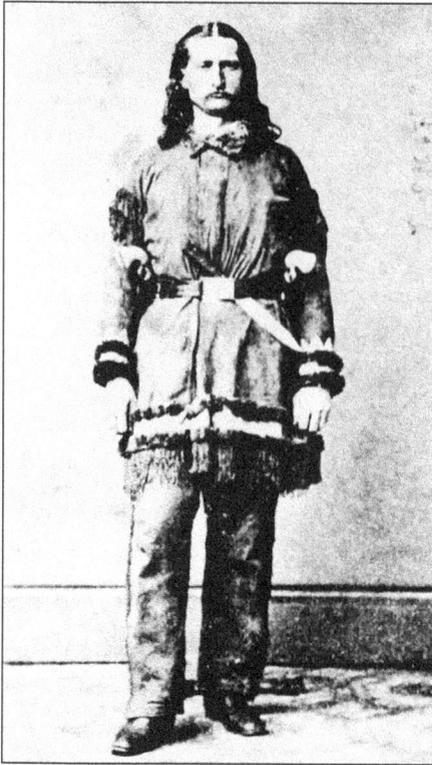

JAMES BUTLER HICKOK, ALSO KNOWN AS WILD BILL, C. 1869. This photograph was taken in the town of Mendota; the photograph was compared with others that were known to be taken at the local photographer's studio by comparing the carpet pattern and baseboard. Hickok was born near Mendota in the town of Troy Grove on May 27, 1827. (Courtesy Mendota Museum and Historical Society from Leo and Norma Muhlach Collection.)

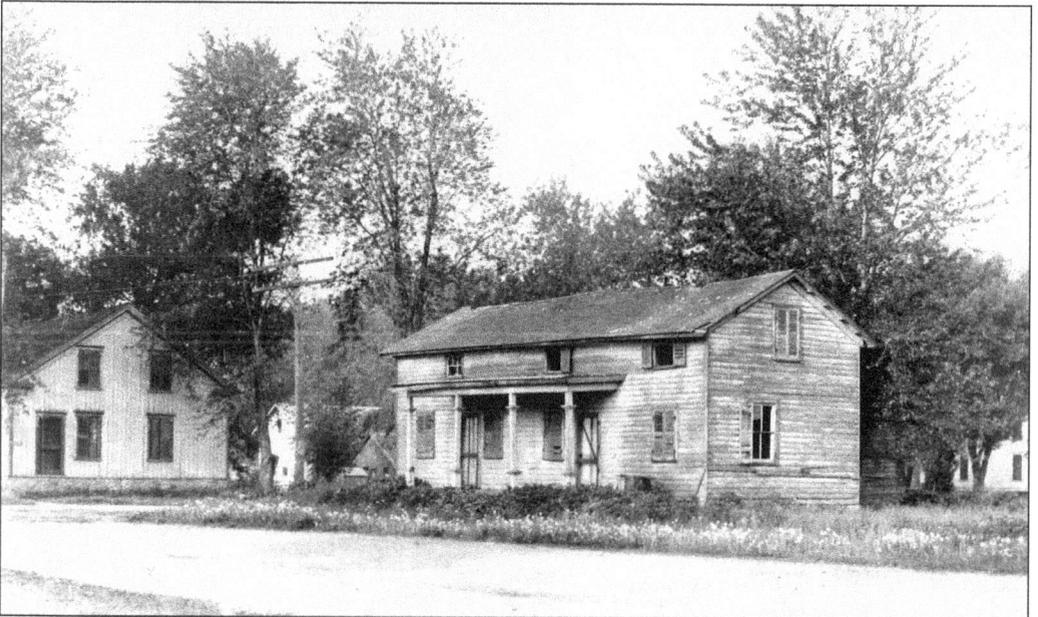

AN AMERICAN LEGEND'S BIRTHPLACE, C. 1900. Troy Grove was the birthplace of Wild Bill. His home, above, was in the town's center, just steps away from the stagecoach stop and the Green Mountain Saloon. Growing up here he learned to shoot, and he worked on the Illinois and Michigan Canal. When James was 18, he left home and headed west. (Courtesy Mendota Museum and Historical Society from Leo and Norma Muhlach Collection.)

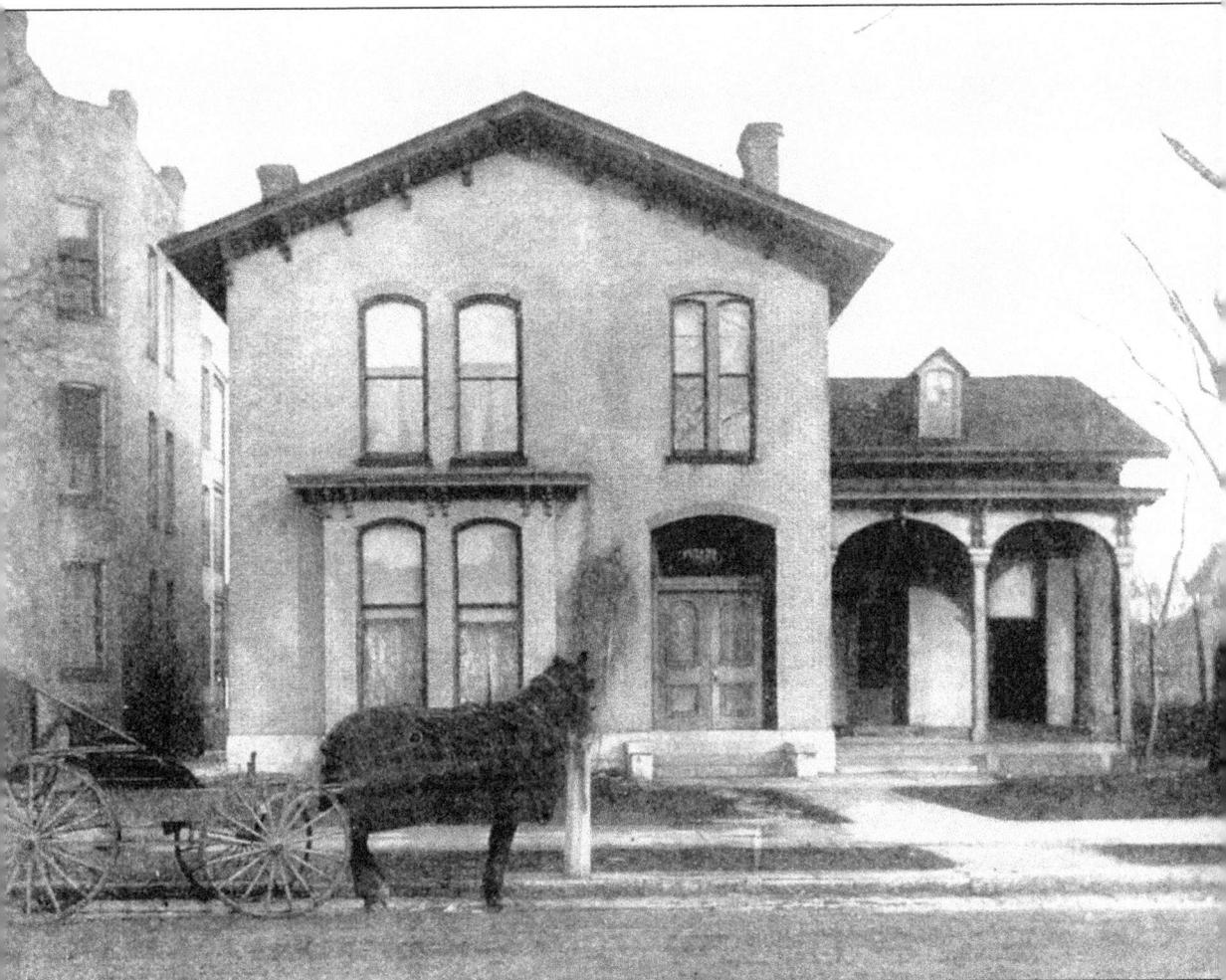

LINCOLN SLEPT HERE, 1860S. Abraham Lincoln came to Ottawa in 1858 for the debates he participated in with Stephen A. Douglas. The home of the mayor, Joseph O. Glover, on 810 Columbus Street, was made available to Lincoln. Mayor Glover's home, above, was Italianate in design and of the Upright and Wing style. Lincoln's height and Douglas's shorter stature made for an interesting pair. Another contrast was that Douglas was known for his speaking ability and political views while Lincoln was a relative newcomer to politics. The name Abraham Lincoln may have been well known to residents of LaSalle County, a portion of them came from Rockingham County, Virginia, where Lincoln's grandfather, also named Abraham, had lived for a time. Lincoln was also known locally as he had participated in a militia company that took part in the Black Hawk War. Thousands of people came to Ottawa's Washington Square to see the debate. To commemorate it, a boulder with a plaque sits in the park along with a beautiful fountain with statues of both debaters. (Courtesy M. Dorothy Clemens.)

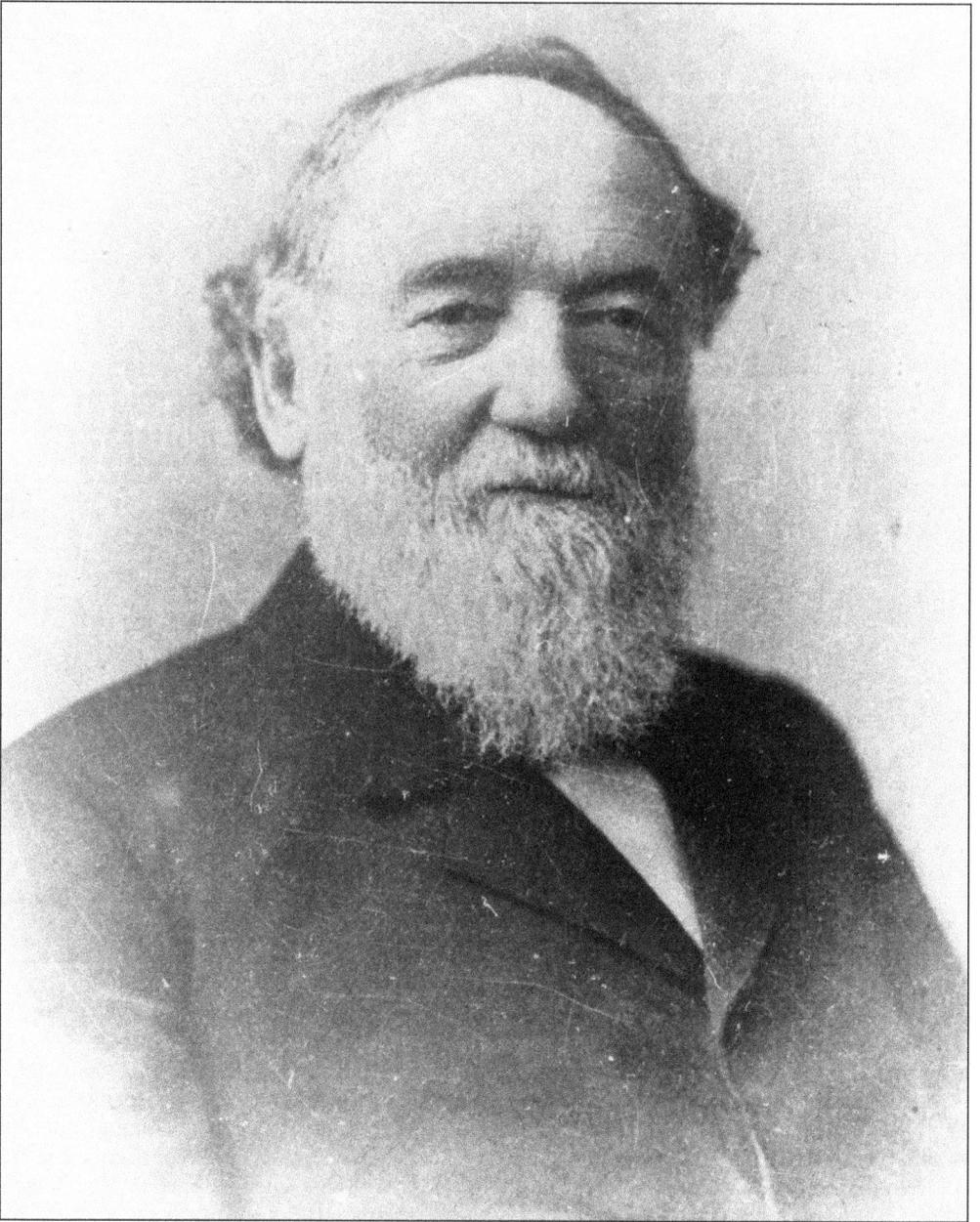

RALPH PLUMB (1816–1903). After serving in the Civil War under General Garfield, Col. Ralph Plumb came to LaSalle County in 1866. He worked for a group of investors as their manager and was able to purchase 4,000 acres in Bruce Township for coal mining. Founding the city of Streator and naming it for Dr. W. L. Streator, the president of the group he managed, Plumb laid out the streets of the town. This prominent citizen and enterprising man was the driving force for improvement, bringing the railroads and culture to the young town. He is credited with building the first high school in the township and building the Plumb Opera House. He served as Streator's first mayor, serving two terms. He was then elected to represent the district in congress and served another term there as well. He married in 1838 and raised three daughters with his wife Marrilla. (Courtesy Streatorland Historical Society.)

HANNAH JENNINGS CLARK ALBERTI, c. 1915. Hannah Alberti is said to be the first white baby girl to be born in Brookfield Township, LaSalle County. Brookfield Township is on the east side of the county below the Illinois River. Alberti was born on November 16, 1835, and she died outside the county in Crescent City, Illinois, on May 27, 1916, at 80 years of age. (Courtesy Marseilles Public Library.)

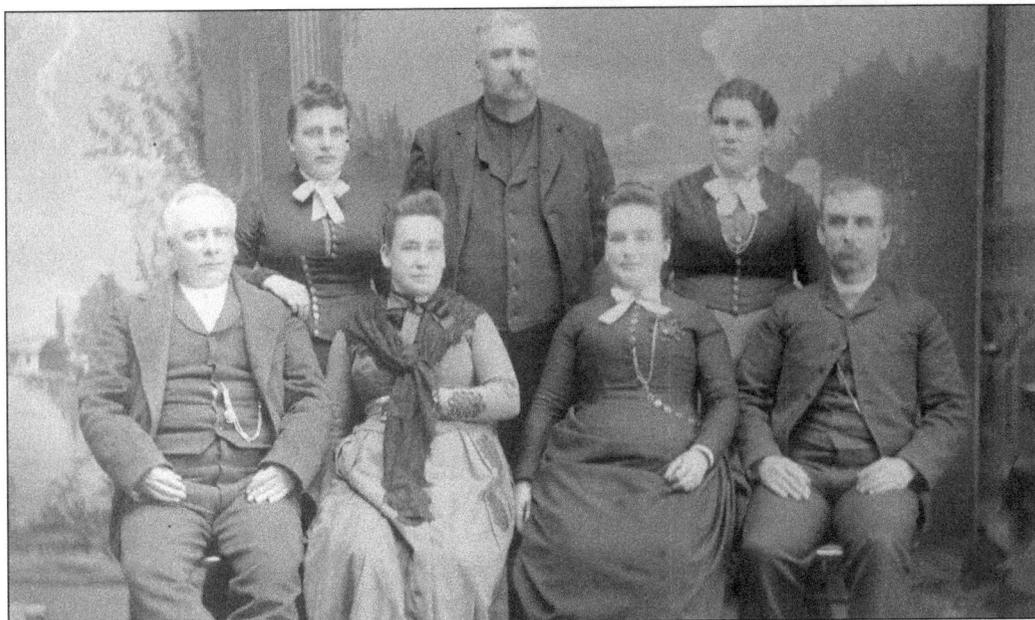

McLAUGHLIN CLAN CAME WEST FROM PENNSYLVANIA. Pictured are, from left to right, (first row) Cyrus McLaughlin, Lizzie Beale, Ann McClure, and John McLaughlin; (second row) Sarah Barnard, Joseph McLaughlin, and Jane Green. The 1877 Earlville directory listed Cyrus's trade as carpentry and John's as constable for Earlville. Joseph and John served in the Civil War; Joseph survived a head wound. (Courtesy Earlville Community Historical Society.)

AN EARLVILLE LIBRARIAN GOES TO CITY HALL. Fanny M. Burlingame, in the photograph below, was the librarian in Earlville for 40 years before the existing library, on Winthrop Street, was built. At one time the library was in the city hall building, pictured on the left, and then in the top floor of a building in downtown Earlville. The Earlville City Hall was built of brick in 1884. The architectural characteristics, such as the large square brick building with double windows that are rounded at the tops and a low-pitched roof, which is supported by brackets under the prominent eve, show that this building is of the Italianate style. (Courtesy Earlville Community Historical Society.)

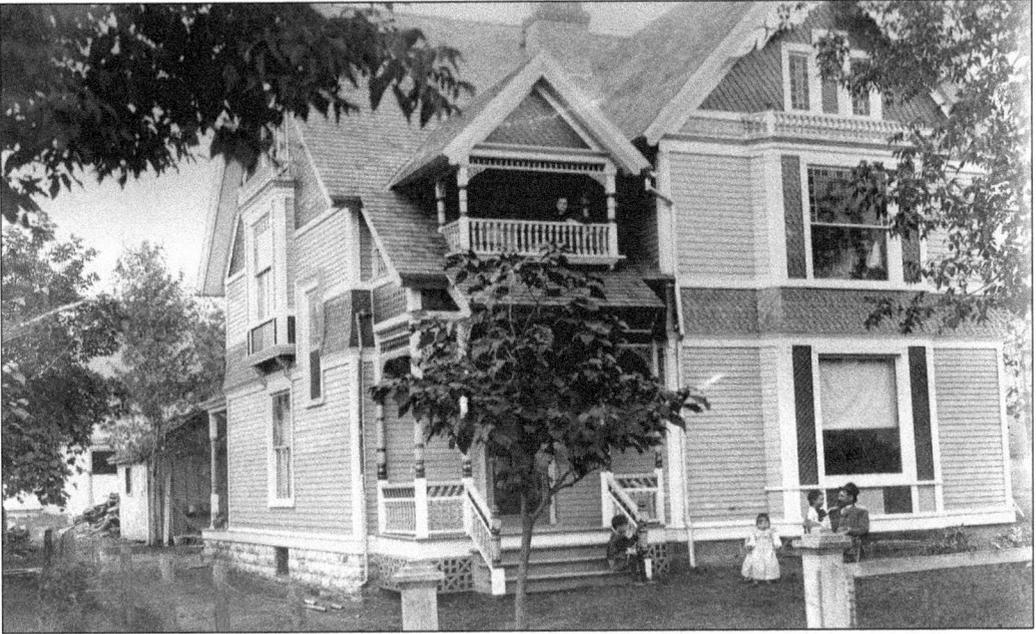

THE HARRINGTON HOUSE, C. 1880. This Queen Anne–style home was built by Robert J. Harrington on Washington Street in Marseilles in the 1880s. Robert Harrington is sitting out in front with his three children. They are Neita, Bruce, and Ted. Mary Harrington (née Scott) is looking out from the second floor balcony. Robert conducted a business in Marseilles called Scott and Hamilton. (Courtesy Marseilles Public Library.)

A LOVELY LADY FROM SENECA. This is a photograph of Annie Weir (née Farley) of Seneca, Illinois. Her photograph was taken at the Jenkinson Brothers Photography Studio in Seneca in the late 1890s. The Farleys came to the county as early as the 1860s. (Courtesy Seneca Public Library District.)

15

THE KELLYS—BROTHER AND SISTER. These two *c.* 1895 portraits are of Tim Kelly and his sister Margaret. They show siblings who were born and raised in Seneca. The land of their family home was eventually bought by the Du Pont Company for an explosives plant, just three miles from town. In the early 1900s, Du Pont bought up many explosive companies and increased production of a smokeless powder. During World War I, Du Pont De Nemours and Company was able to supply almost half of the smokeless powder that was used by the U.S. Military and their allies. (Courtesy Seneca Public Library District.)

THE DUPEE FAMILY OF EARLVILLE.
Sara Cone Dupee's photograph is on the
right and was taken in 1898. Ella Dupee's
photograph is below; its date is unknown.
The 1886 LaSalle County Directory has
the Dupee Brother Mercantile firm doing
business in Earlville. Their business
was started in 1867 and was considered
one of the best stores to be found in
all of LaSalle County, selling clothing
including boots and shoes, and dry goods
as well as groceries and furnishings. The
1920 census for LaSalle County, Illinois,
revealed that Sara was Ella's mother; they
lived on East Street and Sara was the
head of the house. (Courtesy Earlville
Community Historical Society.)

HIS IMAGINATION CREATED HOPALONG CASSIDY. Clarence E. Mulford was born on February 3, 1883, in Streator. The house above, built in 1883, where he grew up, was built on Bridge Street. Mulford wrote his first story in 1904. From that beginning, the door was opened; he wrote over 25 western stories. The Hopalong Cassidy series of stories were turned into the popular movies staring William Boyd. (Courtesy Streatorland Historical Society.)

THE JOHN WIDMAN FAMILY PORTRAIT. John Widman worked in a popular industry; he was employed by Star Union Beer in Peru. Star Union started as many other breweries did, under a different name, and it evolved over its 120-year history. This photograph was taken in the early 1900s before prohibition. (Courtesy Peru Public Library Local History Room.)

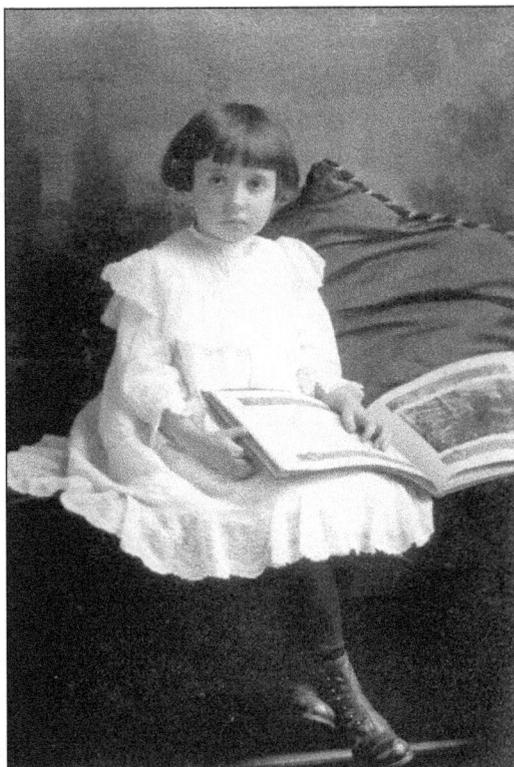

EARLVILLE CHILDREN HAVE THEIR PORTRAIT TAKEN, C. 1900. The young lady, right, is wearing a white lawn dress, which features a yoke, yards of ruffled lace, and a standing collar. It was usually offered only in white. Her shoes have seven buttons and rise well over her ankle, which was considered very stylish. Her stockings could have been made of wool, cashmere, silk, or cotton. The child on the wicker chair, below, could be a girl or boy as babies were dressed the same no matter their sex. One can tell, however, that the child next to the wicker chair is a boy as he is wearing "knee pants," which girls did not wear. He is wearing a sailor collar suit, which was ordered through the catalog by the age of the child. (Courtesy Earlville Community Historical Society.)

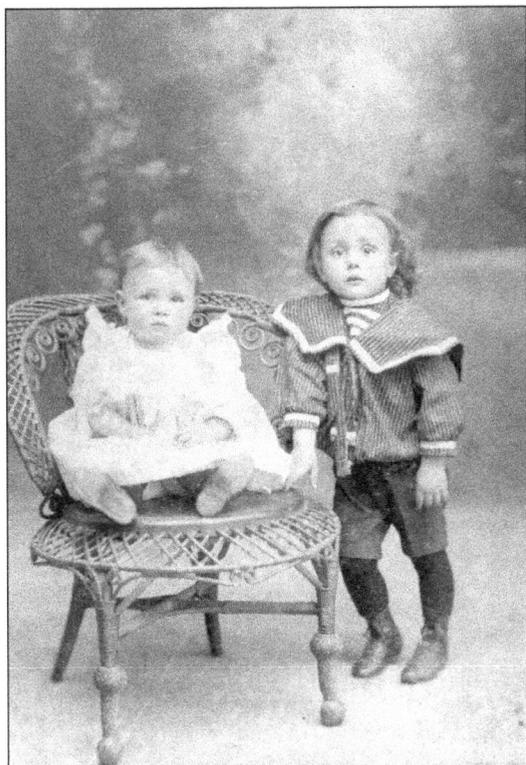

AUGUSTA ZIESING, POSTMISTRESS FOR PERU. Officially the post office permitted women postmistresses in 1933, but other women had been postmistresses before the post office officially permitted it. The Ziesing family is listed in the Peru directory of 1894–1895 as Augusta (who was a teacher at Central High School), Henry (a physician), and Julius and Minnie also lived at 1415 Fourth Street in Peru. (Courtesy Peru Public Library History Room.)

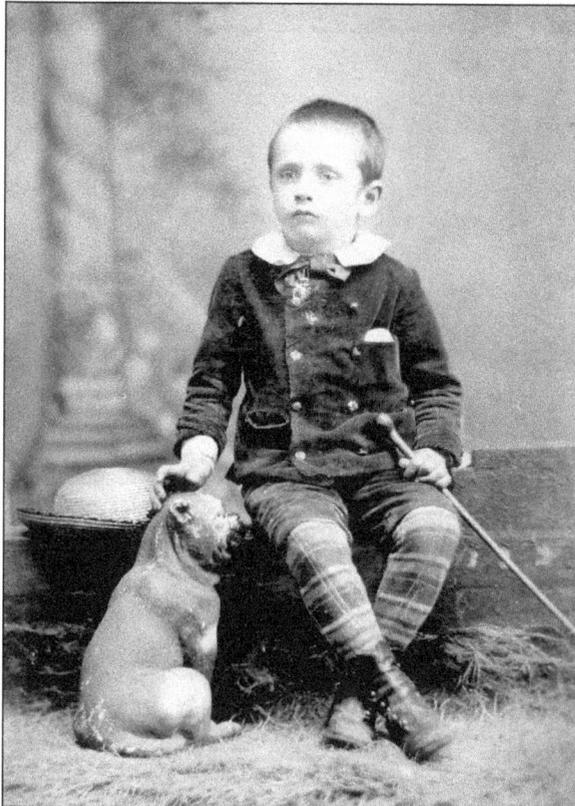

A DAPPER YOUNG MAN. Little Billy Duggan poses while patiently petting the puppy beside him. His straw hat is placed at his side and he holds a walking stick. Duggan is sporting plaid leggings and button shoes and has a hankie in his pocket in this c. 1900 portrait. (Courtesy Seneca Public Library District.)

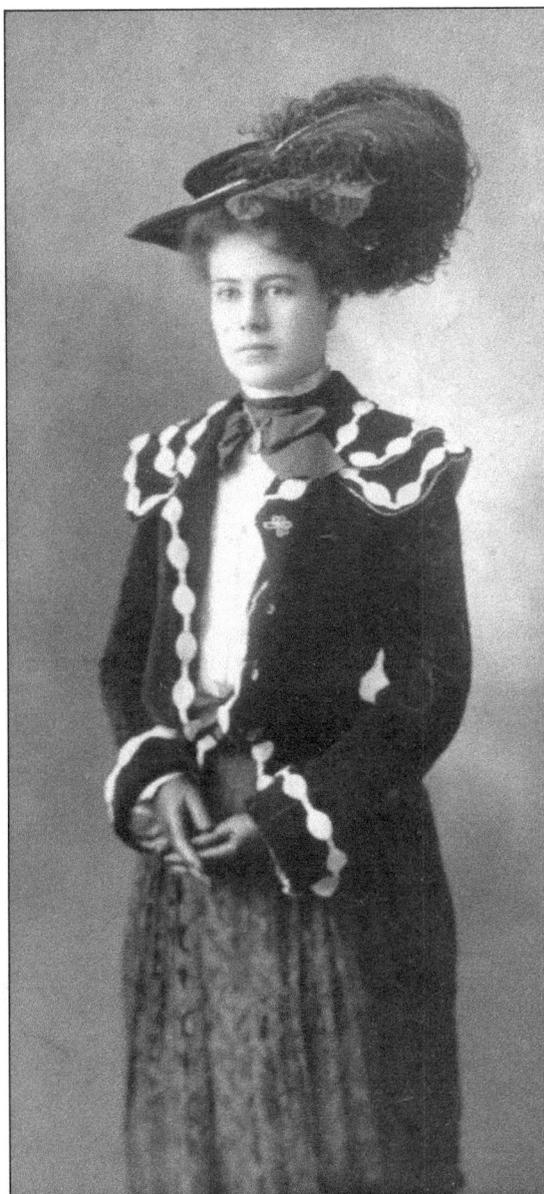

A Stylish Woman. Styles of the time, 1900–1914, were becoming looser and easier for women to wear. With the lack of confinement in one area came restrictions in another. Notice the slimness of this ladies skirt. As skirts were designed slimmer and more natural looking, they were styled much narrower at the hemline, which confined the legs movements. Some skirts called "Hobbles" made it so that the length of a woman's step was restricted. The skirt pictured here is not shown completely and may not be a Hobble, but it is of the style of the slimmer skirt with a more natural line. This lady's suit is called a "Tailor-made," usually worn with a shirtwaist, which was another item of clothing that was comfortable and easy to wear, along with being affordable. As women's clothing styles became slimmer and more natural looking, their hats became larger. The hats were complementary to the ladies dresses and were usually ornately adorned, as this feather hat shows. They were secured with a long hat pin. (Courtesy Earlville Community Historical Society.)

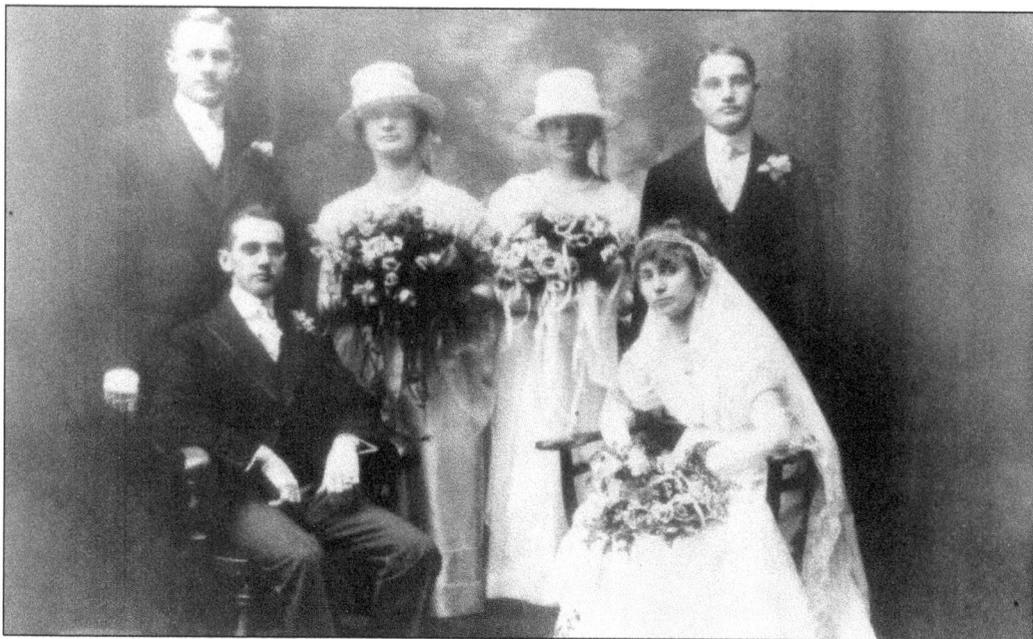

NEWLY MARRIED. Andrew A. Hebel and Helen Hardebeck (seated) are pictured on November 4, 1916. The best-known wedding tradition may be something old, new, borrowed, and blue. Something old represents a lasting marriage, new symbolizes the new beginning, something borrowed from a happily married couple represents your wish for a happy marriage, and something blue is for the couples pledge for love, faithfulness, and chastity. (Courtesy Peru Public Library Local History Room.)

A TOUR OF WESTCLOX. The Roya Midgets were performing at the Majestic Theater in June 1922. Here they pose for a photograph after a tour of the Westclox factory. Westclox began operations in the city of Peru in 1885, making various kinds of clocks. The company ceased operations in Peru in the later part of the 20th century. (Courtesy Peru Public Library Local History Room.)

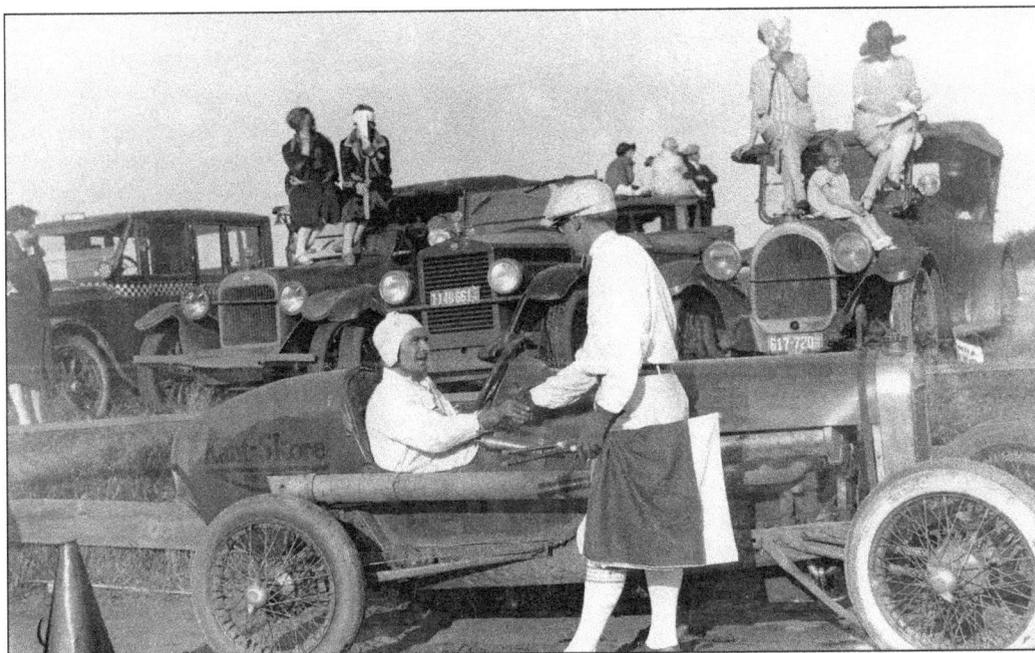

AT THE RACES. In this 1926 photograph, Ed "Scratchy" Politsch is seen here in his early race car, which could be a French-made Delfosse. The races were held at the fair grounds in Mendota. The Politsch family is listed in the 1917 Farmers Directory as living in Mendota since 1907. (Courtesy Mendota Museum and Historical Society from Leo and Norma Muhlach Collection.)

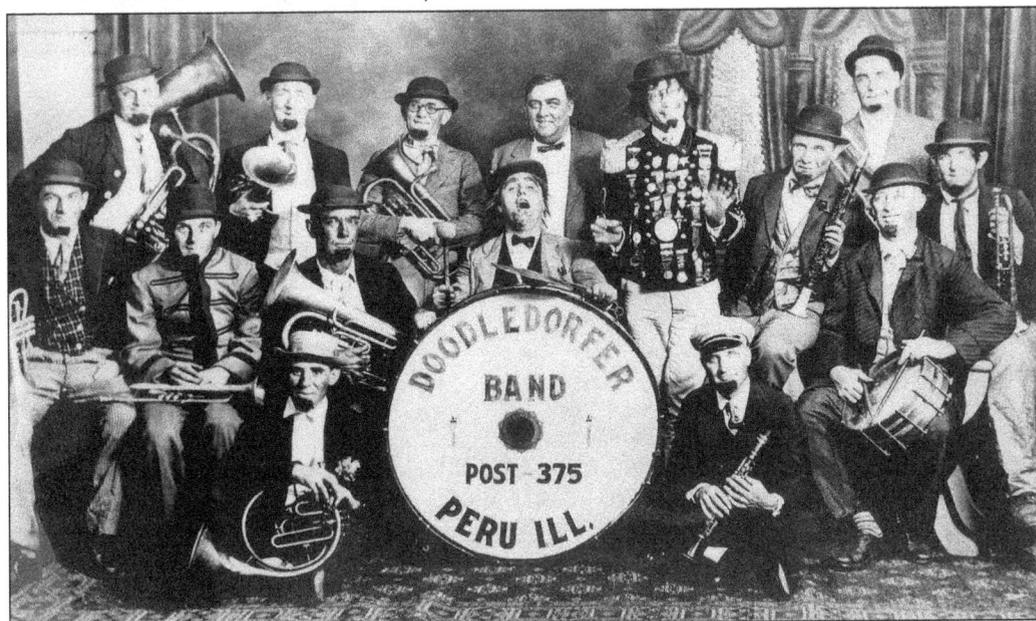

THEY KNEW HOW TO HAVE FUN. This c. 1928 photograph shows the Doodledorfer Band who are, from left to right, (first row) Harry Stedman and August Soedler; (second row) Kent Lenzen, Victor Frizol, Bill Krummeich, John Gehrig, Carlier Lauer, Bob Dingler, and W. Meisenbach; (third row) Joseph Schmitt, Harold Trench, Herman Link, Dan Galvin, Harry Hundt (band director), and N. Hoffman. (Courtesy Peru Public Library Local History Room.)

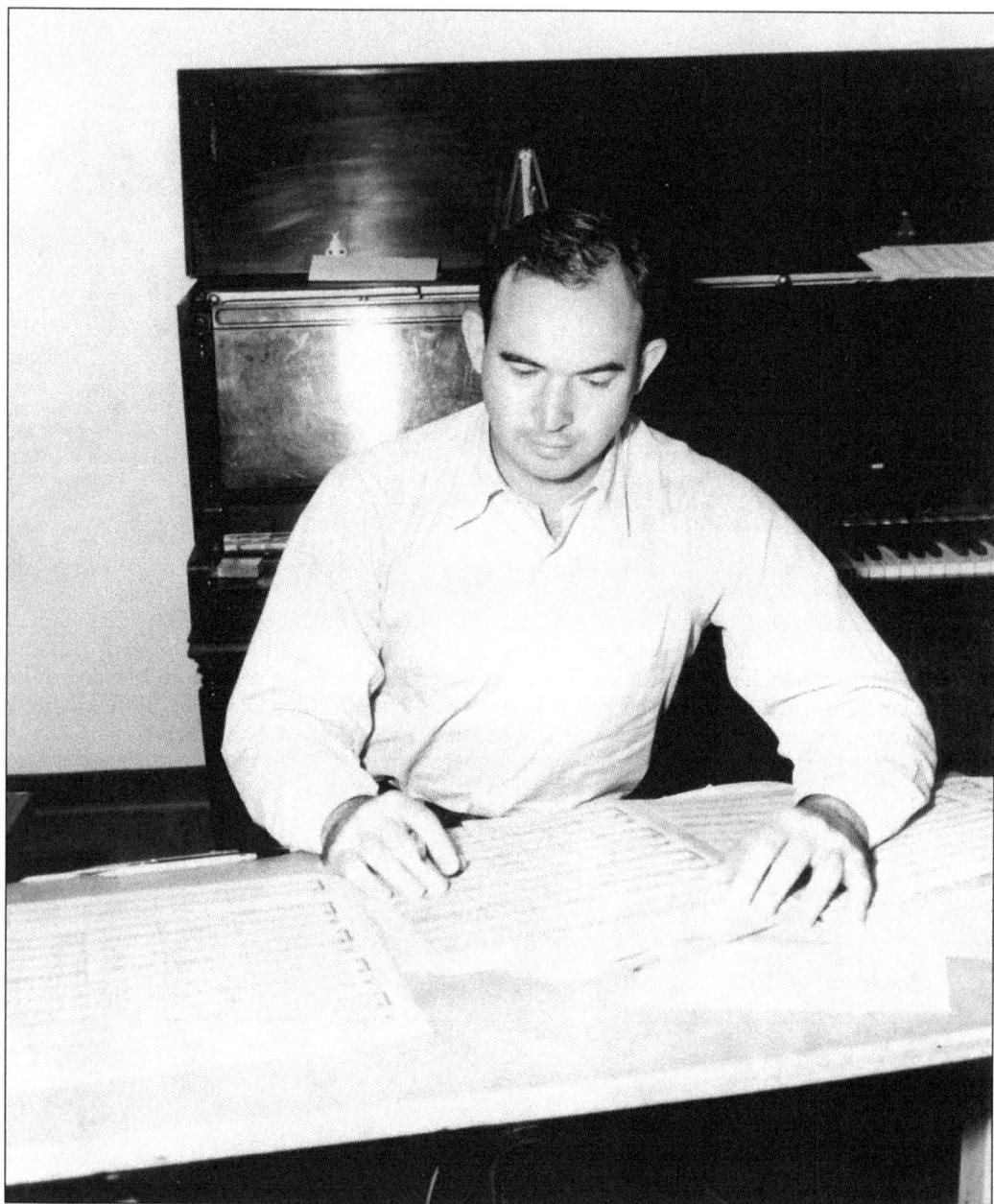

HE WORKED FOR WALT DISNEY STUDIOS, EARLY 1940S. Edward H. Plumb was born in Streator in 1907. He graduated from Streator High School in 1925. Edward is a direct descendent of Ralph Plumb, who was the founder of the town of Streator. In 1938, Edward was working for Walt Disney Studios as a music arranger. One of his first compositions was for the Disneyland television series, it was an episode called, "Mother Goose goes Hollywood" which was televised in 1938. Edward also worked on; *Fantasia* (1940), *Dumbo* (1941), *Bambi* (1942), *The Three Caballeros* (1944), *Song of the South* (1946), *Peter Pan* (1953), *Davy Crockett, King of the Wild Frontier* (1954), and *Lady and the Tramp* (1955). These examples of his work are among his more well-known projects for Disney Studios, which number over 35. (Courtesy Streatorland Historical Society.)

24

Two

MOVING AROUND
THE COUNTY

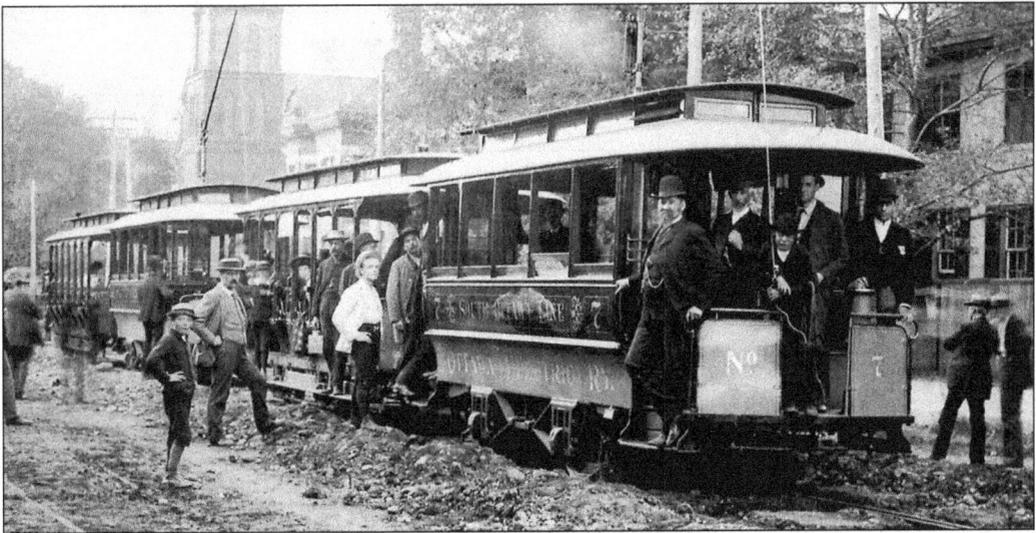

TRANSPORTATION NOT A PROBLEM. In the late 1800s, one had many choices as to how one would move about. The choices included the Interurban, city streetcars, trains, wagons, boats, one's own feet, or maybe a bicycle; all one had to do was make up ones mind. This is the South Ottawa line No. 7, showing the brand new Interurban street car line; notice the rough road with dirt piled on either side of the tracks. The Interurban began running as early as 1893, and most every state in the union, at that time, came to have one. Their popularity grew so much that one could travel from Chicago to New York via this mode of transportation. There were even advertisements for one to travel to California, at a cost of about $50. Some of the cars were elegantly made up—on longer trips sleeping berths were provided, and heat came from a coal stove. Farmers who let the tracks go through their fields were treated to the use of the electricity that this conveyance needed to run. (Courtesy M. Dorothy Clemens.)

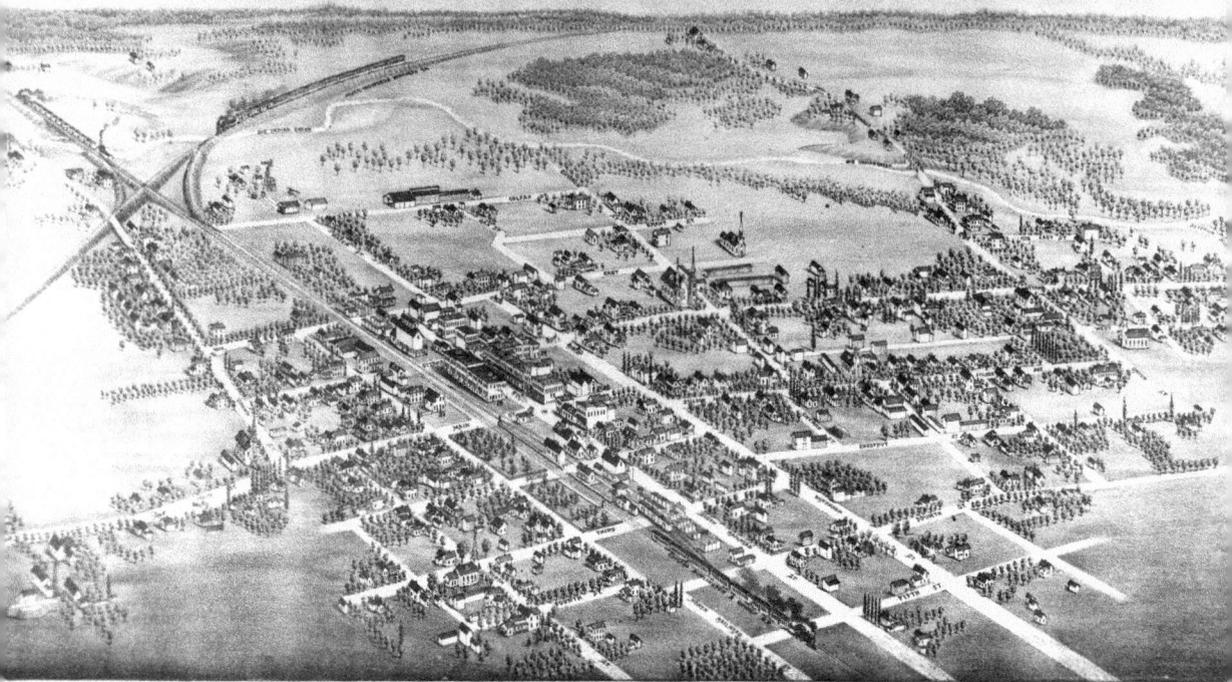

THE TOWN OF EARLVILLE. This map shows what it calls a "bird's eye view of the city" in 1882. Shown is a view looking southeast. There are seven churches listed in the map's index, all of different denominations. The map shows three trains moving through or about to go through town, two being passenger trains and one hauling freight. There are three physicians listed, one meat market, two barbers, and only one schoolhouse. Barnard and Radley handled furniture and undertaking. The sawmill and flour mill to the southwest sits on the outskirts of town on Sutphun Run and Ottawa Street. There are four grocery stores, a saloon with a billiard hall, a brick yard, a lumberyard, a jeweler, a harness shop, and, last but not least, a bakery with confectionery. This certainly is not the sum total of the town—there is much more to the index listing—and one gets the idea that this town is a growing concern. (Courtesy Mendota Museum and Historical Society from Leo and Norma Muhlach Collection.)

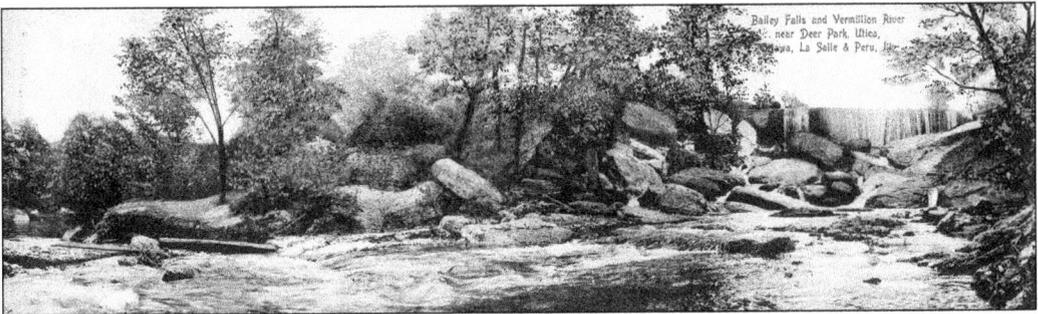

BAILEY FALLS AS IT ONCE WAS, C. 1909. At the Vermillion River, near Utica, is a beautiful falls that once attracted tourist and locals. The cool water, the sound of the water falling over the rocks, and the many trees made a beautiful spot on the otherwise flat prairie lands. (Courtesy LaSalle County Historical Society Museum.)

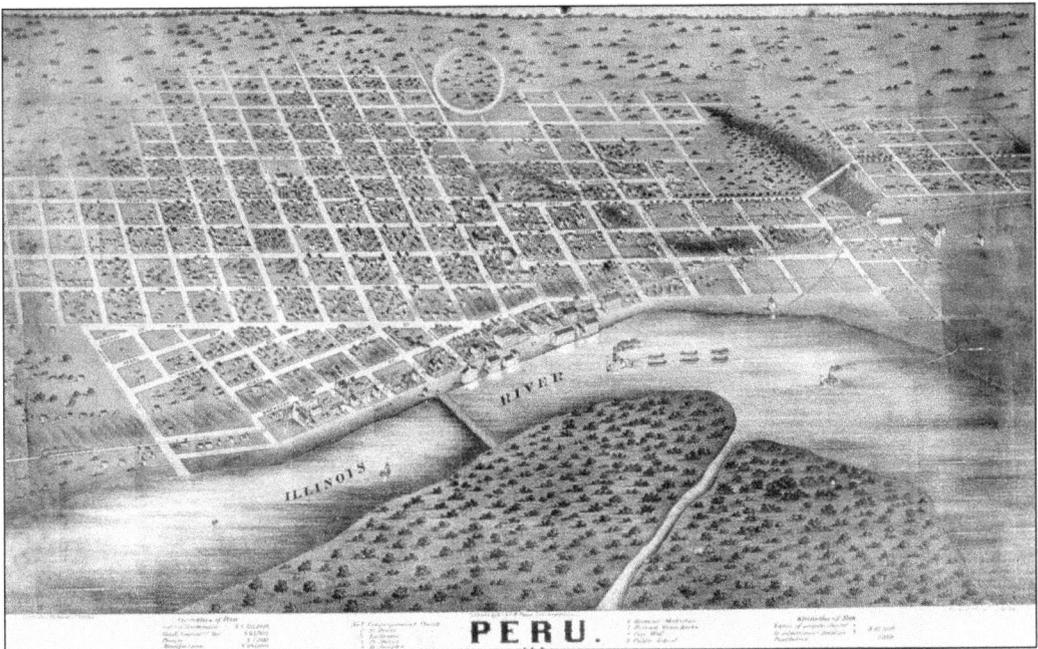

A MAPMAKER'S LOOK AT THE CITY OF PERU, 1868. This drawing of Peru, Illinois, shows a well-developed city in 1868. The town had its beginnings in 1835 and was well situated on the Illinois River. Later the Illinois and Michigan Canal came into the town and had its terminus there at the Illinois River. (Courtesy Peru Public Library Local History Room.)

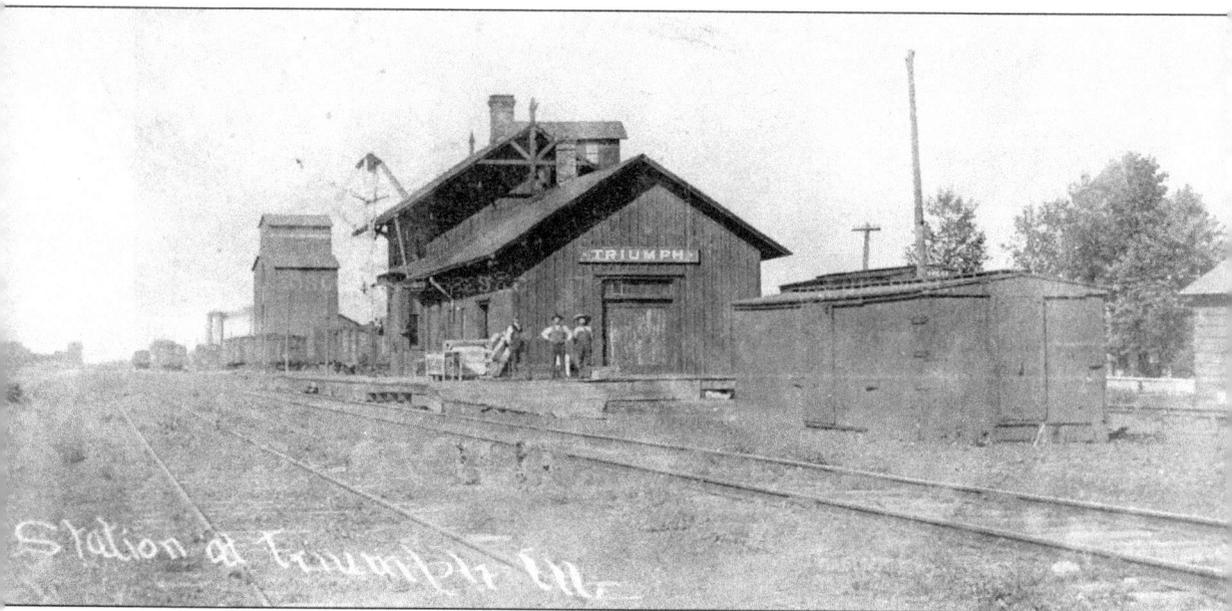

THE RAILROAD STATION IN THE TOWN OF TRIUMPH, C. 1900. The railroad station, in any town at the beginning of the 20th century, was a busy place. People as well as goods came and went on these rails regularly. The town of Triumph is on the west side of Ophir Township in the northwestern part of the county. The name of the town changed a few times before a decision was made final, having been called Lafayette and Hardscrabble respectfully. The location of the town also changed, moving slightly east from where it was originally plotted, after the railroad arrived in the later part of the 19th century. The railroad helped to increase profits for local farmers shipping their wares to Chicago and other markets. The railroad also helped to lessen the losses associated with shipping grain, produce, and other farm products by wagon. (Courtesy Mendota Museum and Historical Society from Leo and Norma Muhlach Collection.)

HALFWAY HOUSE. Called the Sulfur Springs Hotel and the Wayside Inn, this was the halfway point between Chicago and Peoria on the Frink and Walker Stage Coach Line. The hotel had 12 guest rooms, a grand ballroom on the third floor, and private drinking rooms and was situated on 267 acres with sulfur springs, which were thought to be good for one's health. (Courtesy Peru Public Library Local History Room.)

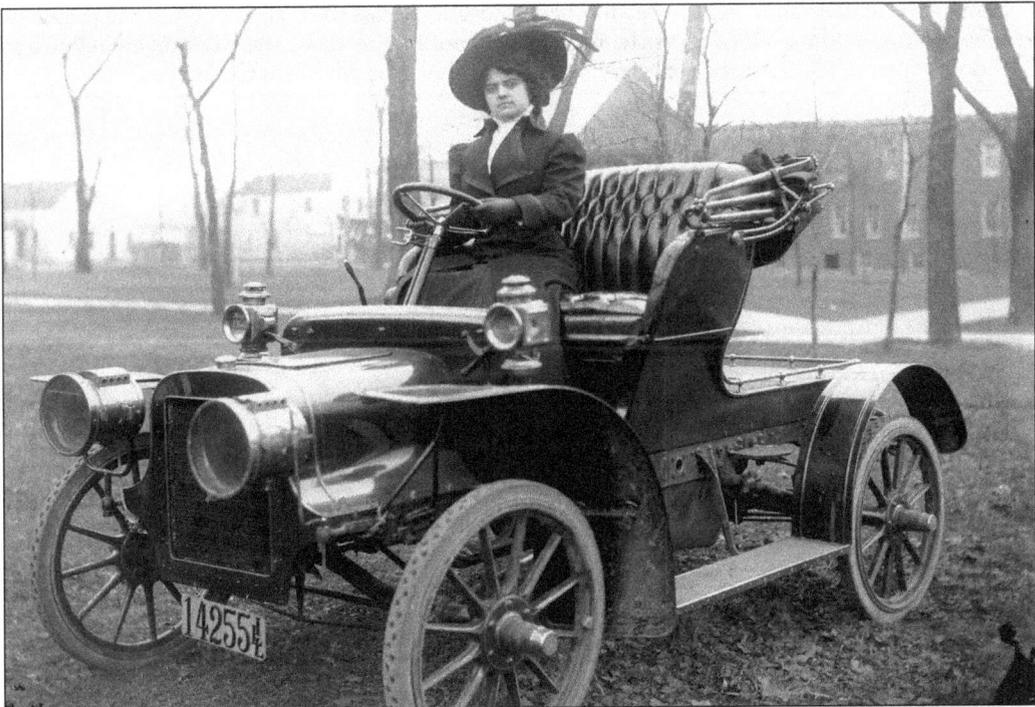

SITTING PRETTY IN CITY PARK. This unidentified woman's photograph was taken in the early 1900s. Her car is reportedly a 1908 Cadillac, Model S Runabout. Cadillac's Model S was introduced in 1907; it had 12-spoke wooden wheels. The 1908 model year was the last year that Cadillac used a one-cylinder engine. (Courtesy Mendota Museum and Historical Society from Leo and Norma Muhlach Collection.)

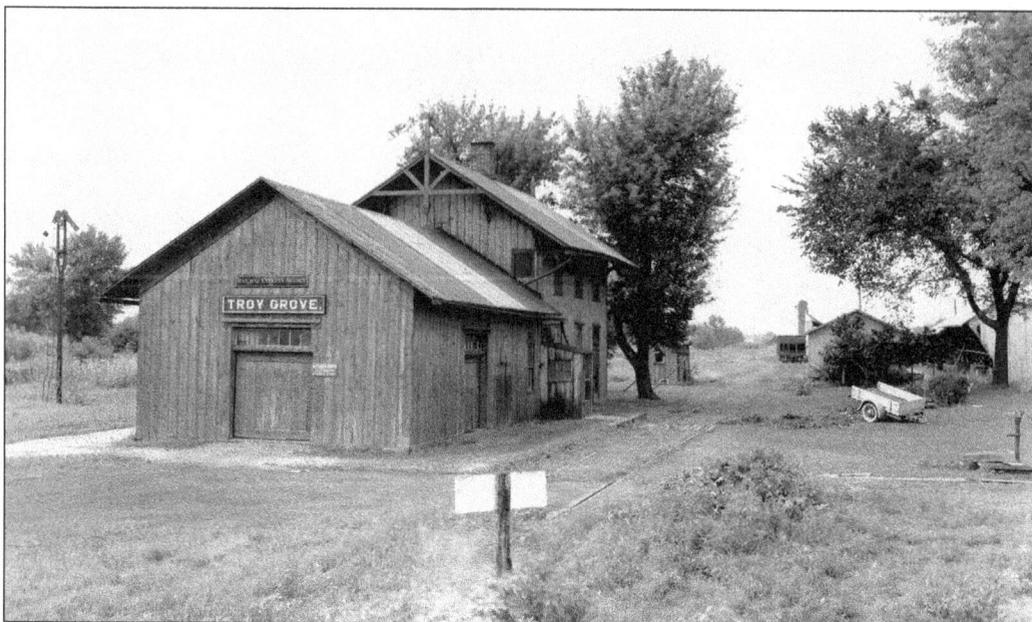

TROY GROVE DEPOT, C. 1940. This depot served as the Railway Express Agency (REA) and Western Union Telegraph Cable Office. The REA would ship anything a customer wanted, from explosives to circus animals, and served most communities across the country. When the shipment arrived, one would be notified by postcard. Pick-up would be made at the REA office. (Courtesy Mendota Museum and Historical Society from Leo and Norma Muhlach Collection.)

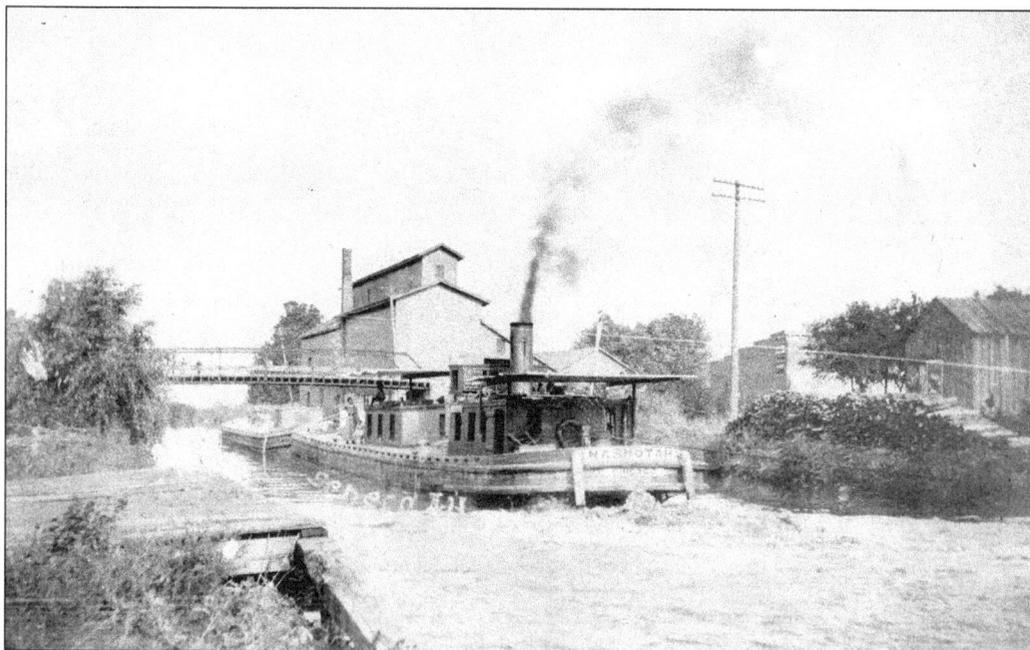

THE STEAM BOAT NASHOTAH, C. 1900. This boat is in the Illinois and Michigan Canal at Seneca in front of the Hogan grain elevator. On the boat can be seen a woman with two children, the family of the captain often traveled with him. This boat was owned by M. J. Hogan and was under the command of John Donovan. (Courtesy Marseilles Public Library.)

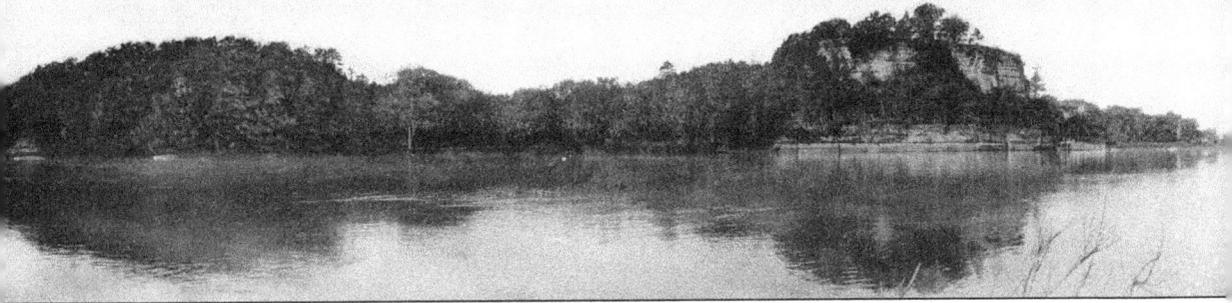

STARVED ROCK AND LOVERS LEAP. Starved Rock is named for the story of the Illiniwek peoples who, trapped atop the rock by their enemies, had neither food nor the desire to be killed. They chose to starve to death. This photograph was taken in 1909 directly across the Illinois River from Starved Rock and Lover's Leap, in the area that the Illinois Waterway Facility now sits. East of Starved Rock is Lovers Leap or "Maiden's Leap." A tale of unrequited love gave this rock its name; when a young maiden's lover did not return to her, she threw herself from the rock to the river below. The cliff rises above Starved Rock by 17 feet and is 170 feet above the river. It has been said that the Maiden's Leap Rock, when viewed from a particular position, looked like a water pitcher. (Courtesy LaSalle County Historical Society Museum.)

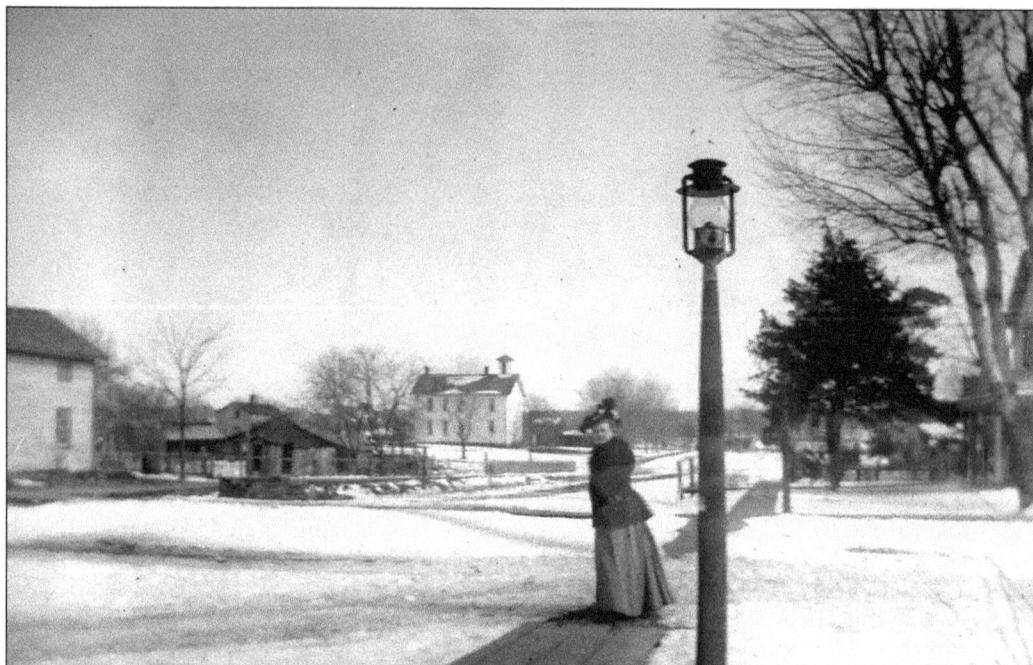

WOODEN SIDEWALKS IN TROY GROVE AND MARSEILLES, C. 1900. Mrs. Hapeman is the lovely lady taking a stroll in the snow on Troy Grove's wooden sidewalks. The white building in the center background of the above photograph is the Troy Grove schoolhouse. The lower photograph shows the elevated wooden sidewalks and staircases for Marseilles on Glen Avenue, just northwest of Main Street in the bluffs. Wooden sidewalks were a tremendous help in the days of dirt roadways, horse and buggy, and stylish dresses that reached to the ground. (Above, courtesy Mendota Museum and Historical Society from Leo and Norma Muhlach Collection; below, courtesy Marseilles Public Library.)

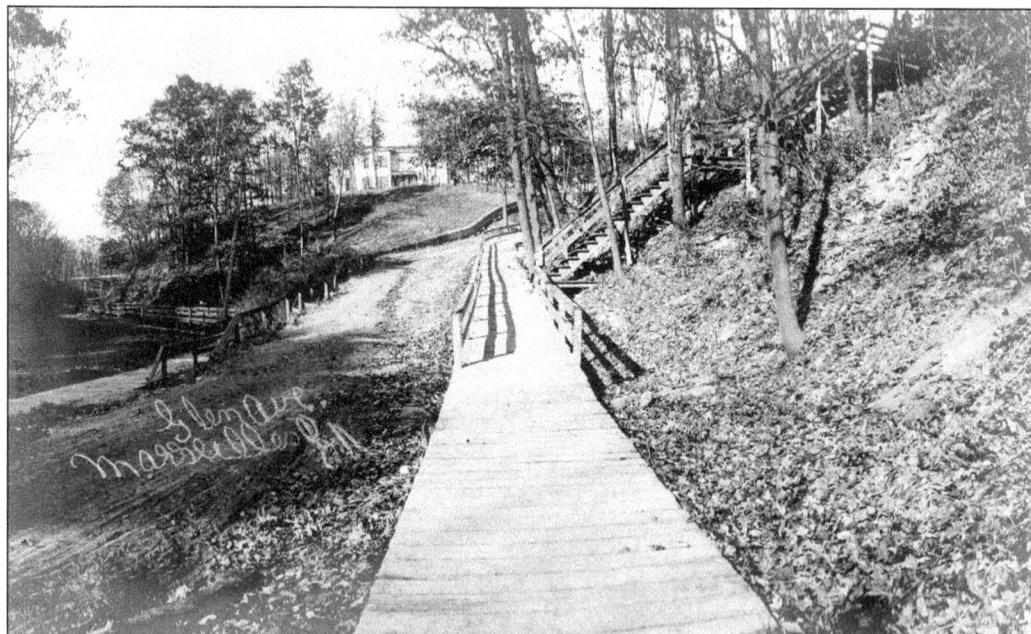

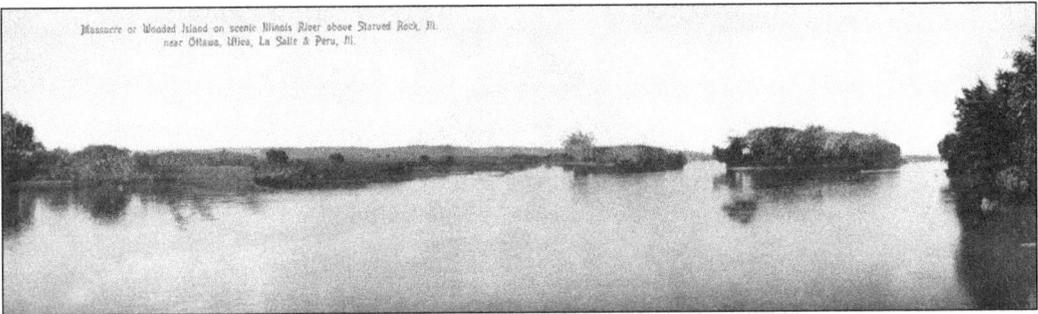

PLUM ISLAND ABOVE STARVED ROCK, C. 1909. Before being called Plum Island it was called Massacre or Wooded Island. It was called Wooded Island for the abundance of trees, and Massacre Island for the bones found by archeologists. The bones give archeologists reason to believe that a massacre took place on the island. Today the island is a sanctuary where bald eagles can be seen each winter. (Courtesy LaSalle County Historical Society.)

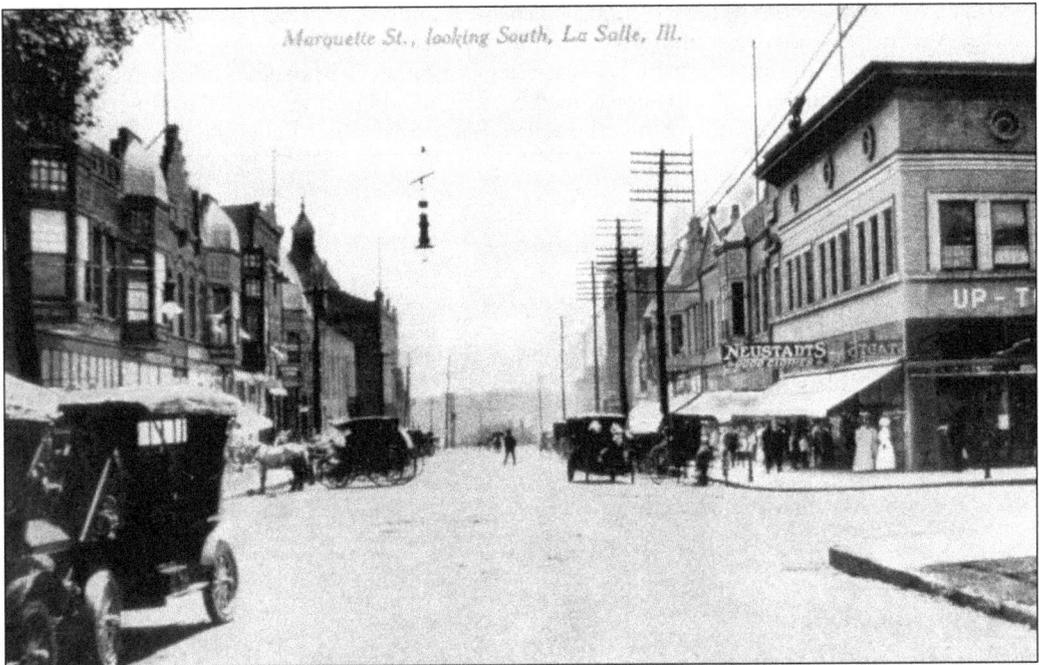

MARQUETTE STREET IN THE TOWN OF LA SALLE, C. 1900. This postcard shows Marquette Street, looking to the south, in La Salle, Illinois. The Illinois and Michigan Canal would have been found at the end of this street. The sign on the right side is advertising Neustadt's Good Clothes. (Courtesy Peru Public Library Local History Room.)

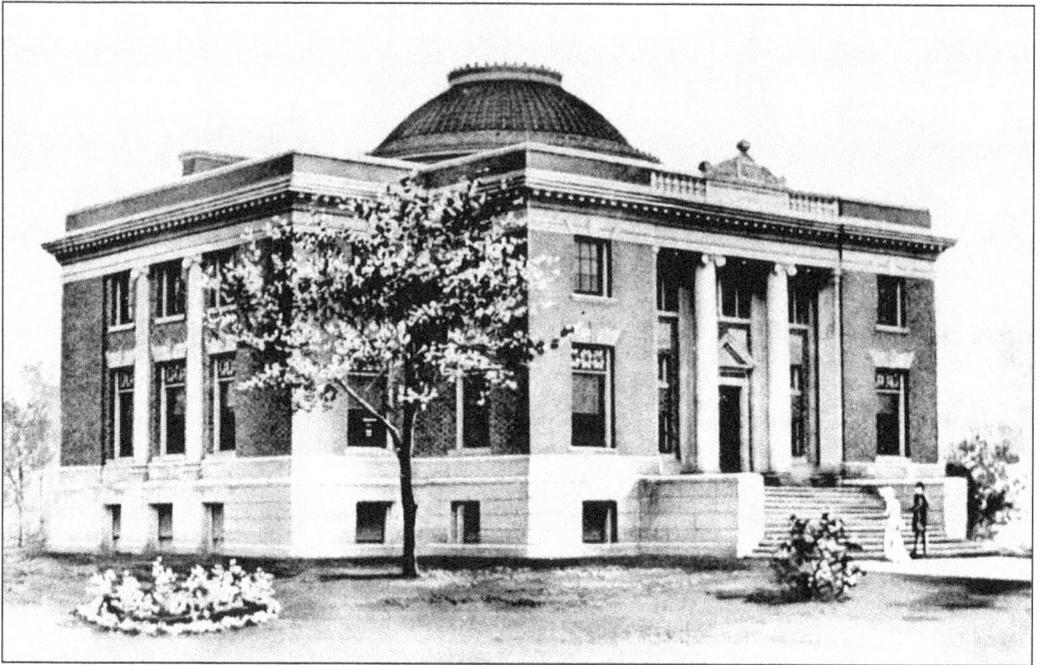

ON THE NATIONAL REGISTER OF HISTORIC PLACES. The Streator Public Library was listed on the national register February 5, 1996. Built in 1903, with bricks locally made, this building was built for $35,000, which was donated by Andrew Carnegie, after Streator's founder Ralph Plumb reminded him of his promise for the funds. Carnegie founded over 1,600 libraries in the United States. Another one of those libraries is the library pictured below. Marseilles Public Library is Colonial in style and was built in 1905, at a cost of $10,000. Marseilles celebrated its 100th anniversary in November 2005. In approximately 1939, an addition was added to the back of this library. (Courtesy Streatorland Historical Society. Below Marseilles Public Library.)

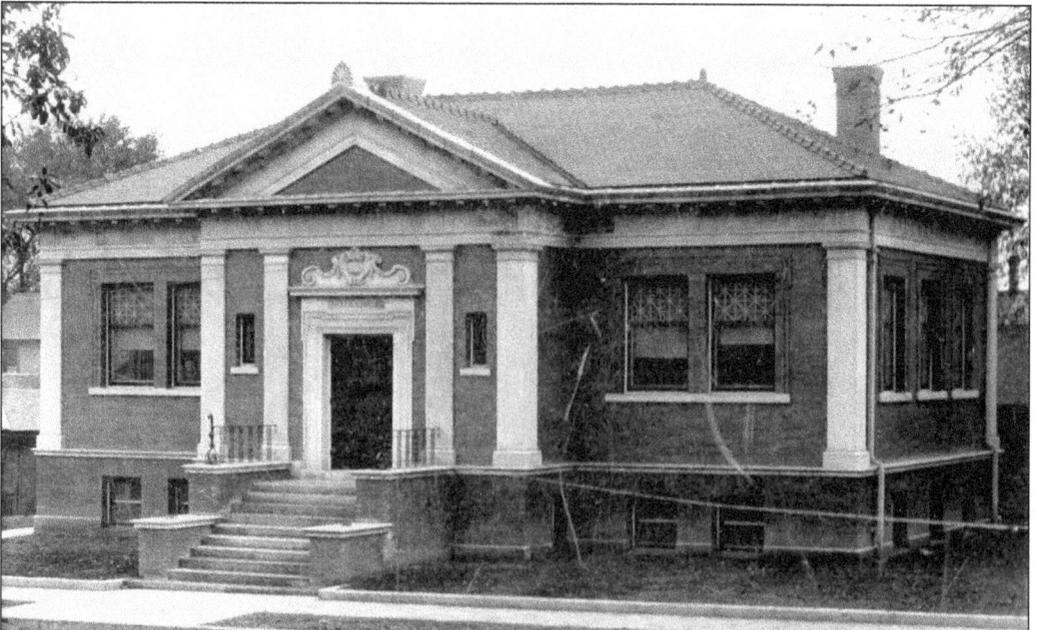

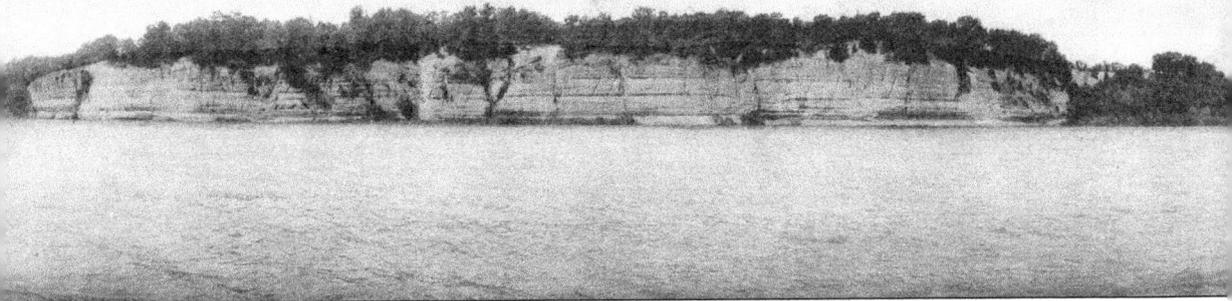

Buffalo Rock on Illinois River, west of Ottawa, Ill. famous in Illinois History and now new site of the Homeopathic Tent Villa Co.

HISTORIC BUFFALO ROCK, C. 1909. Beauty attracts attention; this rock is no different for there are many years of events that took place on or around this beautiful bluff near Ottawa. Its history includes a French trading post. It was home to the Illinois Indians and a place of death for that same tribe. Death also came to 15 Irish workers during the construction of the nearby Illinois and Michigan Canal. For a short time, Buffalo Rock was used by a religious group for meetings and then by the Crane Company, who owned the rock for 16 years, turning it over to the state when they left. Long ago when the Illinois River ran deeper, this rock was an island; it now is part of the Illinois State Park system, with 298 acres available to be enjoyed. (Courtesy LaSalle County Historical Society Museum.)

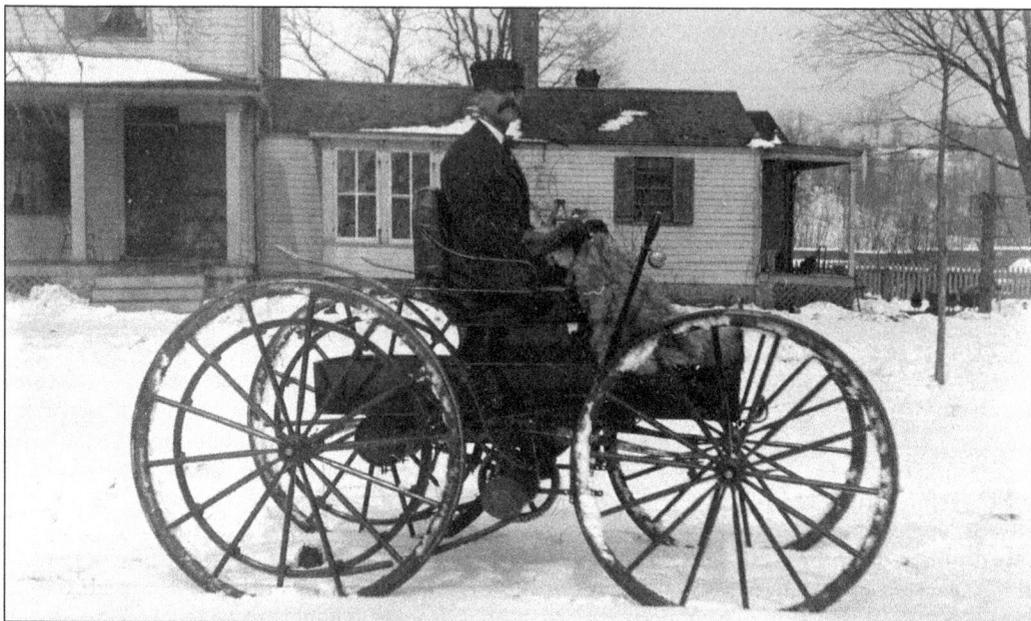

A HORSELESS CARRIAGE. Henry P. Grove is pictured in this *c.* 1905 photograph in his Holsman automobile. The Holsman was manufactured from 1903 through 1911 in Chicago. The Holsman was a high-wheeler and was very popular in the Midwest. The steel cable drive, which this automobile sports, was used from 1905 through 1909, before that a rope drive was used. (Courtesy LaSalle County Historical Society Museum.)

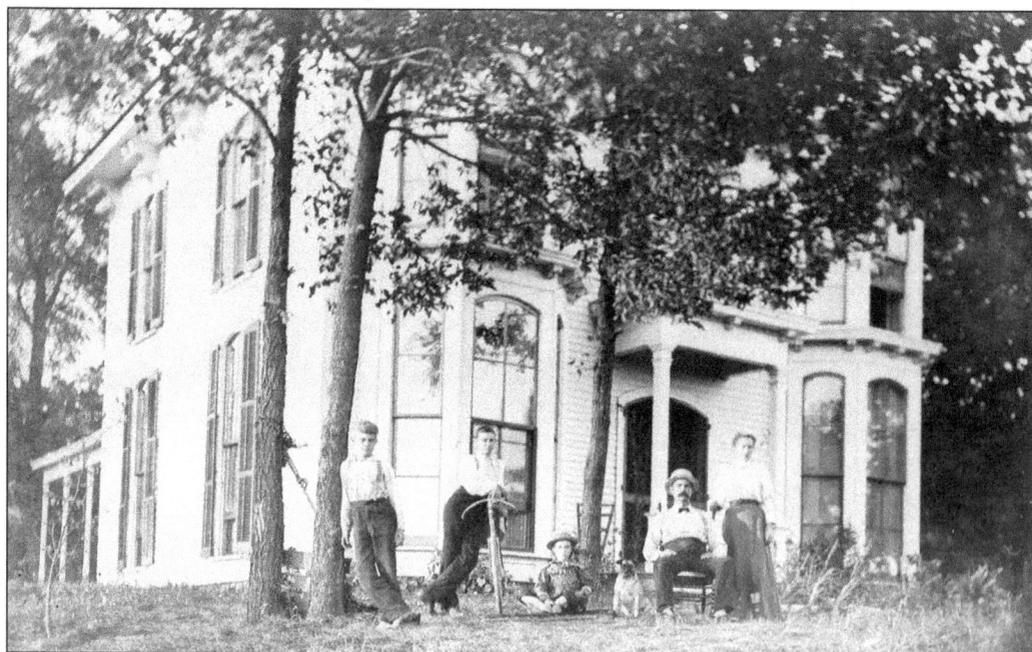

THE PARR HOME, C. 1880. The Samuel E. Parr family lived in the Marseilles area, or Rutland Township, since 1870. The home is of the Italianate style with its paired brackets, under the eves, the low windows on the first floor that reach to the floor, and the grouping of three windows in the bays or tower in front. (Courtesy Helen Crawford.)

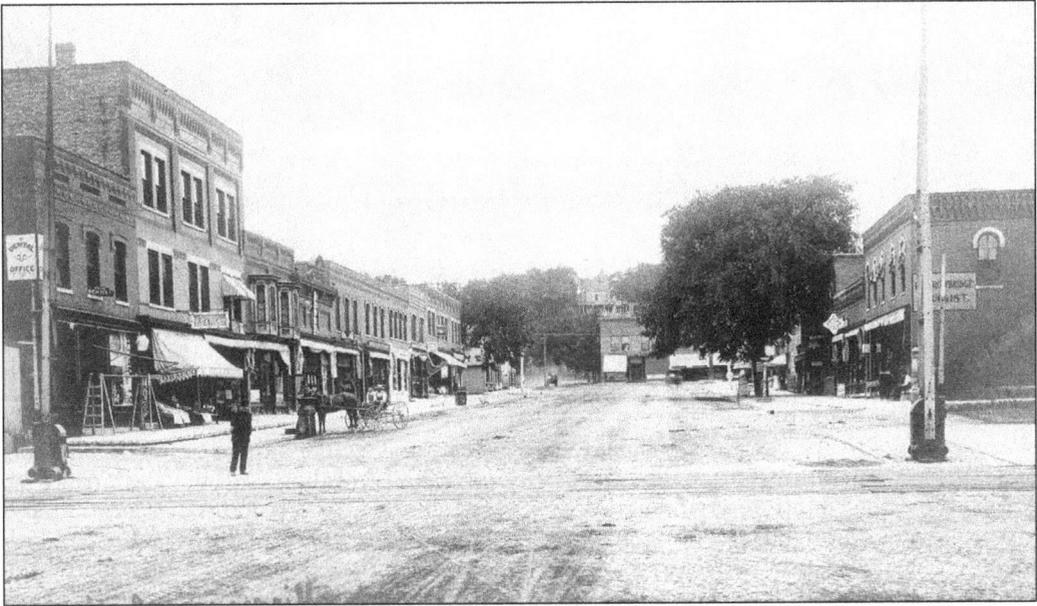

MAIN STREET MARSEILLES. Looking north down the brick-paved street, called Main, people in wagons, bicycles lying at the curb, a drug store, a bank, a grocery store, a barber, a bakery, and a confectionery can be seen. Furnished rooms are rented at the end of the street. There is a man fixing the awning at the left and V. Orsi's establishment sells ice cream, fruit, and cigars. (Courtesy Marseilles Public Library.)

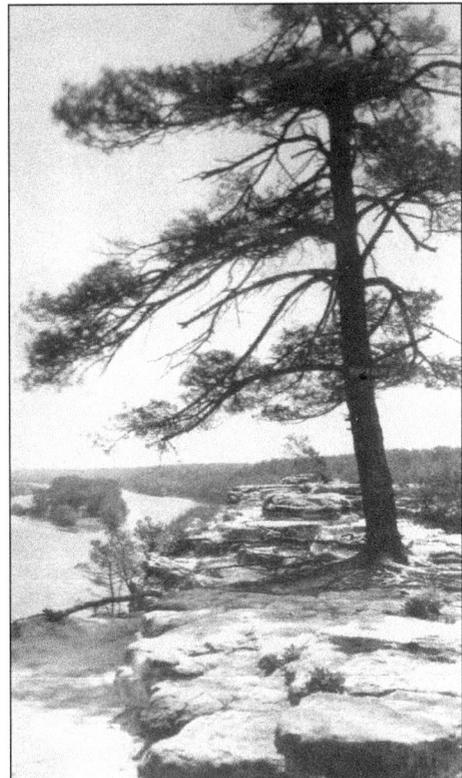

EAGLE CLIFF AT STARVED ROCK. A place to see eagles and for eagles to be seen is this spot in Starved Rock State Park, overlooking the Illinois River. The sign on the evergreen tree, atop the rocks, says "Eagle Cliff. The Eagle Cliff Overlook is east of Starved Rock and Lover's Leap Overlook and just east of the dam." (Courtesy Oglesby Historical Society.)

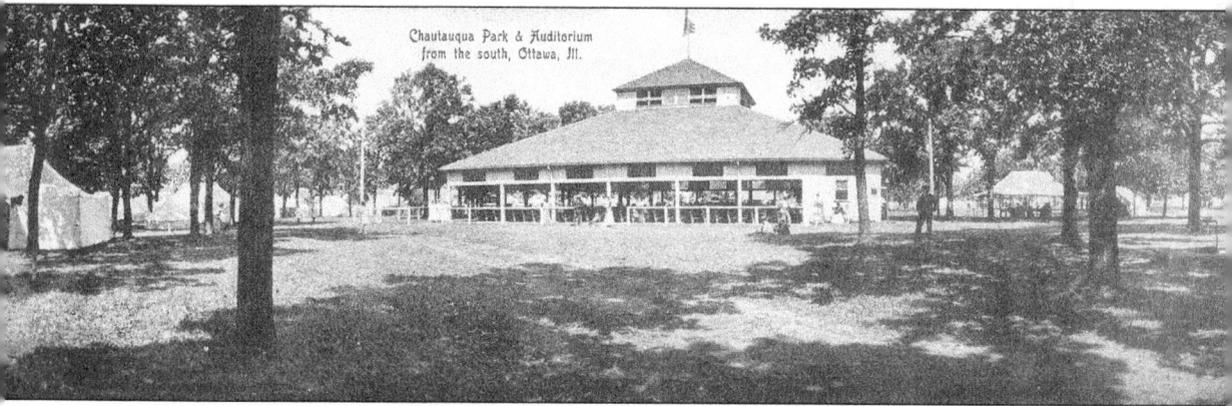

Chautauqua Park & Auditorium
from the south, Ottawa, Ill.

CHAUTAUQUA PARK AND AUDITORIUM IN OTTAWA, C. 1909. The Chautauqua movement started in the 1870s; it became a popular way to educate and lecture indoors as well as outdoors and often in beautiful settings. The popularity grew, and traveling Chautauquas arrived in towns across the country bringing music, politicians, and many other forms of education and culture to the waiting and wanting public. The August 1907 Ottawa Free Trader showed an ad for an upcoming event and advertised Congressman J. Adam Bede, Senator Lafollette, the Honorable J. Hamilton Lewis, Gov. J. Frank Hanely, and the noted orator Rev. Father Dunn among other noted speakers. There would be seating under a tent for this occasion but "Tenting accommodations must be secured early," as they expected a good crowd for such noted speakers. Advanced tickets would set you back $1.50. (Courtesy LaSalle County Historical Society and Museum.)

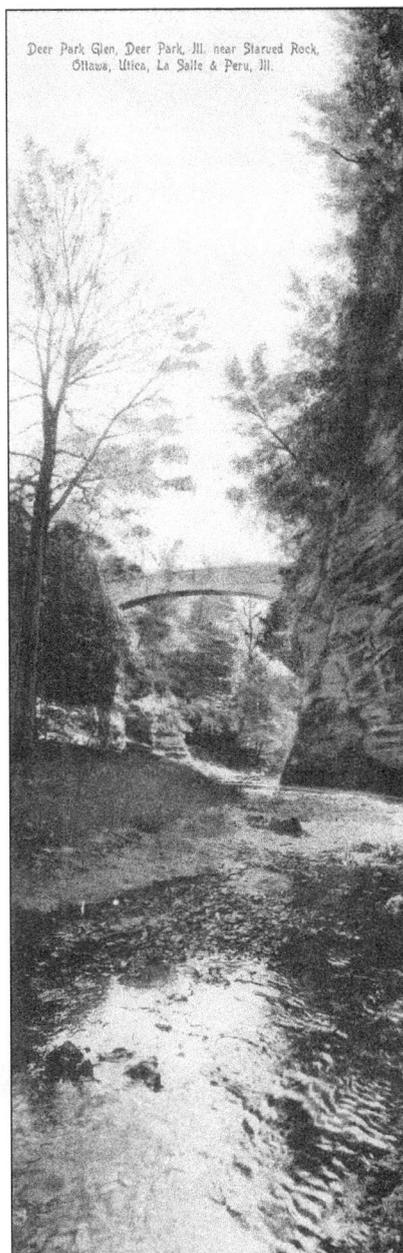

Deer Park Glen, Deer Park, Ill. near Starved Rock,
Ottawa, Utica, La Salle & Peru, Ill.

DEER PARK GLEN. Located in what is now Matthiessen State Park, Deer Park acquired its name from the easy capture of deer by the local American Indians and the abundance of the animal. This 1909 postcard shows exposed rocks of sandstone in an area called the "Dells." The meandering creek ran from Deer Park Lake to the Vermilion River. Frederick W. Matthiessen, who came from nearby LaSalle, purchased the land in the late 1800s and used it for a private park; the land he purchased included over 175 acres. Many trails were constructed along with bridges and stairs to make travel through the area easier. After Matthiessen's death, in 1918, the park was donated to the state, and Matthiessen State Park, named for Frederick William Matthiessen, was opened in 1943 for the public's use. The park's holdings now include over 1,900 acres. (Courtesy LaSalle County Historical Society Museum.)

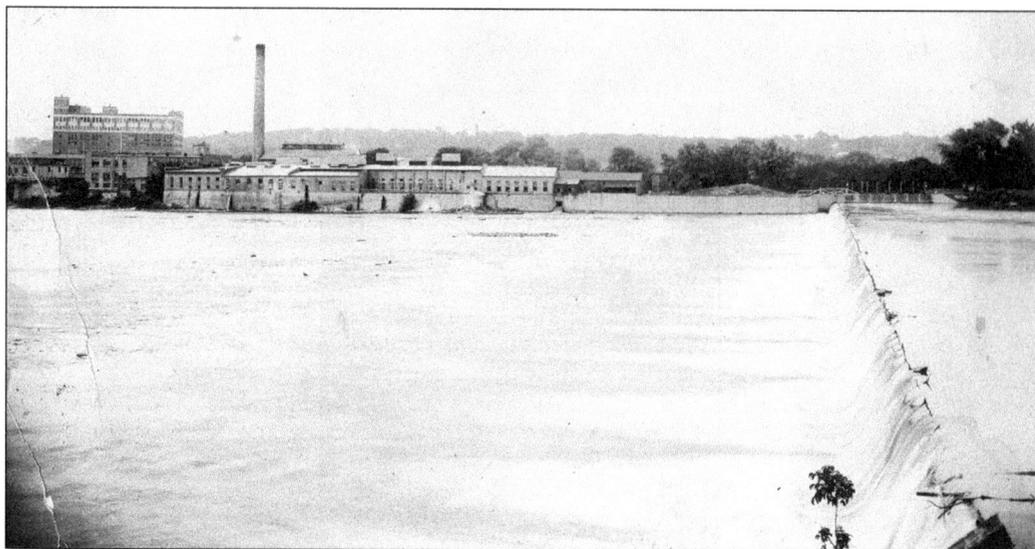

OLD AND NEW DAMS BUILT IN MARSEILLES, C. 1910. In 1836, the enterprising people of Marseilles constructed an eight-foot dam on the Illinois River. The power was used for manufacturing many types of goods and attracted more people to the area. Eventually the hydropower station seen across the Illinois River in the top photograph was built in 1910; today it is listed on the National Register of Historic Places as a landmark of technological ingenuity. The new dam, pictured below, was built in 1903. It is 960 feet long and 12 feet high, and had a construction cost of $30,000. (Courtesy Marseilles Public Library.)

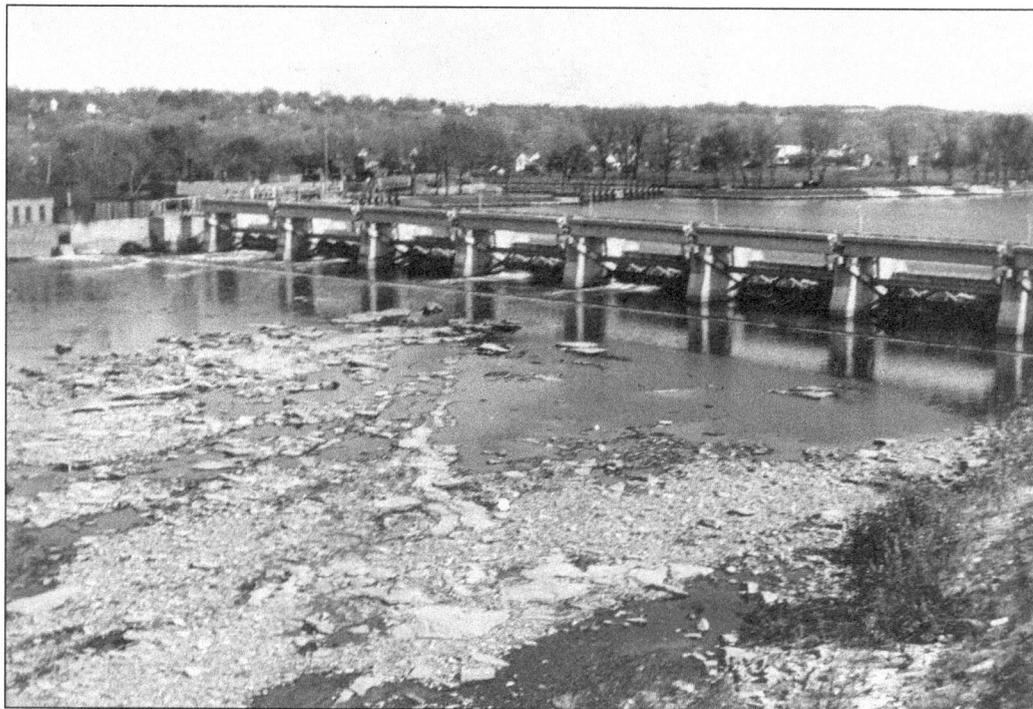

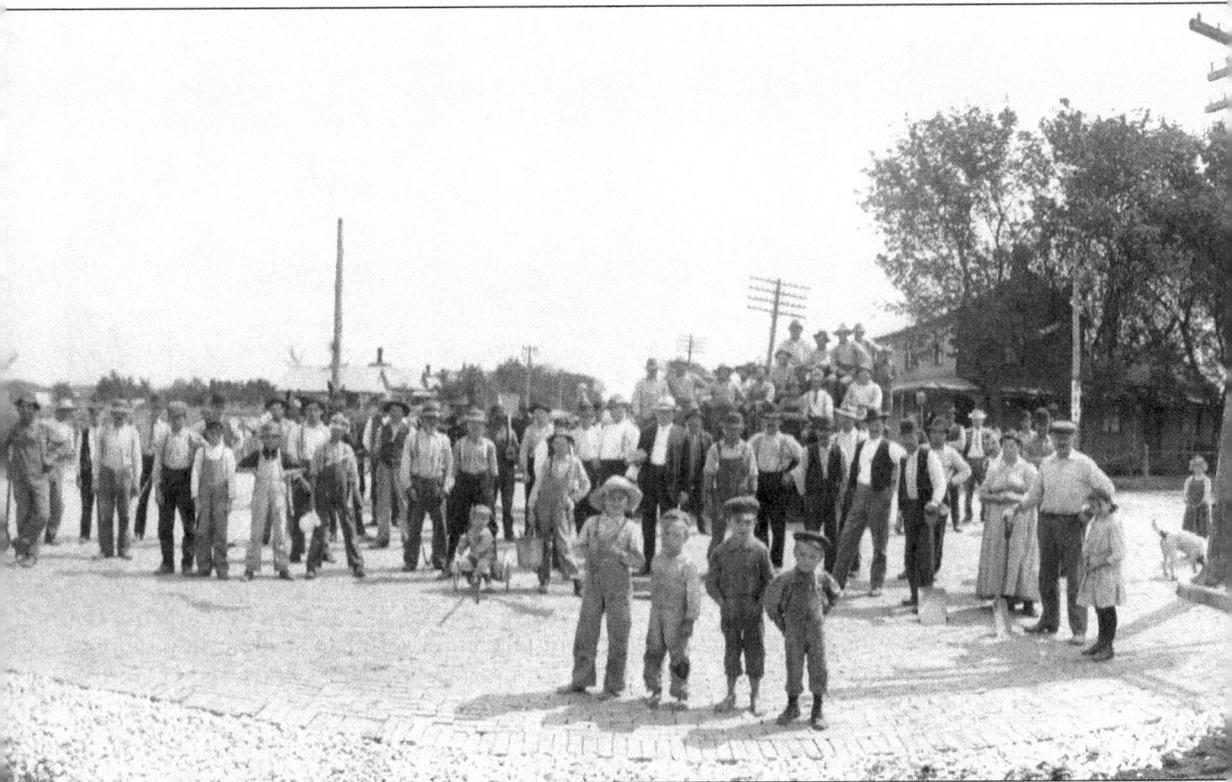

LAYING THE LAST BRICKS ON WALNUT STREET. It is August 27, 1910, and Mayor Lindsay is laying the last brick on West Walnut Street in Oglesby. Many people of the town turned out to help. The mayor is in the middle of the group wearing a suit jacket and white hat; he is holding the last brick. Oglesby had also been known as "Cement City." A slogan that fit the town was "Oglesby by name, cement by fame" because of the cement business that flourished there. The name Oglesby comes from Richard James Oglesby, who served the state of Illinois as its governor and in congress, as a senator. He also served in the Civil War. Oglesby is surrounded by the Vermillion River on its east side. The river runs off of the Illinois River, which is to the towns north. Starved Rock and Matthiessen State Parks are in close proximity to the town. (Courtesy Oglesby Historical Society.)

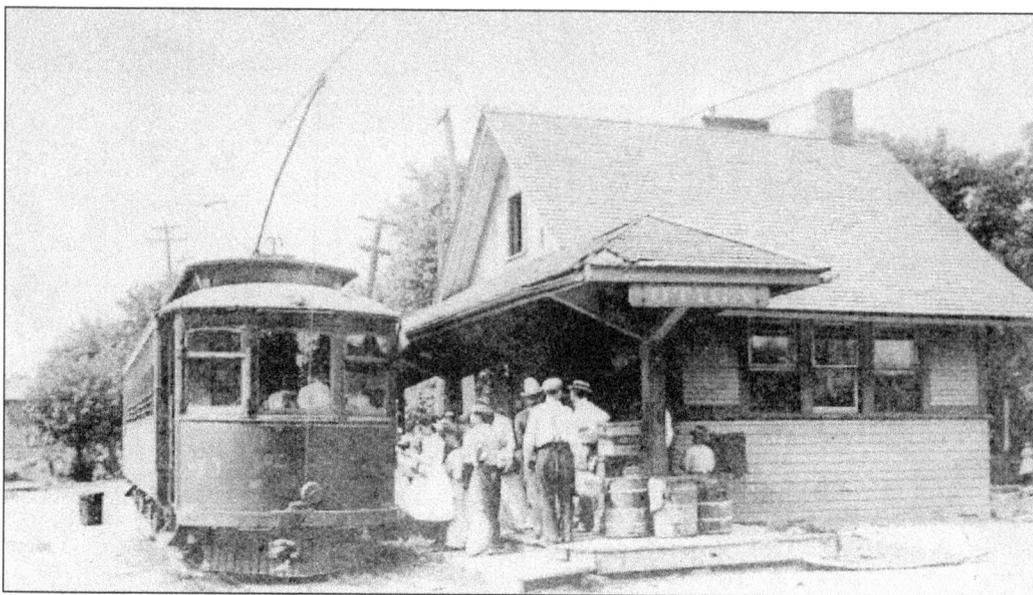

INTERURBAN STATION, UTICA, ILLINOIS. These people are ready to board the interurban at the Utica Interurban station in this c. 1910 photograph. The term interurban means transportation, such as a train, that operates between two cities. Many areas across the country had interurban stations. (Courtesy LaSalle County Historical Society Museum.)

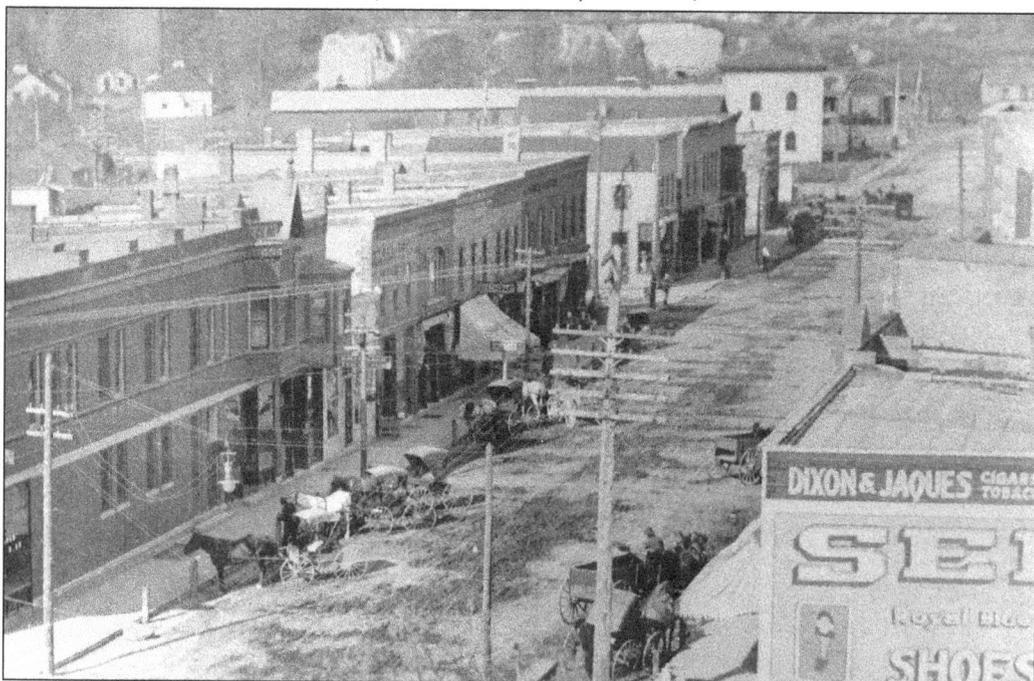

BIRD'S-EYE VIEW OF UTICA, C. 1910. Pictured here is a view of Utica from the rooftop of Manley's Livery—only a portion of the town is visible. Originally the town lay along the Illinois River. Due to flooding and Illinois and Michigan Canal planning, in the 1830s the town was moved north a bit and was then called North Utica. (Courtesy LaSalle County Historical Society Museum.)

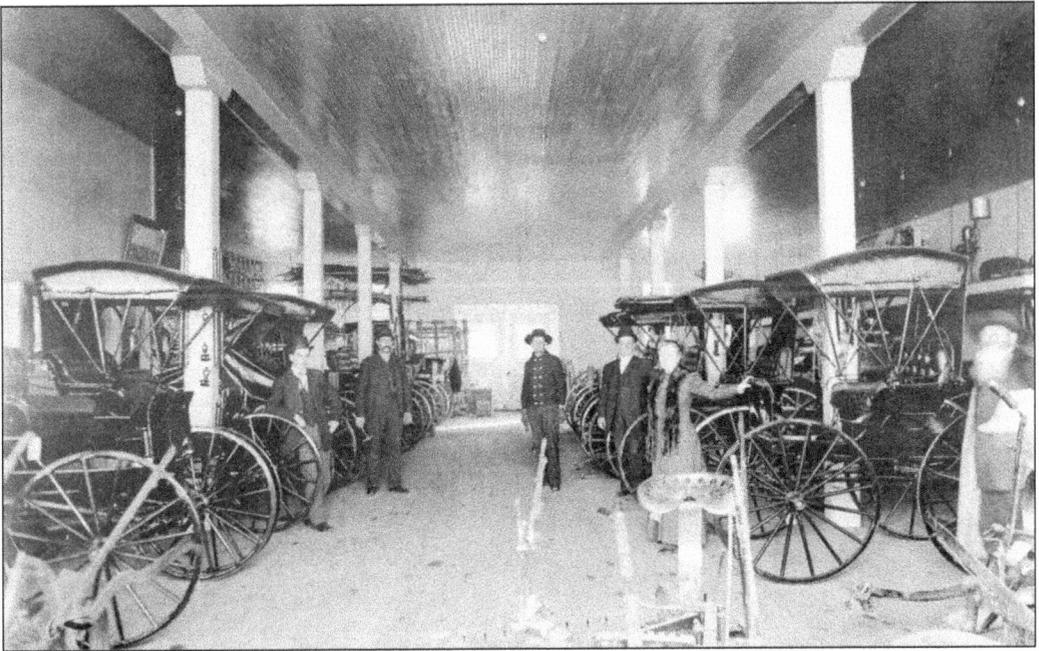

HORSES AND BUGGIES, C. 1910. The above photograph shows J. E. Miller Implements in Mendota. The 1910 buggies in the background are beautifully attired and a sharp contrast to the other rough looking implements in the foreground. Catalogs of the time listed buggies similar to these under $60, with names like Royal and Southern Beauty. The customer had a few options available to them to customize their buggy, such as width of the track and leather upholstery. In the photograph below, although not as new looking, is the same type of buggy as the ones pictured above, driven by Frank Slewder of LaSalle County. (Above, courtesy Mendota Museum and Historical Society from Leo and Norma Muhlach Collection; below, courtesy Helen Crawford.)

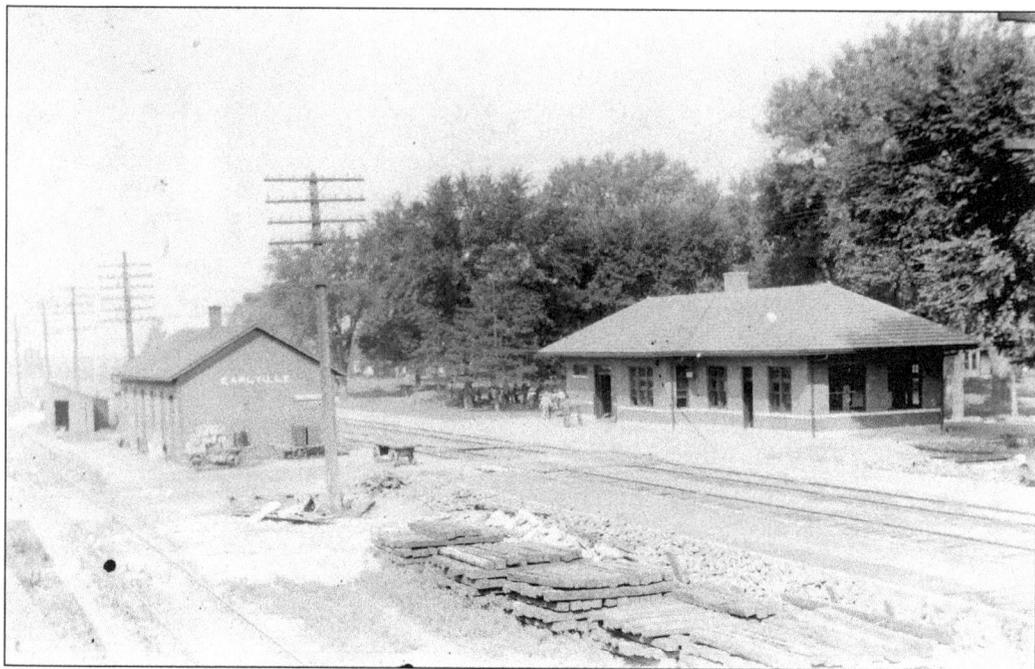

THE EARLVILLE DEPOT, 1913. The new Chicago Burlington and Quincy train depot in Earlville is shown in both of these photographs. The photograph on top shows a brand new brick building with workers to the left of it wearing overalls and holding shovels and other tools. The old Earlville Depot can be seen across the tracks from the new one. The photograph below shows off the new depot building in use, with railings and benches in place ready for train passengers. The Chicago, Burlington and Quincy Railroad started in Aurora, Illinois, approximately 35 miles northeast of Earlville. The main focus of this railroad was to service agricultural areas. (Courtesy Earlville Community Historical Society.)

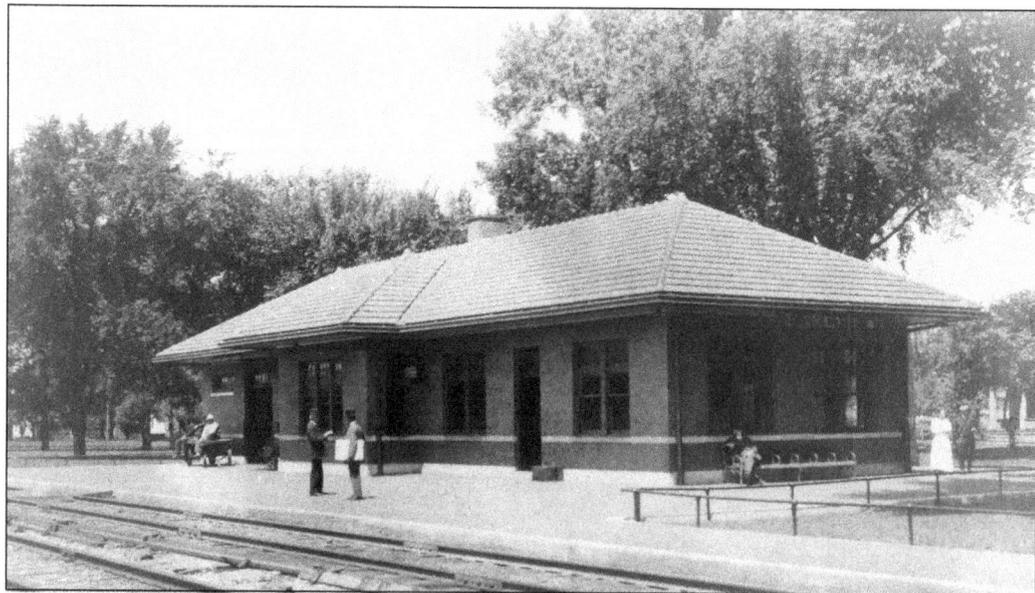

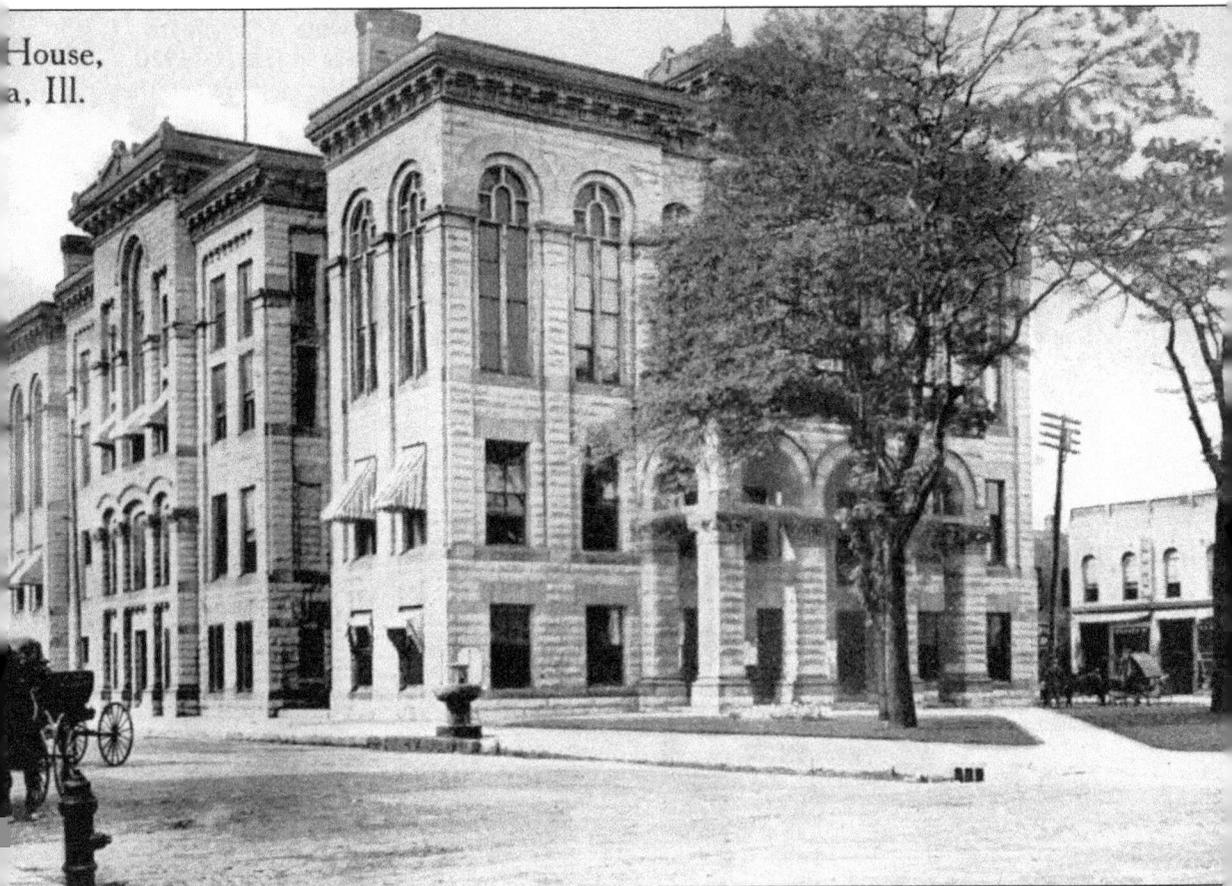

A VERSATILE WATER FOUNTAIN. This 1916 postcard is of the Ottawa Court House, which was one of four buildings that was called "court house" over the years in the county seat. Notice the water fountain at the front left corner of the courthouse, close to the street; this is the northeast corner of the public square at Court Street. This water fountain was placed near the street so that man as well as horses, dogs, cats, birds, and other animals could obtain a cool drink of water easily. The fountain was donated by Herman Lee Ensign, the founder of the National Humane Alliance. It was donated after 1912. A similar fountain was given to each of the 48 states that were in the union at the time. The cost of each water fountain was about $1,000. (Courtesy M. Dorothy Clemens.)

45

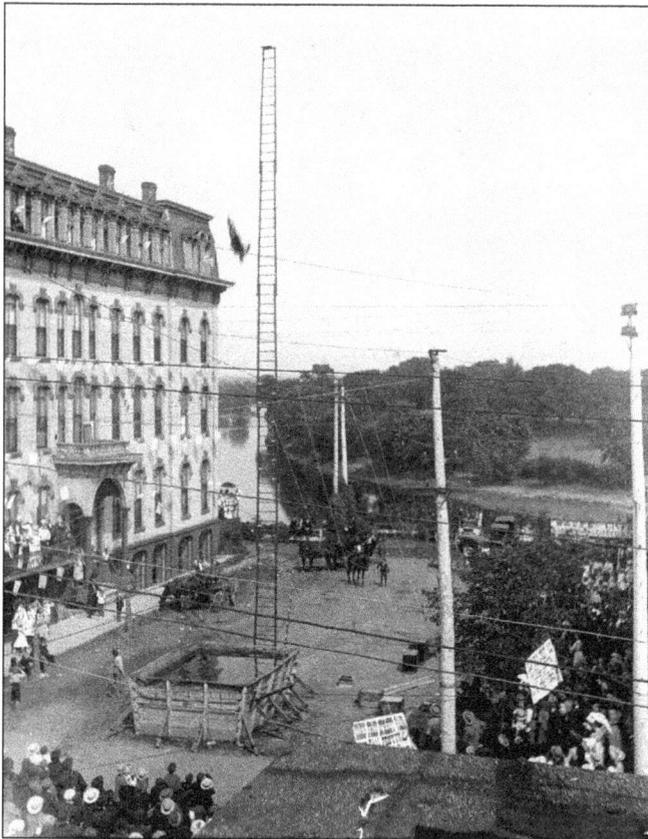

HIGH-WIRE ACT AT THE CLIFTON HOTEL, C. 1920. Crowds are gathered on the street and on the hotel's balcony as the acrobat does his act. He is a blur as he circles the wire. The signs in the crowd are advertising the free street fair and fall festival in Ottawa. The Fox River is east of the building that sits on Madison Street at Columbus Street. (Courtesy Helen Crawford.)

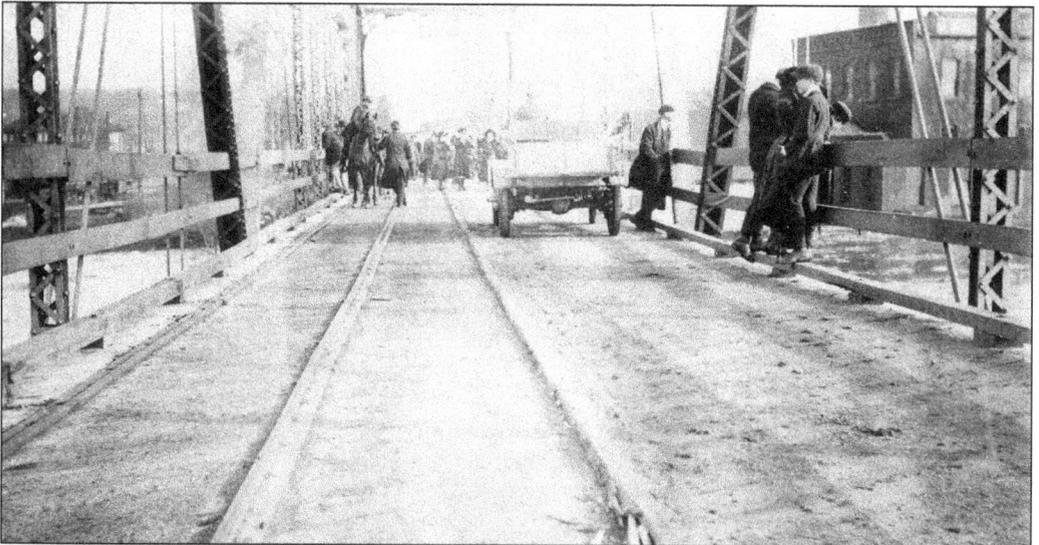

THE ILLINOIS RIVER BRIDGE. This wooden bridge crossed the Illinois River at Marseilles. The tracks for the rail cars that hauled coal from the Manufacturers Coal Mine are visible on the left side of the bridge. This photograph was taken looking north. On the south side of the river from Marseilles is Illini State Park, which was dedicated in 1935. (Courtesy Marseilles Public Library.)

46

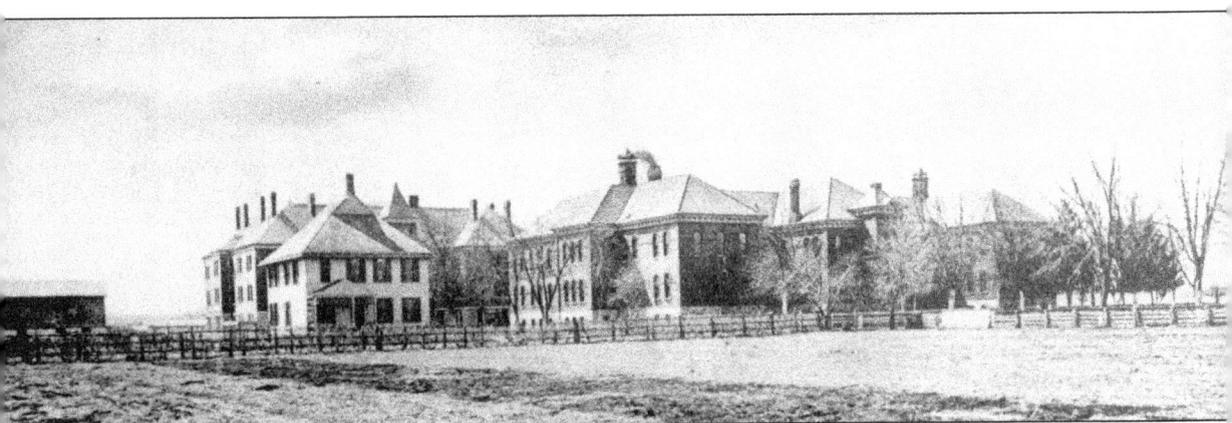

THE LASALLE COUNTY ASYLUM AND POOR FARM. These buildings sat three miles west of Ottawa. The state of Illinois started taking care of the poor in 1819. By 1839, county poor houses were established. These establishments took care of anyone who could not take care of him or herself—from children to the elderly as well as the insane. In 1874, the state required, by law, that all county poor houses keep records about their inmates. These records included the names and ages as well as the reasons for their needing the county's help. Inmates were expected to work; generally crops were grown, and animals were kept for food, which provided work for those in the care of the poor farm. In 1917, poorhouses were kept jointly by counties. Then in 1919, a law was passed that said that any poorhouse kept by the county now be called county homes; these homes eventually could and would only care for the those who were ill and could not care for themselves. (Courtesy Peru Public Library Local History Room.)

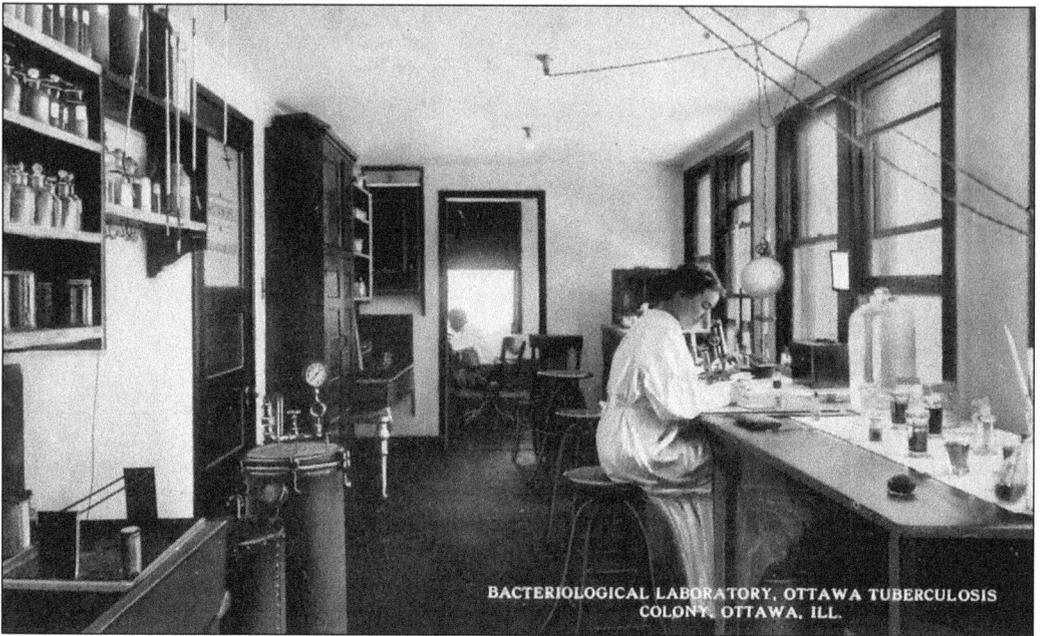

BACTERIOLOGICAL LABORATORY, OTTAWA TUBERCULOSIS
COLONY, OTTAWA, ILL.

OTTAWA TUBERCULOSIS COLONY, C. 1920. Tuberculosis was also known as consumption and the great white plague. A highly contagious disease, it attacked the lungs and other organs of the body. The Ottawa City Directory of 1922–1923 showed that there was a tuberculosis sanitarium and emergency center on East Fourth Avenue. At that same time the Ottawa Colony had a Dr. Pettit as their medical director. (Courtesy M. Dorothy Clemens.)

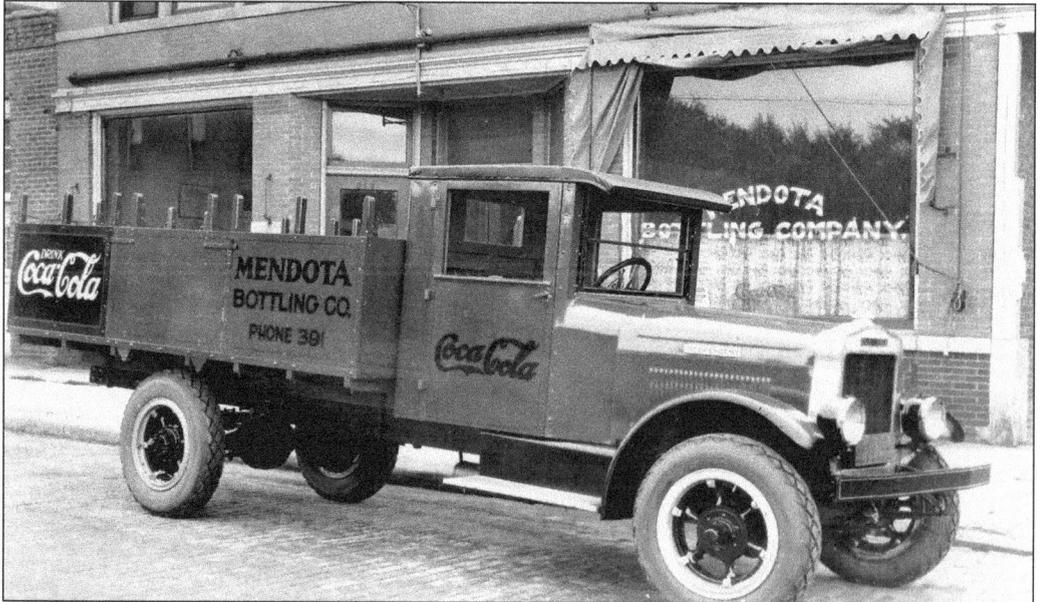

THE COCA-COLA TRUCK. The Mendota Bottling Company establishment, a Coca-Cola bottling franchise, was on the 600 block of Eighth Avenue in Mendota. This photograph was taken in the late 1920s when Coca-Cola had over 1,000 bottling plants and bottlers in the United States and had been in operation for less than 10 years. (Courtesy Mendota Museum and Historical Society from Leo and Norma Muhlach Collection.)

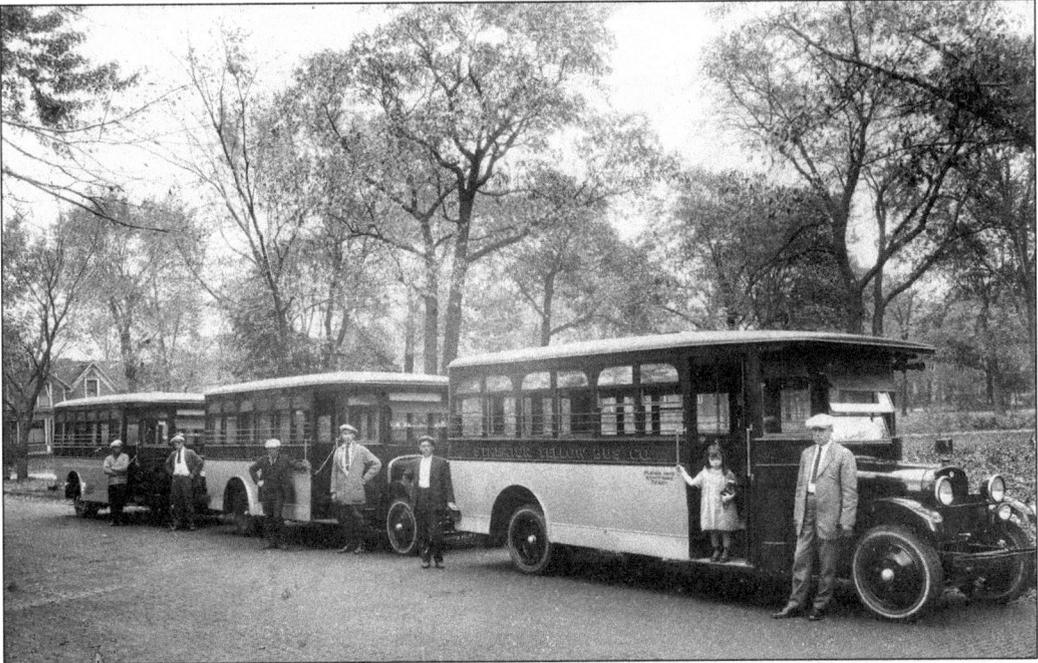

THE STREATOR YELLOW BUS COMPANY. The 1927 Streator Directory lists Charles and Ruth Cate as running the company from Monroe Street in Streator. This *c.* 1924 photograph shows, from left to right, Jack Carrington, a Mr. Harwood, unidentified, Glen Brock, Robert Smith, Jeanne Alice Cate, and Charles Gilman Cate (who is listed as the company's president). (Courtesy Streatorland Historical Society.)

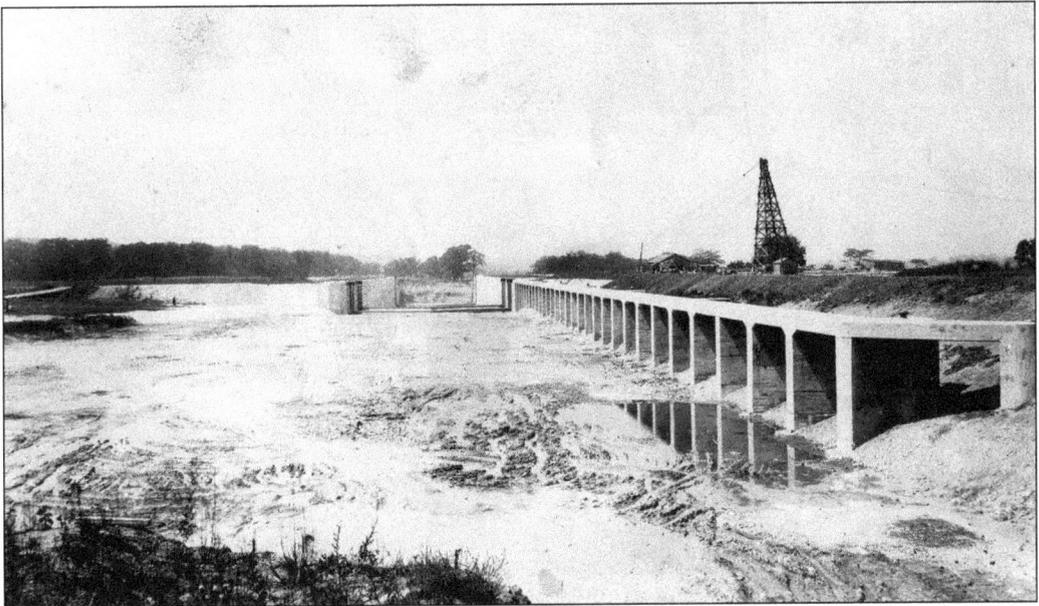

THE MARSEILLES LOCKS, C. 1925. To regulate the amount of water and bypass the rapids of the Illinois River at Marseilles, the Army Corps of Engineers built this bypass around 1925. This important waterway was the highway of its day for manufactured goods to be shipped throughout the world. (Courtesy Marseilles Public Library.)

49

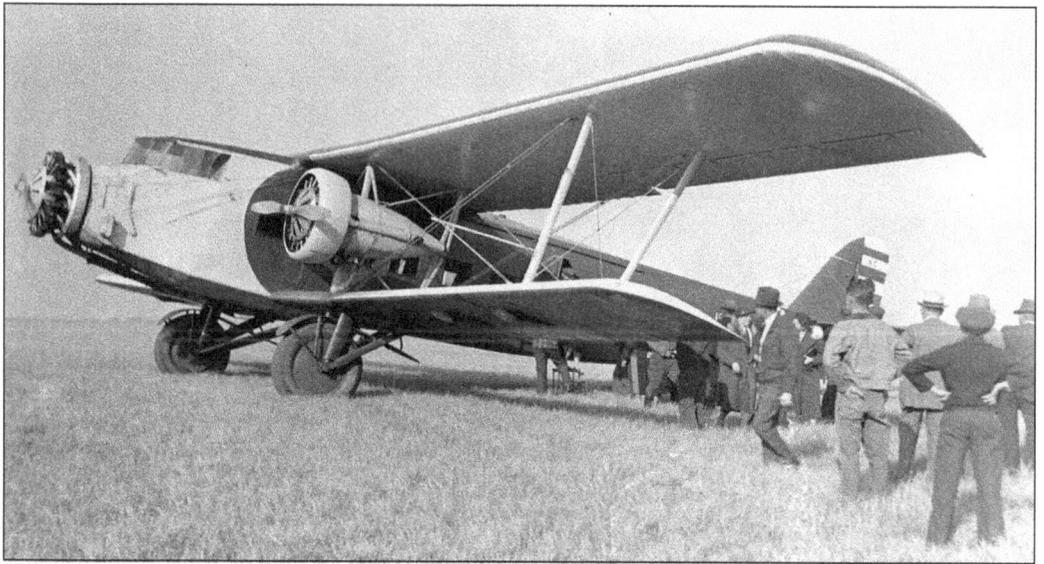

A FORD TRI-MOTOR AIRPLANE, C. 1930. Also known as the *Tin Goose* or the *Flying Washboard*, this Ford aircraft was equipped with a Wasp engine built between 1926 and 1933. Only about 200 Tri-Motors were ever made. This one landed in a field close to Mendota. (Courtesy Mendota Museum and Historical Society from Leo and Norma Muhlach Collection.)

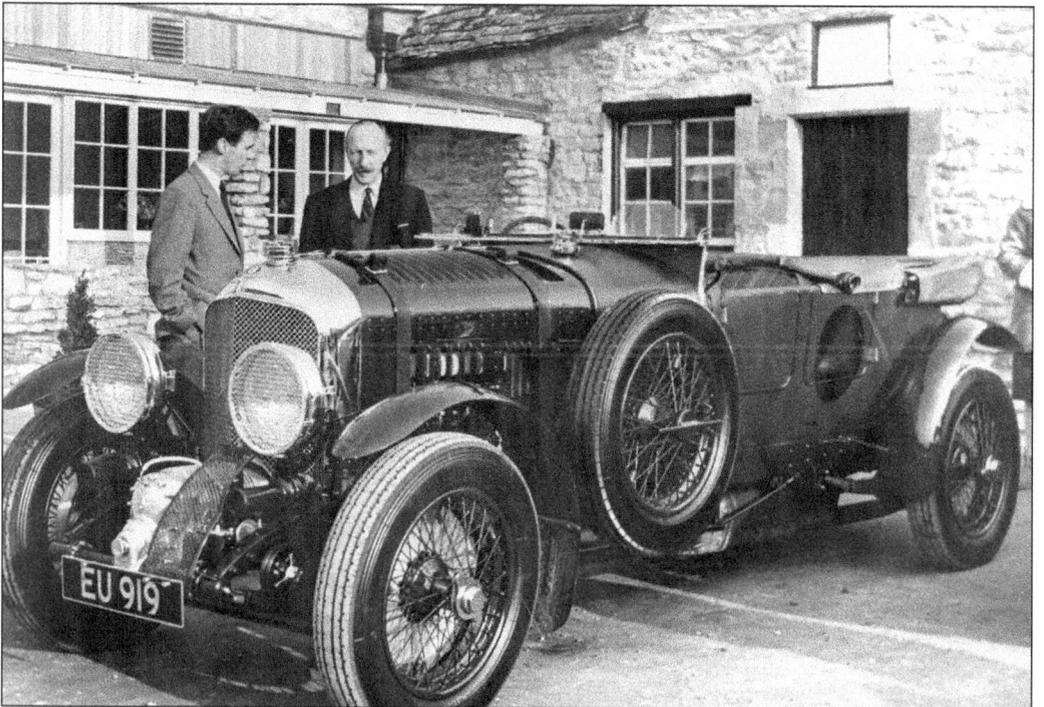

A NEW AUTOMOBILE. Richard Leiser, recipient of the Horace Hume Outstanding Service Award, is pictured here showing off his Bentley. This Bentley was purchased in the early 1950s, flown in from England; it was a loved vehicle of Leiser. He was once a co-owner of the *Mendota Reporter* newspaper. He was also involved in the Mendota Chamber and banking in the community. (Courtesy Mendota Museum and Historical Society from Leo and Norma Muhlach Collection.)

Three

A Trip to Town

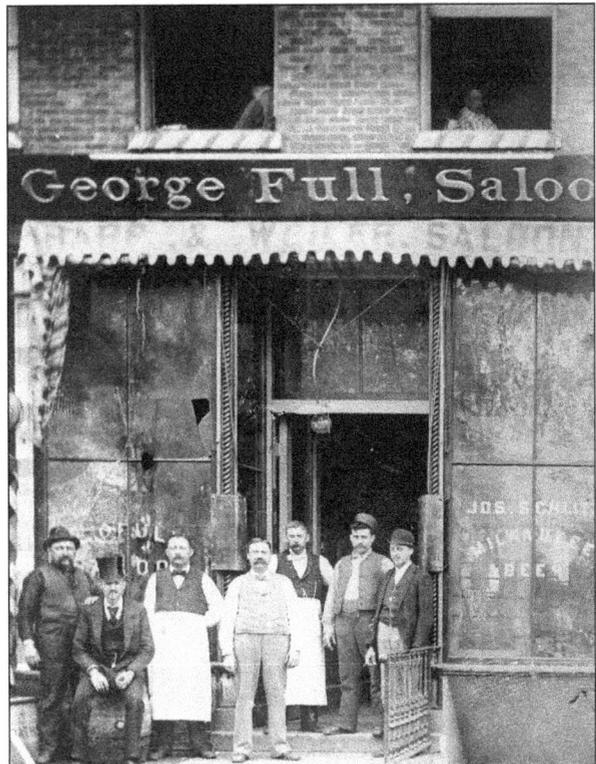

A Main Street Saloon. The George Full Saloon had a succession of owners as the faded name printed on the awning helps attest. The changing of hands that this business went through may be because of the many changes the town of Mendota went through over the years, trying to decide if the town would be dry or not. Carrie Nation came to town in 1910, but she is not to blame for this saloon's broken window, as this photograph was taken in the 1880s. Now look toward the top of the photograph. The very recognizable sign of a barber labels both windowsills. Notice the man in the second story window. He has a towel wrapped around his neck and he appears to be waiting for the barber, while the other window seems to show a barber at work. (Courtesy Mendota Museum and Historical Society from Leo and Norma Muhlach Collection.)

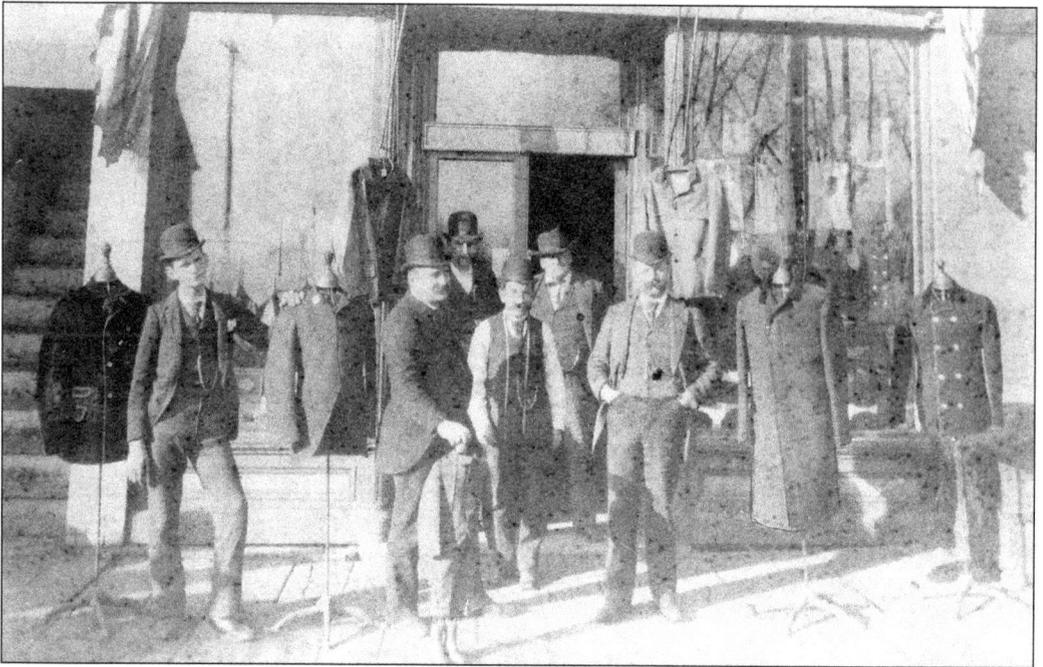

A DANDY NEW SUIT OF CLOTHES. This haberdashery was on Mendota's Main Street in the 1880s. One can see the many suits of clothing provided for men. Notice the young man's suit that is being held up in the center front. It has a rounded collar and features short pants. The shop's window displays men's shirts and ties. (Courtesy Mendota Museum and Historical Society from Leo and Norma Muhlach Collection.)

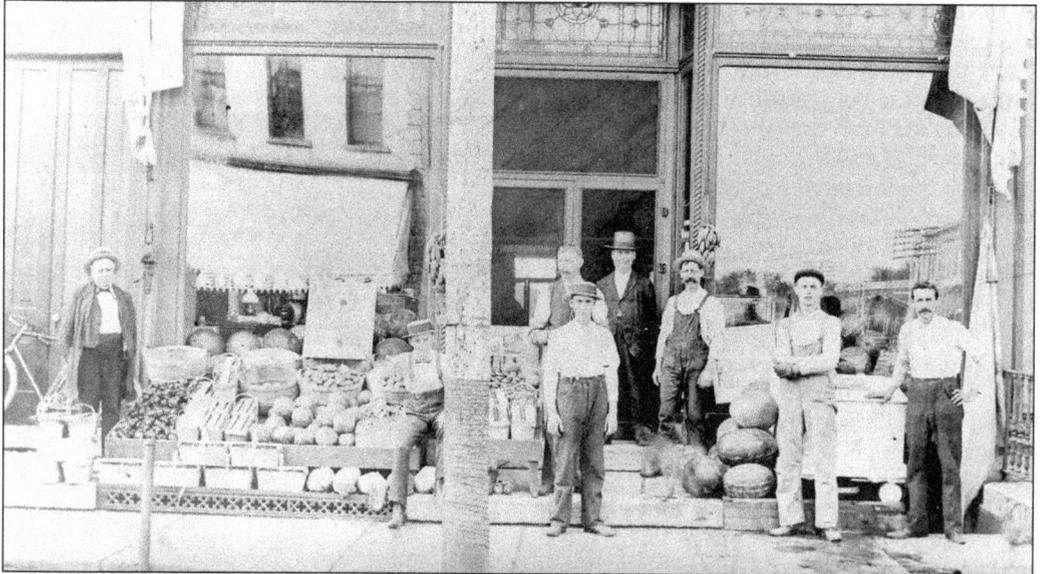

KREIS BROTHERS GROCERY, C. 1890. The entrance of this Mendota grocery store is loaded with peppers, watermelons, potatoes, cabbages, and other produce; it gives one an idea of what local farms produced. There are also two signs that advertise oysters. At the time, oysters were served at social affairs, which were often written about in local papers. (Courtesy Mendota Museum and Historical Society from Leo and Norma Muhlach Collection.)

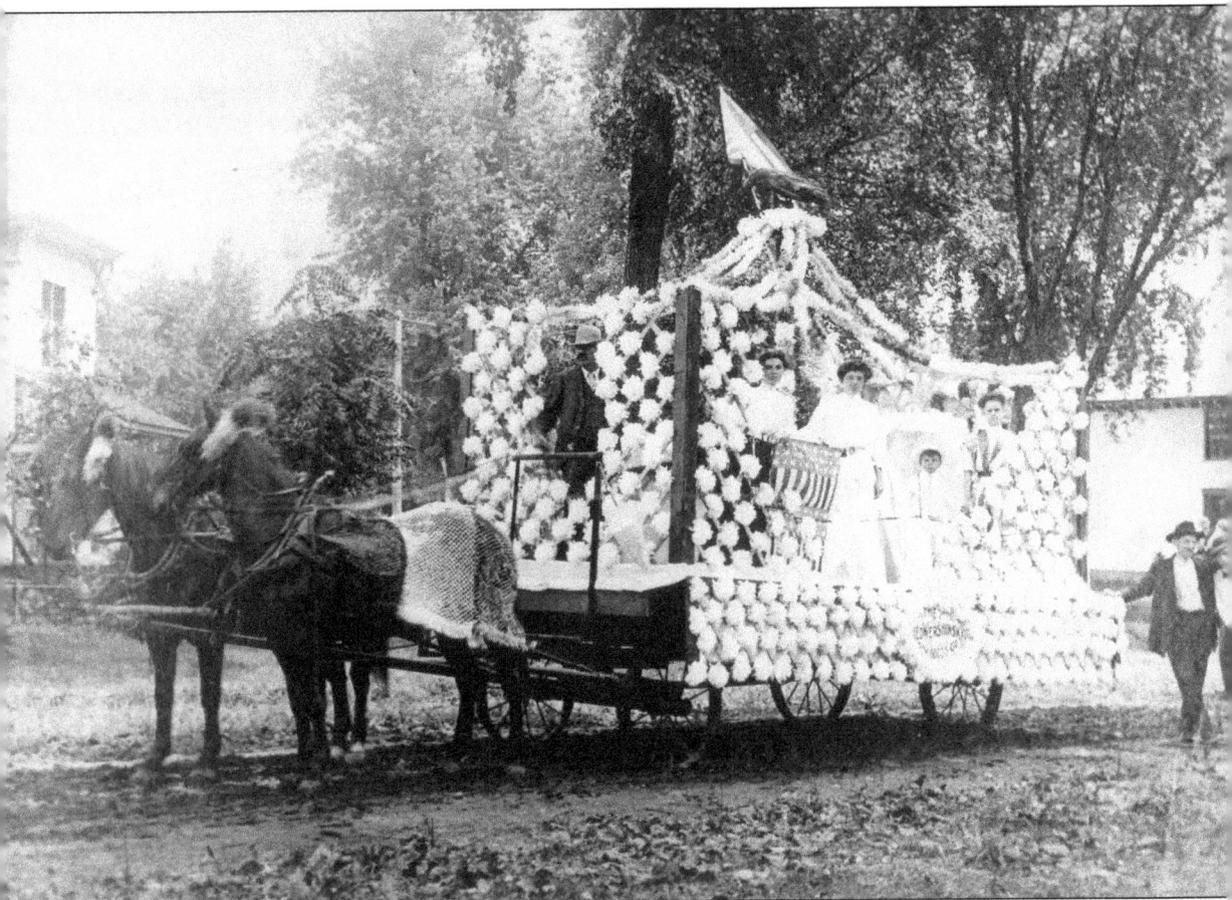

THE FRED WERSHINSKI DRY GOODS COMPANY FLOAT, 1890S. The dictionaries say that a parade is an extravagant display. Does not every community need a little extravagance once in a while? This float certainly gives the parade attendee a beautiful view, with flowers as well as ladies. Fred Wershinski was the owner of a dry goods store in Mendota on Washington Street in the late 1800s. Traditionally these stores carried fabrics and other woven merchandise. In an 1877 directory of LaSalle County, "Fred Werchenskei" is listed as a dry goods merchant. In 1886, Frederick Wershinski is touted as one of the most eminent merchants in Mendota. His shop was situated on the south side of Washington Street near Main Street. Wershinski's carried the finer goods of the time. Wershinski teamed up with H. H. Strouse in 1870, and in 1878 he bought out his partner. (Courtesy Mendota Museum and Historical Society from Leo and Norma Muhlach Collection.)

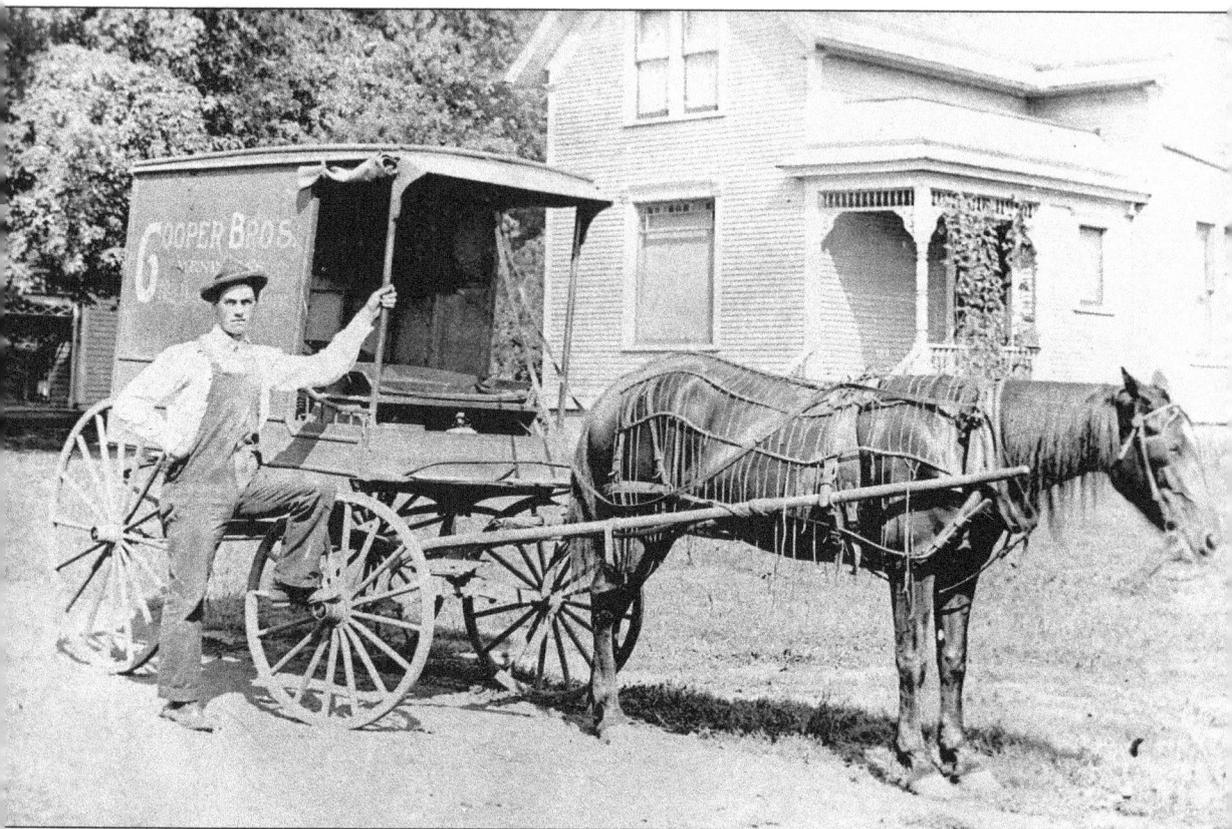

MENDOTA'S BIG DEPARTMENT STORE. The Cooper Brothers's delivery wagon is seen here in this 1890s photograph. Cooper Brothers lays claim to being the town's big department store. The 1909 Mendota Directory showed an advertisement for Cooper Brothers, a cash store "The Standard of Excellence." They tell their customers to insist on having White Star Coffee and that their store is their customer's headquarters for crockery, graniteware, tinware, fruit jars, tea, coffee, spices, and tobacco and that plain and fancy dinner sets are a specialty. Harley Whitmore stands beside the wagon ready to make deliveries. This is a time when department stores still known today were just emerging in nearby Chicago. Department stores like Cooper Brothers provided excellent customer service as the railroads made it easy to go into Chicago for the day to shop. (Courtesy Mendota Museum and Historical Society from Leo and Norma Muhlach Collection.)

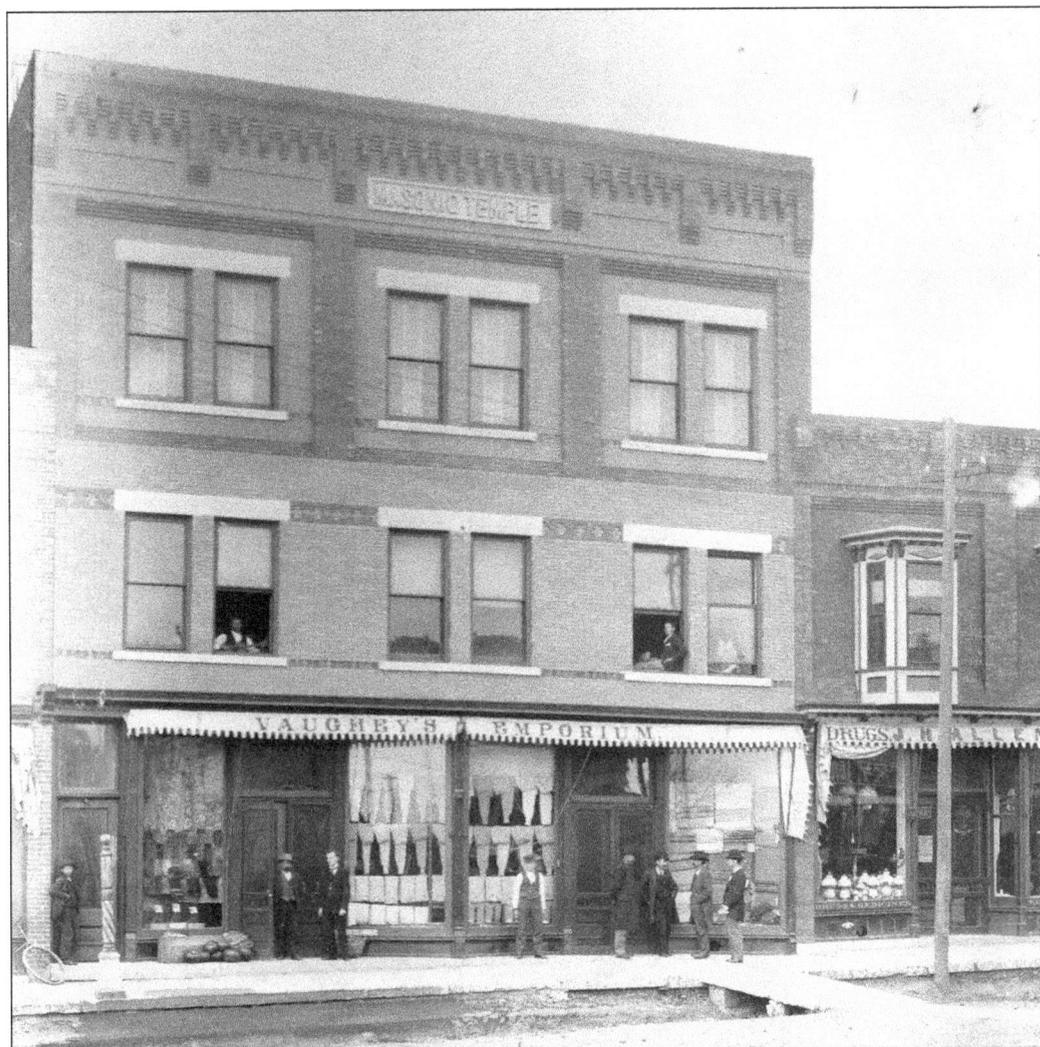

VAUGHEY'S EMPORIUM, C. 1900. Emmett Vaughey stands in the doorway of his establishment in Marseilles. He is the man without a hat. On the second floor in the left window is a man playing a guitar, and the window over J. H. Allen Drug Store, to the right of Vaughey's, holds the offices of Dr. Blanchard. At the top of the Vaughey building the sign reads "Masonic Temple." The last two men standing in front of the emporium on the right are Van Thompson (the towns postmaster), and John Nicholson (a reporter for the local newspaper). To the left of the emporium stands a barbershop pole. Behind the pole a boy stands, possibly about to go into the barber. A bicycle is resting against the building. In the 1877 LaSalle County Directory, Alex Vaughey is shown running a dry goods store in Seneca. He came from Ireland in 1834 and settled in Seneca, purchasing 160 acres of land. In 1861, Alex Vaughey established his business and also became very involved in town activities. (Courtesy Marseilles Public Library.)

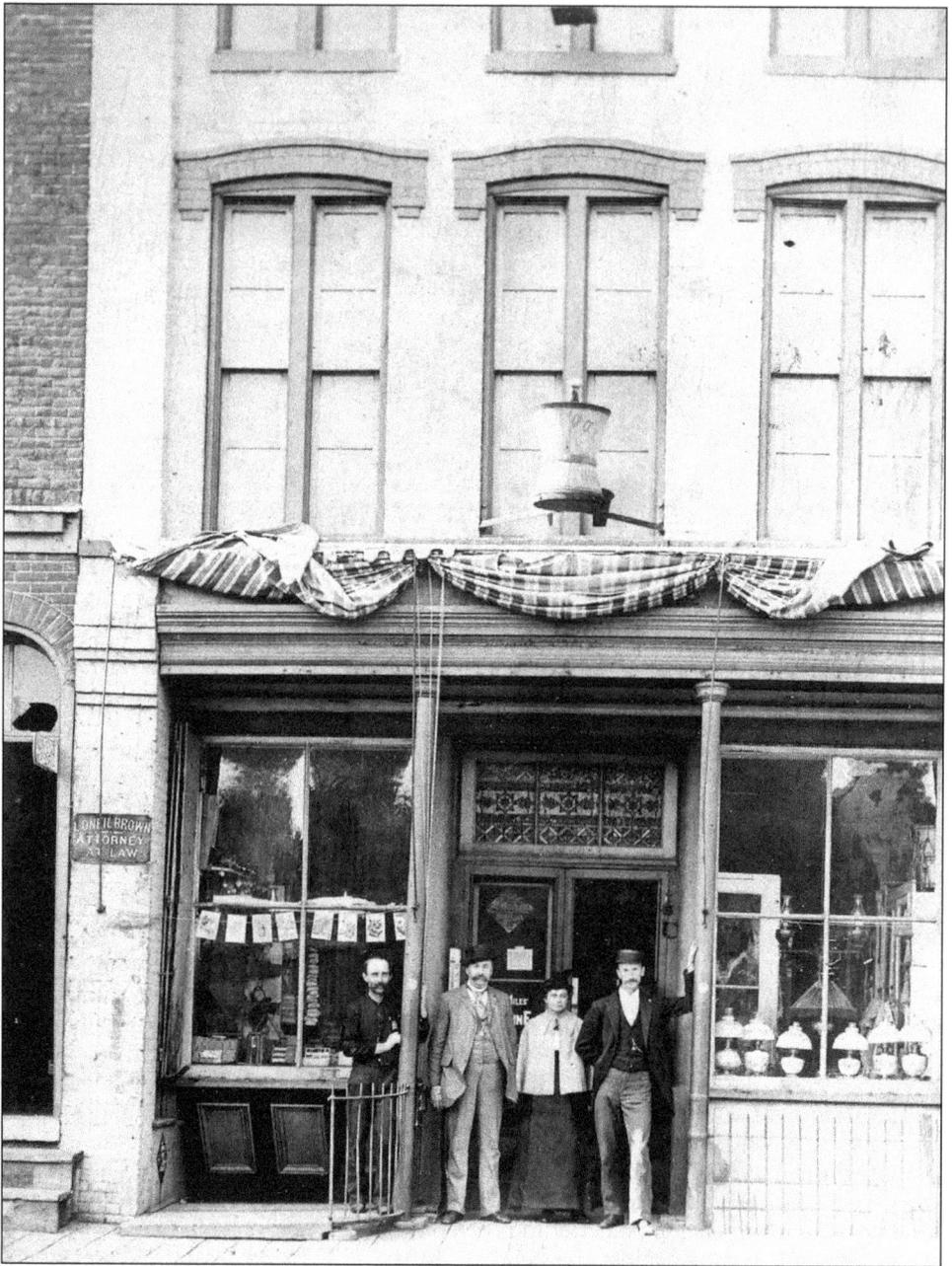

POOL DRUG STORE. J. J. Pool's building was the first brick building built in Earlville. In 1861, Pool started his drug business. In 1877, he served as mayor of the town, and he also held other public offices. High above the door of the store is a mortal and pestle with the store's name printed on it. An Ottawa druggist of 1902 placed this advertisement, "Sign of the large golden mortar . . . Drugs, Medicines, Family Recipes, Etc. Manufacturing Pharmacist." Still, another drugstore in Ottawa in 1907 advertised, "Lutz's, Soda is a great American drink, it cools and refreshes with out ill effects. At Lutz's it is properly served cold and from the best supplies. Plenty of delicious crushed fruit, ice cream. Try a Glass; all flavors. We make our own syrup. They're fine. Lutz's Prescription Drug Store." (Courtesy Earlville Community Historical Society.)

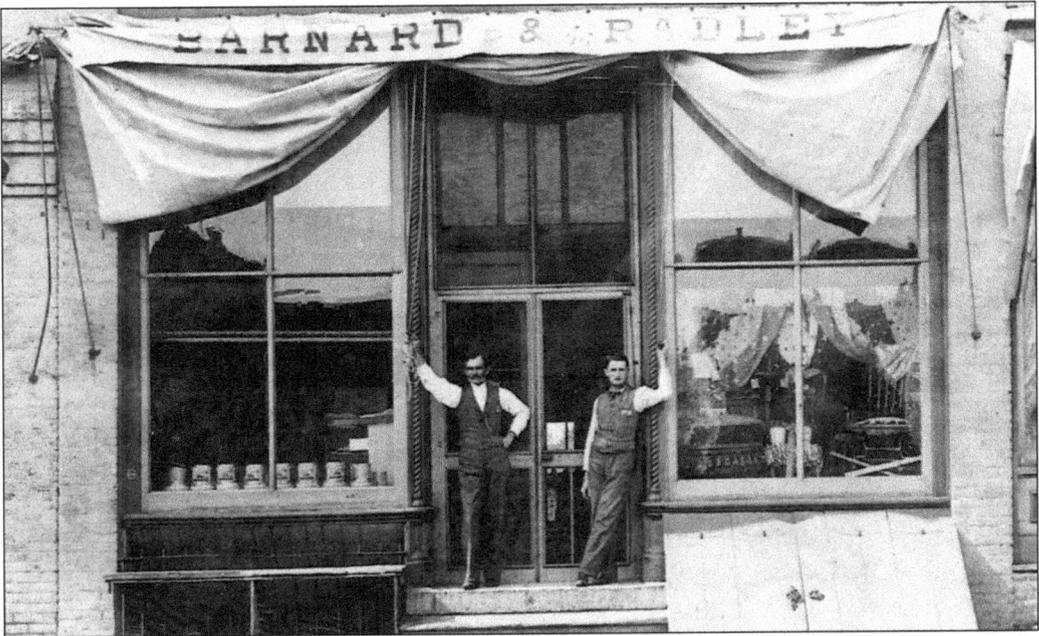

A FURNITURE BUSINESS. D. L. Barnard and T. Barnard are listed in an 1877 directory as cabinet makers and carpenters in Earlville; also Jas. Radley was listed as a cabinetmaker. An Earlville newspaper from 1874 showed an advertisement for Barnard and Radley, advertising a handsome new store with parlor, dining room, office, and kitchen furniture. Their shop window shows a rocking chair and an upholstered chair. (Courtesy Earlville Community Historical Society.)

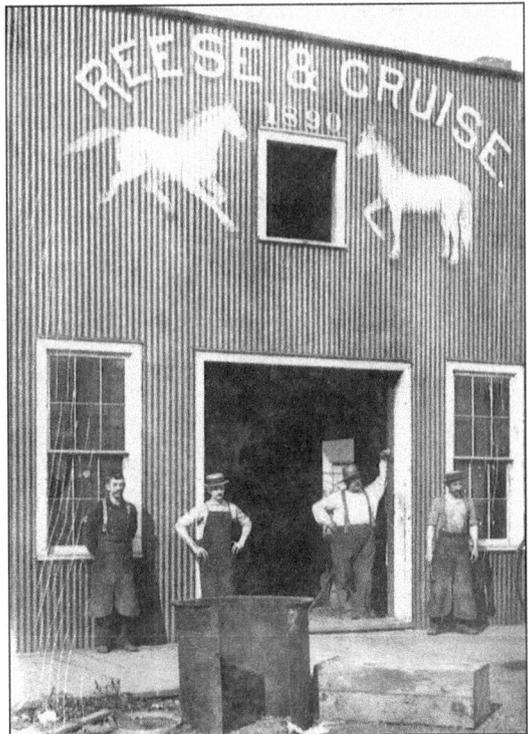

REESE AND CRUISE LIVERY IN EARLVILLE. This establishment, which started in 1890 (as they proclaim high above the center door), is believed to have gone out of business in 1905. Another livery of the time advertised, "Manufacturer and dealer in harness and saddles, bridles, collar, whips, robes, blankets, brushes, combs, and fly nets. Repairing promptly attended to; the celebrated Vacuum oil blacking always on hand." (Courtesy Earlville Community Historical Society.)

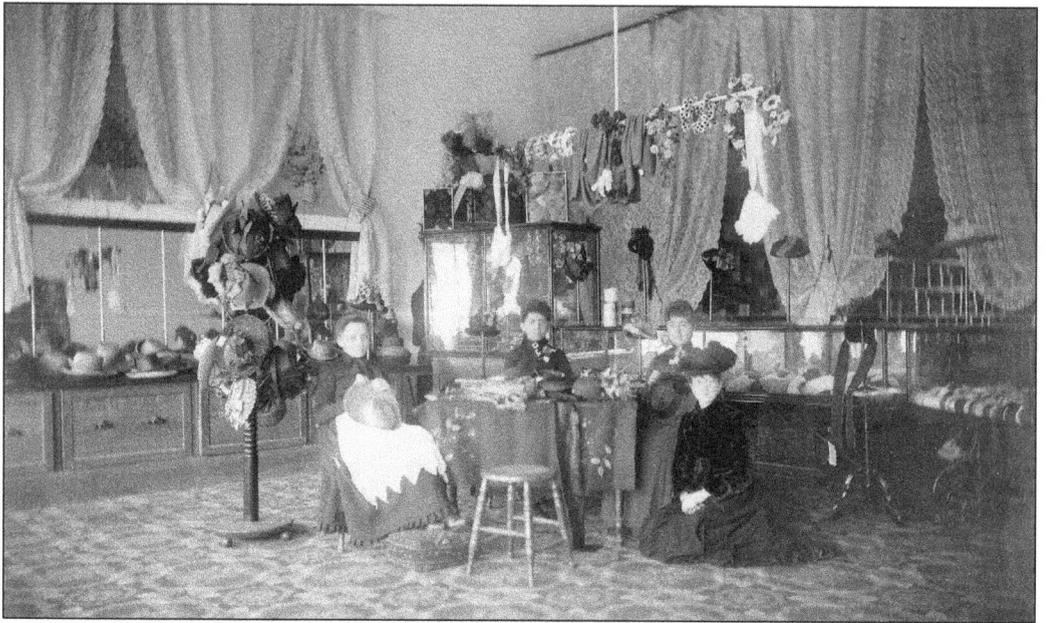

HATS FOR ALL OCCASIONS AND A WELL-ESTABLISHED DRY GOODS STORE, C. 1888. Hoscheit and Kobbemann's Millinery store was in the town of Peru along with the Hoscheit Dry Goods Store below. The Peru Directory of 1877 listed C. Hoscheit running a dry goods store that sold boots and shoes; the same directory listed J. Koebbeman working as a clerk. The 1917 Farmers and Breeders LaSalle County Directory listed the Hoscheit family as living in the county since 1881. The windows of the store below are filled with men's shirts and a mannequin that is dressed in a woman's skirt and blouse. The opposite window has a large quilt hanging in it. The unusual object in front at the street, in the middle of the photograph, is thought to be a sign used for advertising. (Courtesy Peru Public Library Local History Room.)

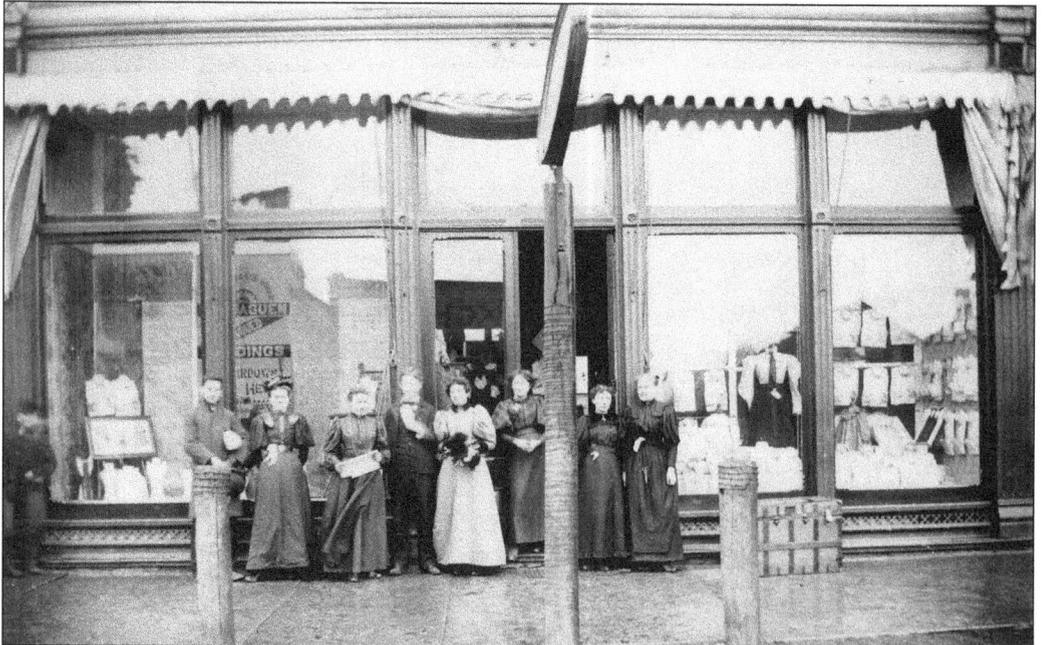

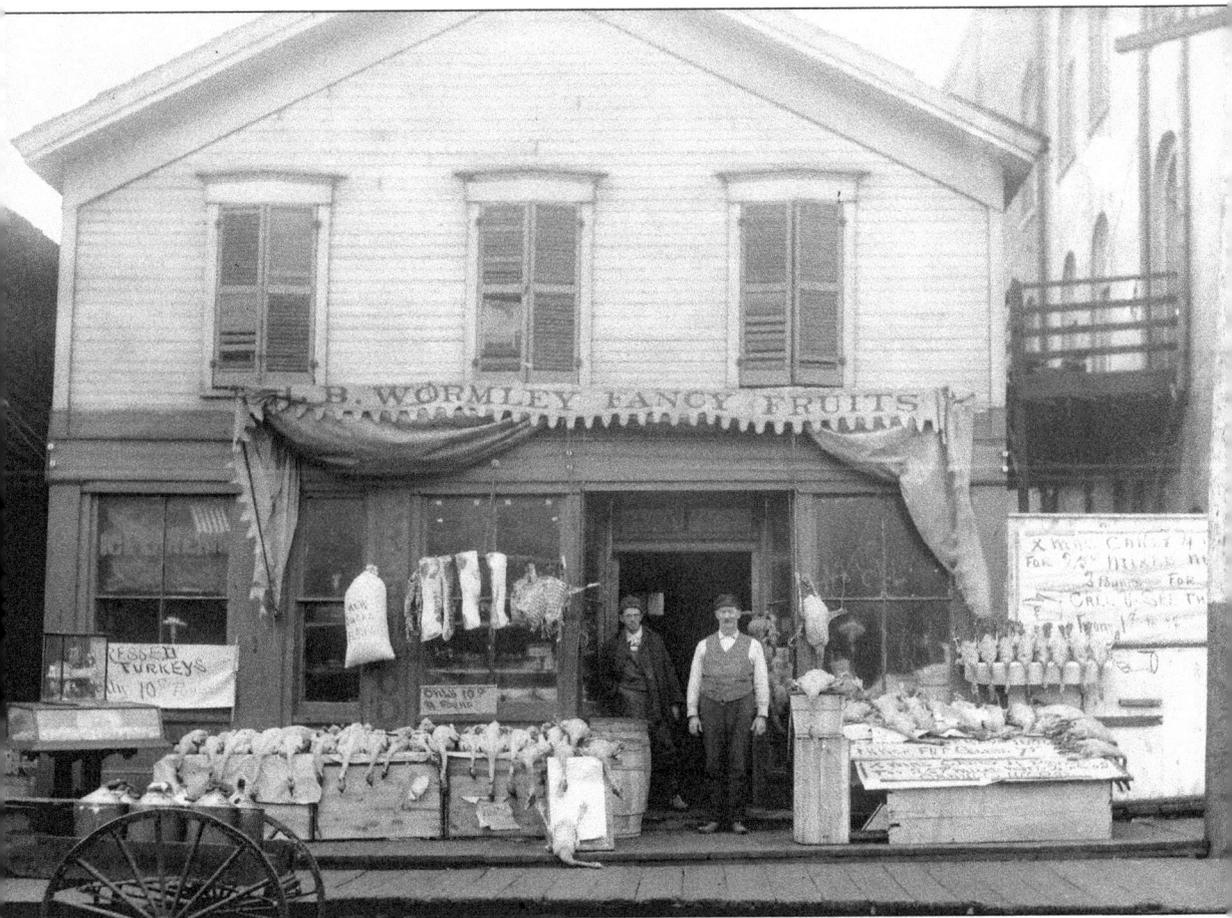

IT MIGHT BE THANKSGIVING, C. 1890. The awning reads J. B. Wormley Fancy Fruits, but the display shown out front is nothing but fowl. Fancy fat geese are 7¢ a pound; dressed turkeys are 10¢ a pound. These birds are displayed outside across the front of the store, lying on crates. There are also sides of meat hanging outside the center window next to a bag of new duck feathers. The sign on the right reads "Xmas candy four pounds for 25 cents and mixed nuts two pounds." The price is behind the pole at the street on the far right. Ice cream is also for sale here, advertised in the far left window; candles are for sale at 10¢ a box. There are two display cases on the far left, one has candy in it and the other on top of the candy case appears to have small figurines or toys displayed. Inside in the center window are toy houses and animals on display. (Courtesy Mendota Museum and Historical Society form Leo and Norma Muhlach Collection.)

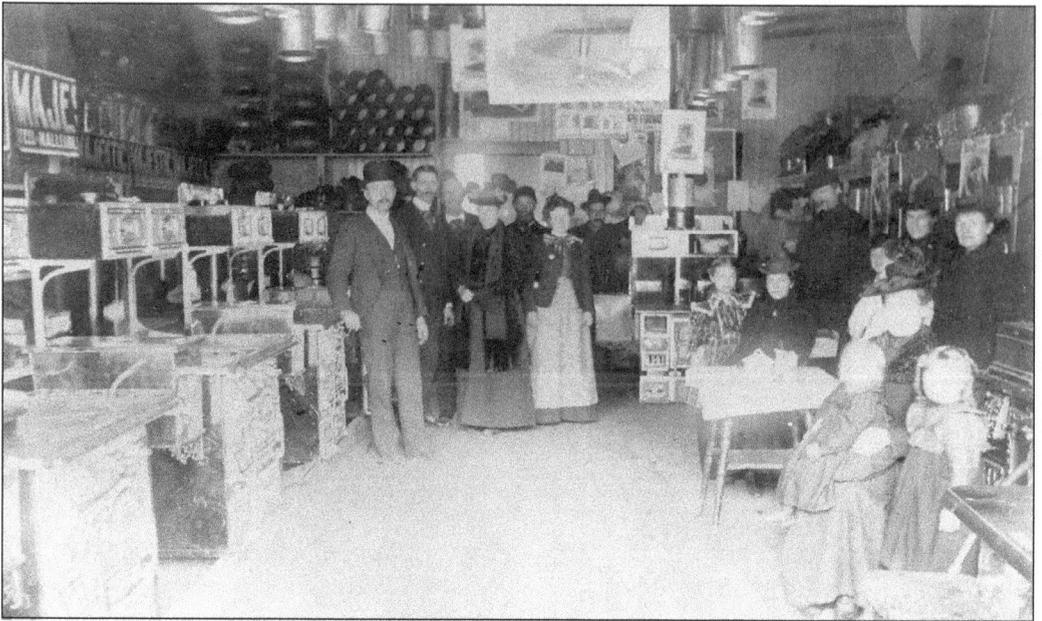

THE BLACKSMITH SHOP EVOLVED. This is the 1890s hardware store called Wittgan's; the 1903 Mendota Directory listed Hoffman and Wittgan on Illinois Street with this advertisement, "Plumbing, Roofing, Spouting, well and cheaply done by Hoffman and Wittgan. Stoves, Ranges, Furnaces and all kinds of hardware." Notice the stoves and the pipes on the shelves and hanging from the ceiling as well as the signs advertising furnaces and steel products. (Courtesy Mendota Museum and Historical Society from Leo and Norma Muhlach Collection.)

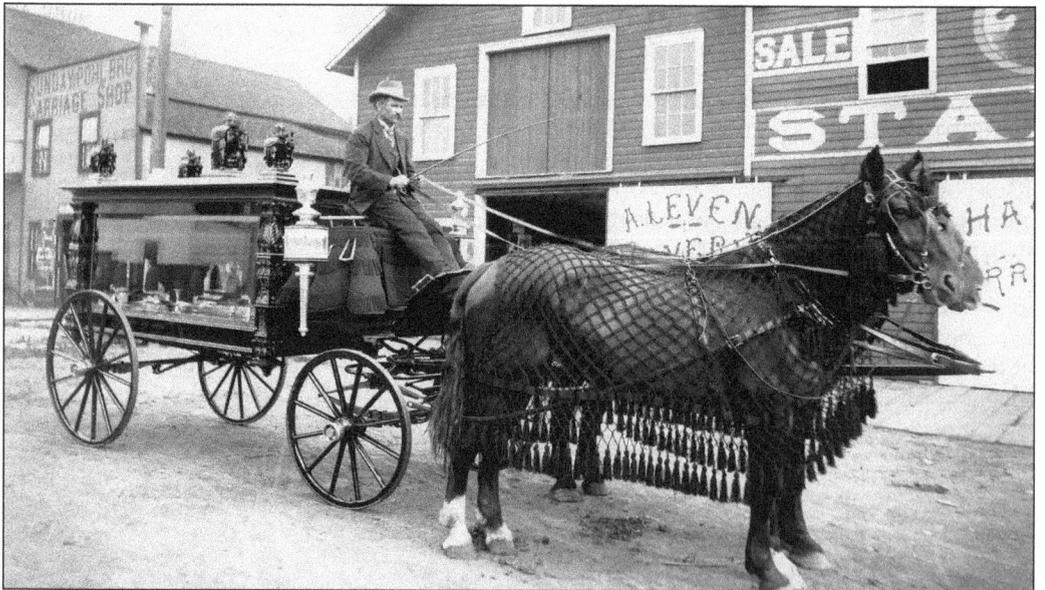

SUNDAY AND POHL SHOW OFF A NEW CARRIAGE, C. 1890. The new hearse is pictured in front of A. Leven's Livery to the right of Sunday and Pohl Brothers Carriage Shop, on Main Street. Gabriel Pohl, one of the earliest settlers in Mendota, opened the first livery stable in 1857. The horses are wearing heavy diamond-knotted fly nets. (Courtesy Mendota Museum and Historical Society from Leo and Norma Muhlach Collection.)

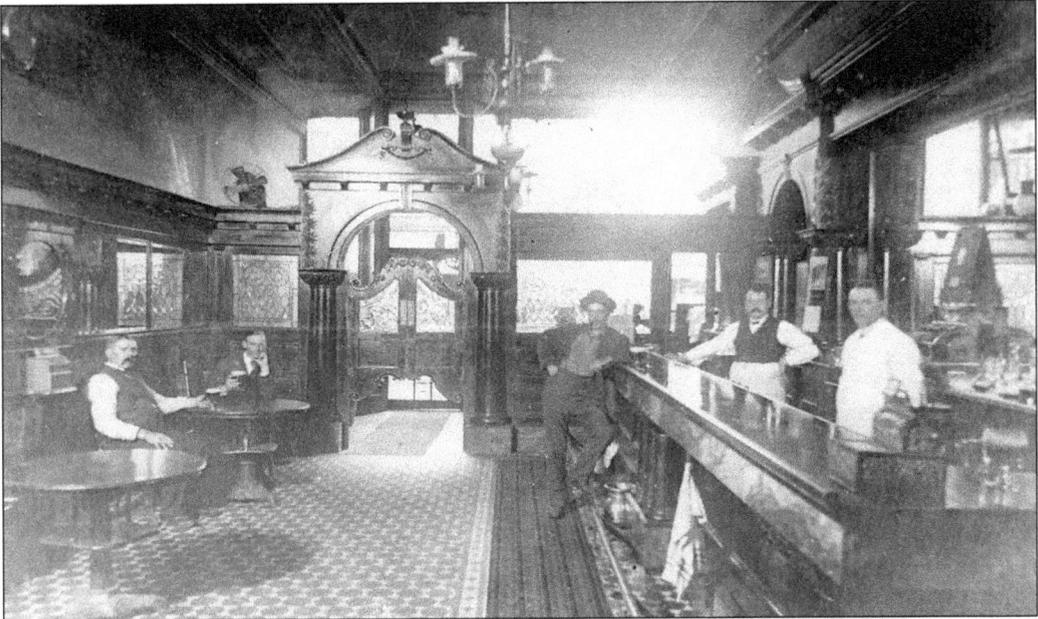

THE UP-TO-DATE SALOON LOOKING VERY TRADITIONAL, C. 1900. Complete with spittoons, this saloon is all decked out with swinging doors, stained glass windows, and a reflective wood bar. The other woodwork around the room is accented with columns, scrolls, and dentils. The bartenders are Mr. Brosheidt and Mr. Bly behind the counter. (Courtesy Mendota Museum and Historical Society from Leo and Norma Muhlach Collection.)

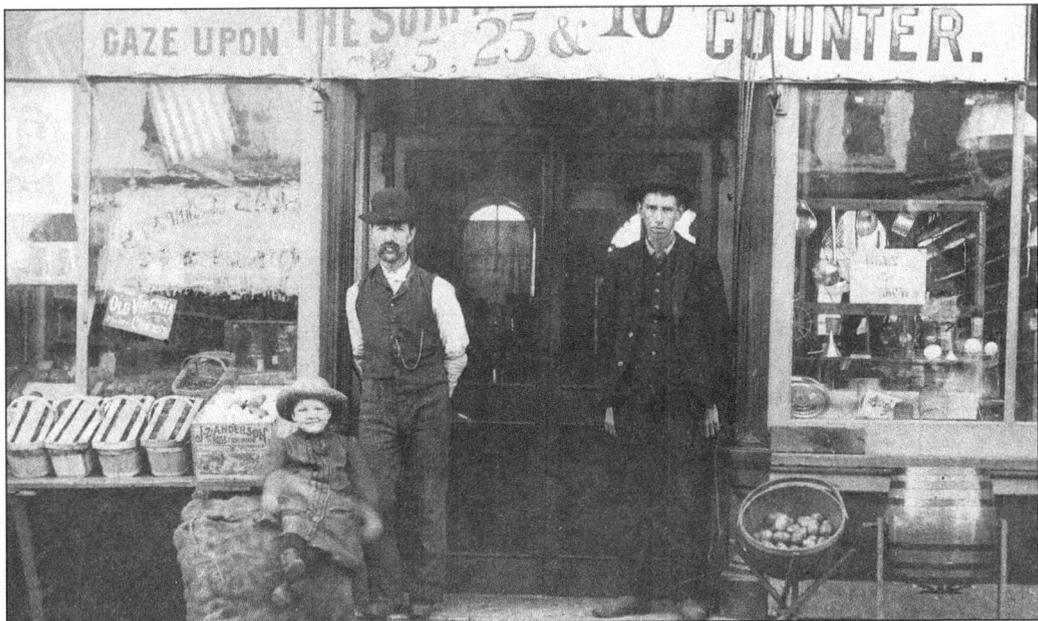

STEP IN AND GAZE UPON THE SURPRISES. This Earlville grocery store is selling a little bit of everything in 1894. There are lamps, potatoes, kitchen utensils, cheroots, and fruit. Kitchen utensils are selling for 5¢ each; Old Virginia Cheroots are five for 10¢. A box of fruit out in front of the store proclaims, "J. Z. Anderson, The Boss Fruit Packer in California." (Courtesy Earlville Community Historical Society.)

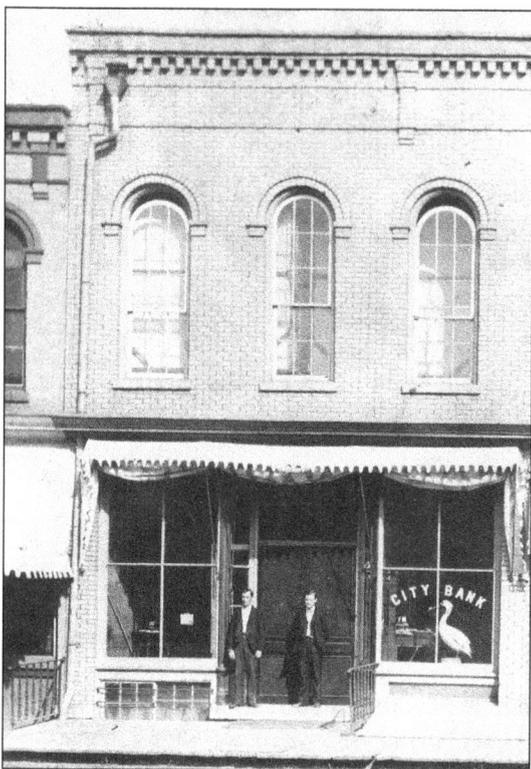

CITY BANK IN EARLVILLE. D. A. Town and his son owned the bank. This photograph is from 1894. In 1900, the City Bank of D. A. Town and Son showed a transaction with National Bank of Chicago. It had been thought that the bank had failed earlier than 1900. (Courtesy Earlville Community Historical Society.)

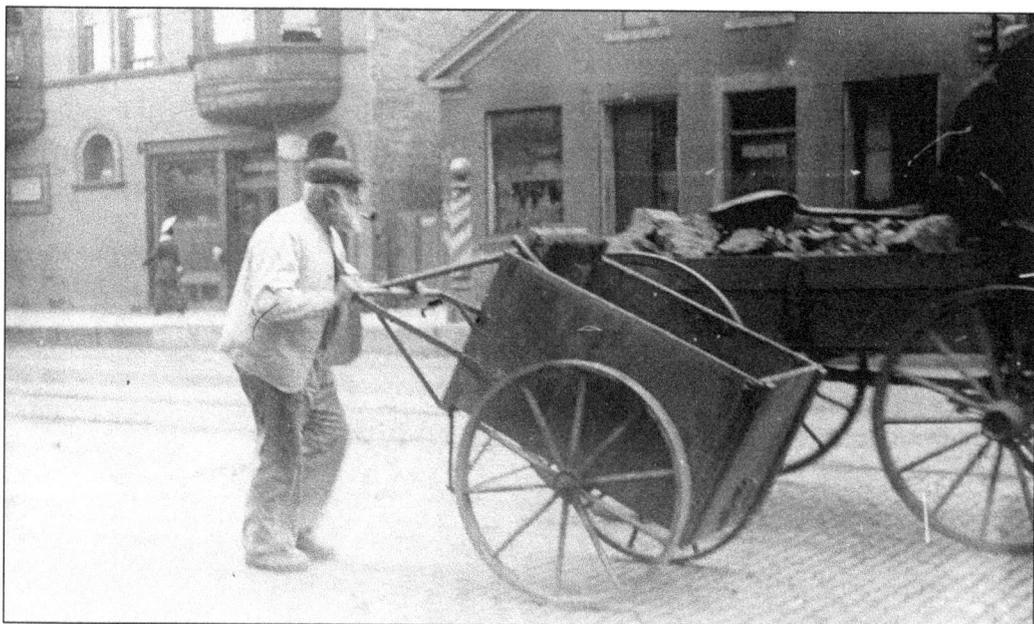

KEEPING THE STREETS OF PERU CLEAN, C. 1900. Notice the push broom that is balanced on the dumpcart; this gentleman is possibly working for the town to keep the streets clean. These carts were lightweight and easy to maneuver. Notice the handle on the back panel; it could be pulled up, opening the back for dumping of items that needed to be transferred. (Courtesy Peru Public Library Local History Room.)

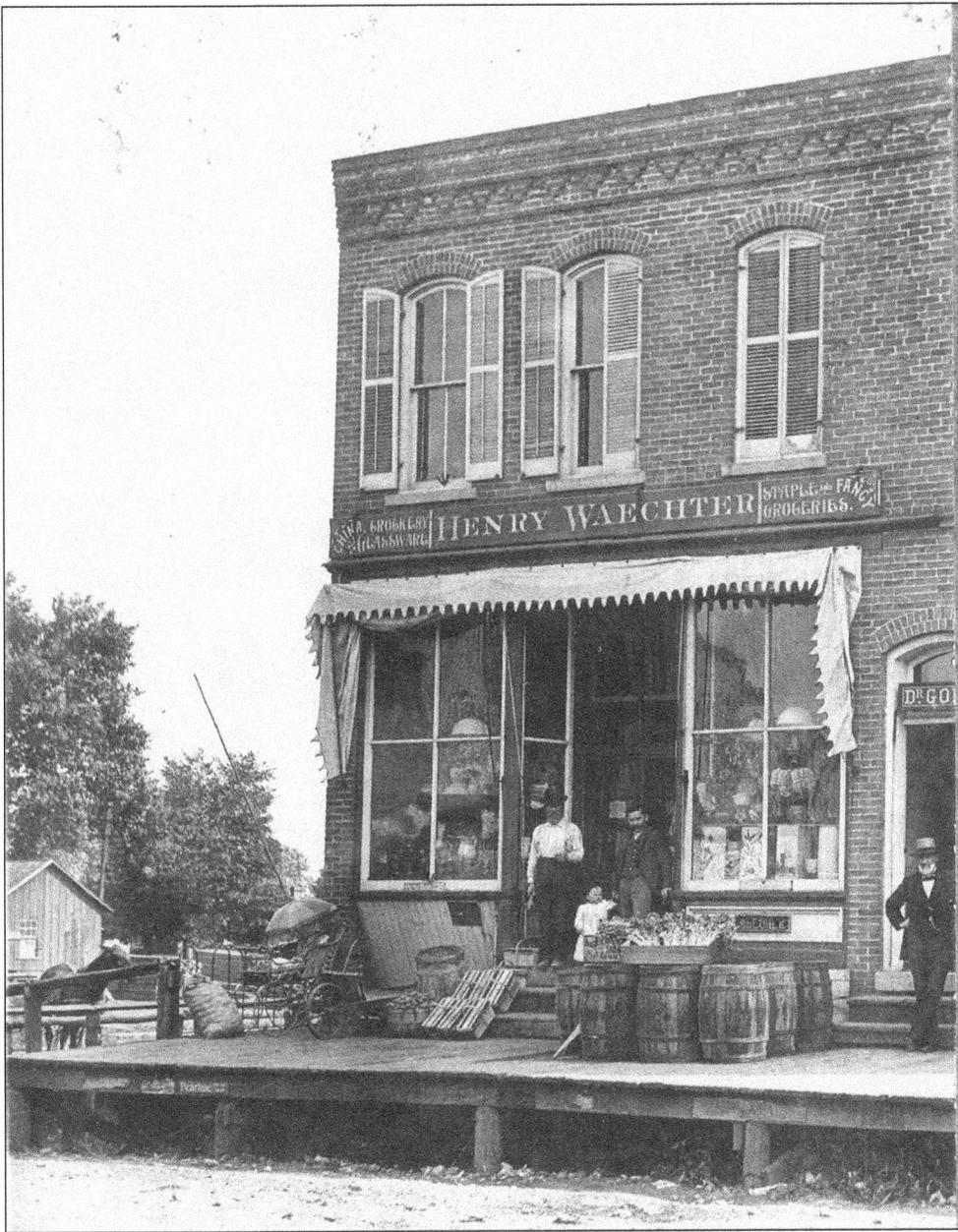

HENRY WAECHTER'S GROCERY STORE. The above photograph was taken in 1894 in Earlville. Waechter's sells china, crockery, Pearline glassware, Ivory soap, staple groceries, and fancy groceries. Pearline glassware was a pressed glass that eventually was offered in many colors. This glassware was used for serving food. There were jugs, dishes, jars, and baskets to name a few of the pieces offered. In an 1877 county directory, Henry Waechter is listed as working as a clerk in Earlville. Seventeen years later, he has his own establishment. Another example of a grocery store of the time was found in the Peru Directory, which listed "D. B. Gates, dealer in groceries, provisions, wooden and Willow ware, dried fruits, canned fruits, choice tea sugar, coffee, molasses, etc., etc. Also a full stock of sporting and blasting powder, fuse, shot, percussion caps, etc." (Courtesy Earlville Community Historical Society.)

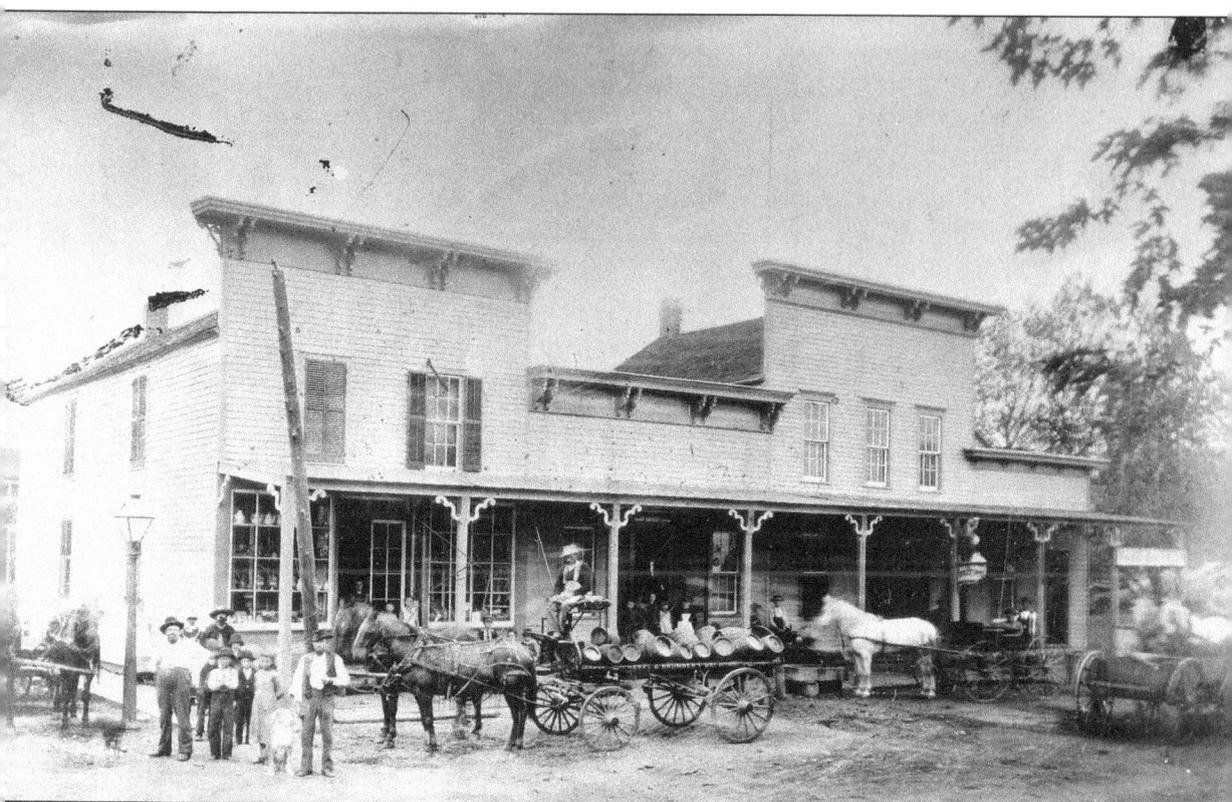

A SALOON AND GROCERY STORE, C. 1890. It was not uncommon to combine businesses such as the William Sperber's Saloon and Grocery Store. Sperber's thriving business was on Fourth and Calhoun Streets in the city of Peru. The wagon with the barrels in it is a delivery from the Hebel and Brunner's Brewery. The grocery portion of the business looks to be on the left side of the building and has many household items shown in the window. In 1877, a C. Sperber as well as William Sperber was listed working as a salesmen in Meyer's grocery store in Peru. William and Charlie were the children of Richard Sperber, who had five children in total. Richard came to Peru in 1849 as a cabinetmaker. He built his own shop and did carpentry as well as contract and building work. (Courtesy Peru Public Library Local History Room.)

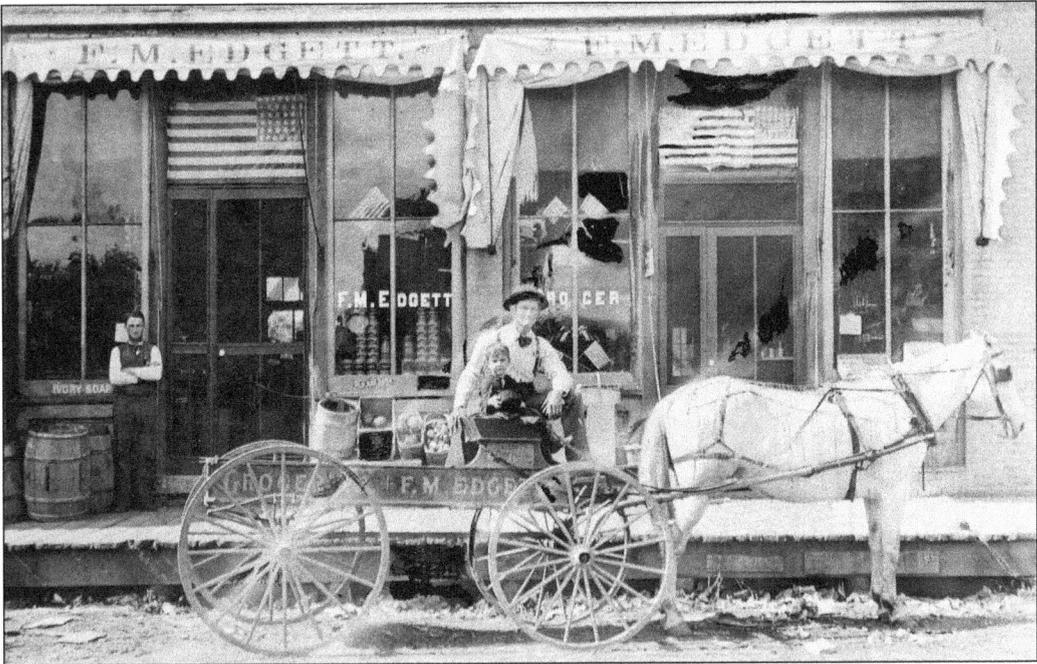

F. M. EDGETT'S GROCERY STORE. The American flags hanging in the windows of this grocery store tell a patriotic story in 1896 in Earlville. The flag on the far left is from 1876 when there were 38 states in the union. In 1889, Washington was admitted and there were 42 stars on the flag just like the flag on the right above the right side door. (Courtesy Earlville Community Historical Society.)

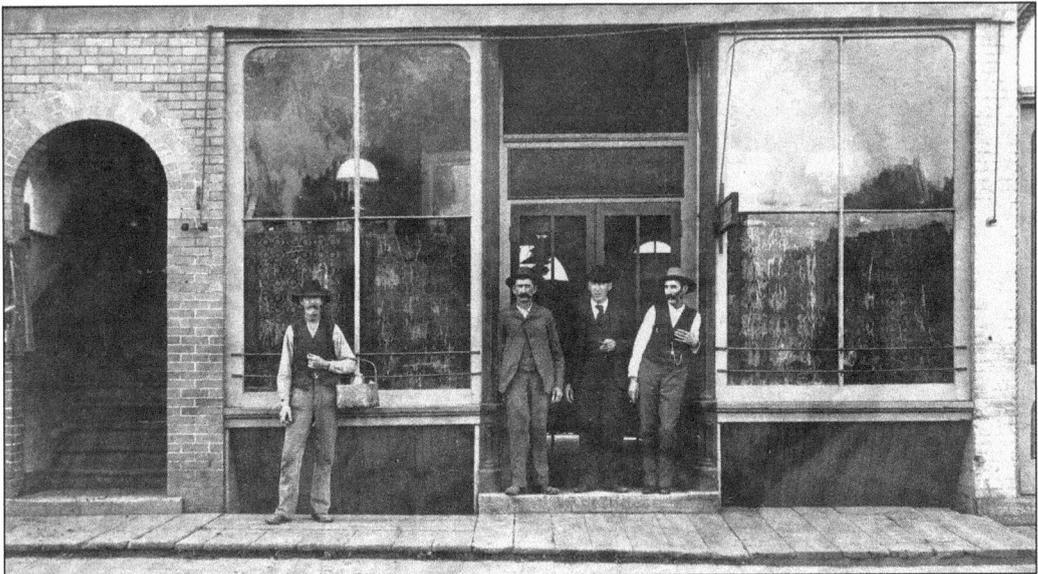

FRANK'S SALOON 1895. These four gentlemen are standing in front of the establishment called Frank's Saloon. There are heavy drapes over the lower half of the saloon's windows and double screen doors with what looks to be the traditional saloon type swinging doors behind them. A directory listing of the time advertised, "Dealers in fine imported and domestic wines, liquors and cigars, choice bottled goods." (Courtesy Earlville Community Historical Society.)

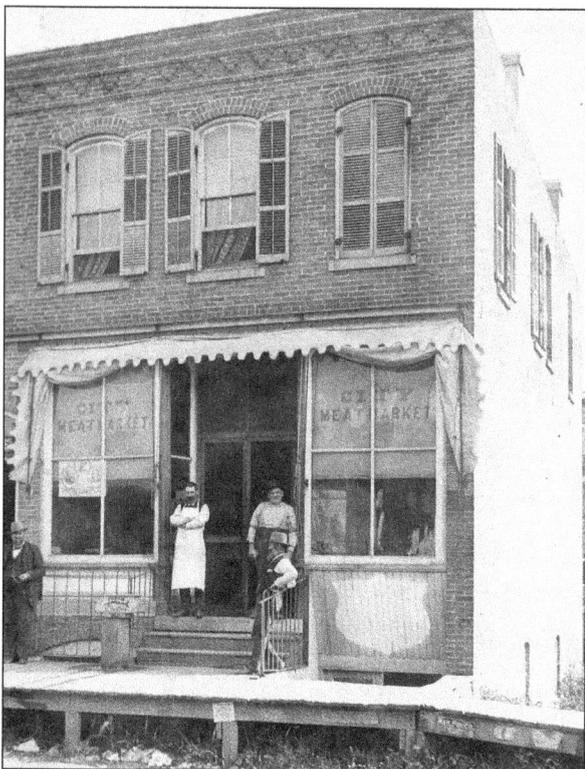

A MEAT MARKET, 1895. This photograph shows the City Meat Market in Earlville. On the sidewalk is a box sitting on a barrel with a fish painted on it that says "Fresh C. West." This 1876 advertisement for a butcher shop boasted; "All kinds of fresh, salt and smoked meats, lard, sausage, head cheese, etc., for sale at reasonable rates." (Courtesy Earlville Community Historical Society.)

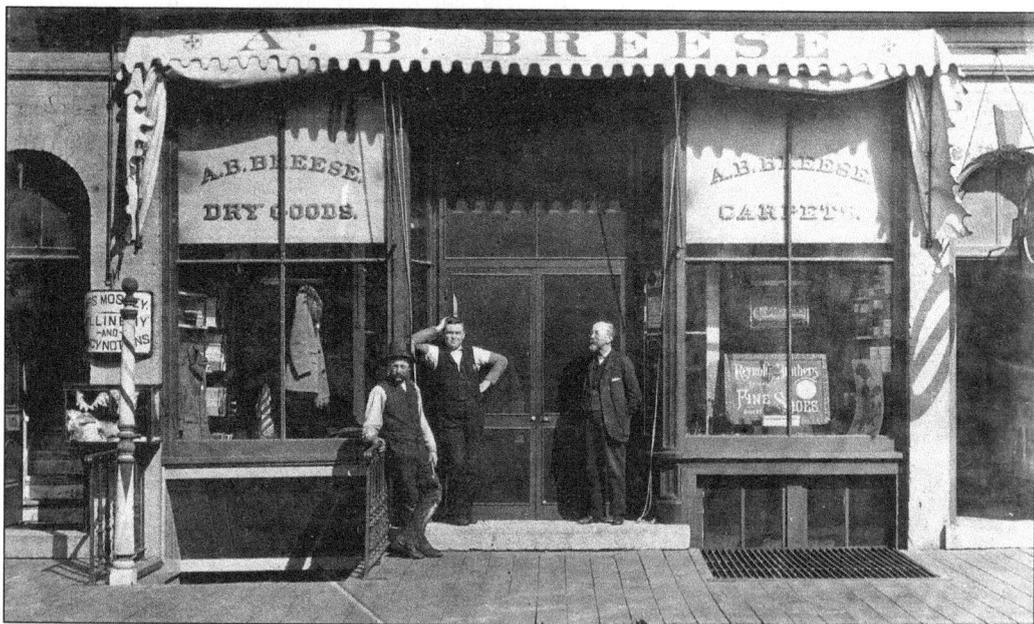

LADIES SHOES SOLD HERE. A. B. Breese was listed in the Mendota Directory of 1877 as selling dry goods and groceries in Earlville. This photograph was taken in 1895 when Breese's also sold carpets, boots, and ladies shoes from Reynold Brothers who claimed to have "the best made" shoes. The sign to the far left advertises "Mrs. Mosley's Millinery and fancy notions," behind the barbershop pole. (Courtesy Earlville Community Historical Society.)

THE PROPRIETOR OF HOME BAKERY
POSES, 1896. Home Bakery in Earlville,
also a restaurant, advertises Booth's
Oysters, which were shipped in from
Baltimore and were in advertisements as
early as 1873. Boxes of fruit are displayed
out front and boxes of Mason Brother's
Crackers are stacked in the right window.
The door at the right of the bakery is
for the Advent Mission Hall. (Courtesy
Earlville Community Historical Society.)

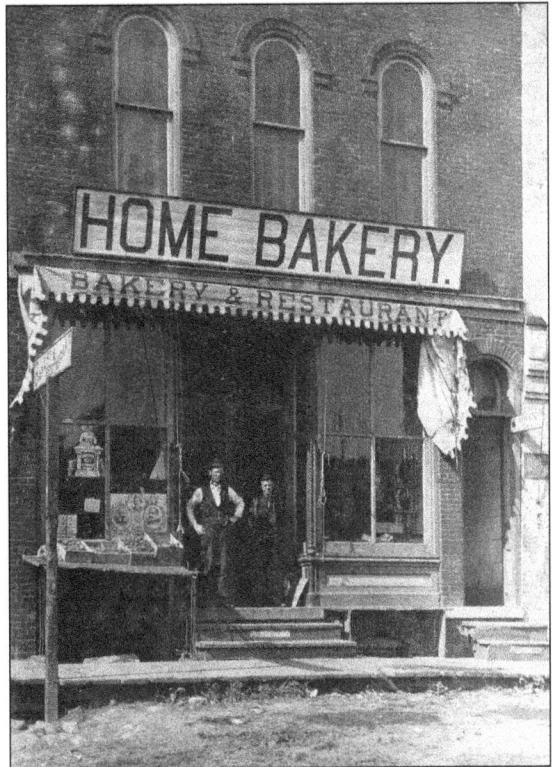

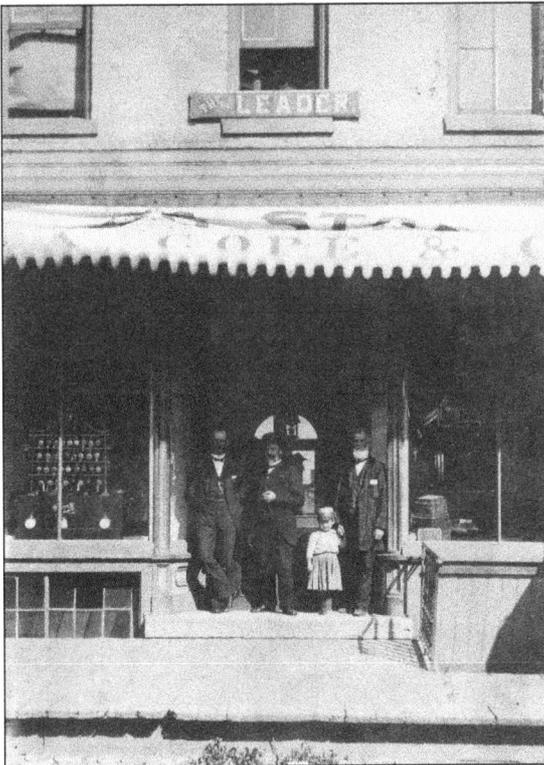

AN 1897 DRUG STORE. In Earlville, A.
Cope and Company is "the Leader," as a
sign above the awning proclaims. There
are watches and clocks on display in
the left window and a sign for Lehann's
Cigars is in the window on the right.
There is also a sign advertising Bitters.
Bitters were used for stomach tonic and
came in a bottle as a liquid. (Courtesy
Earlville Community Historical Society.)

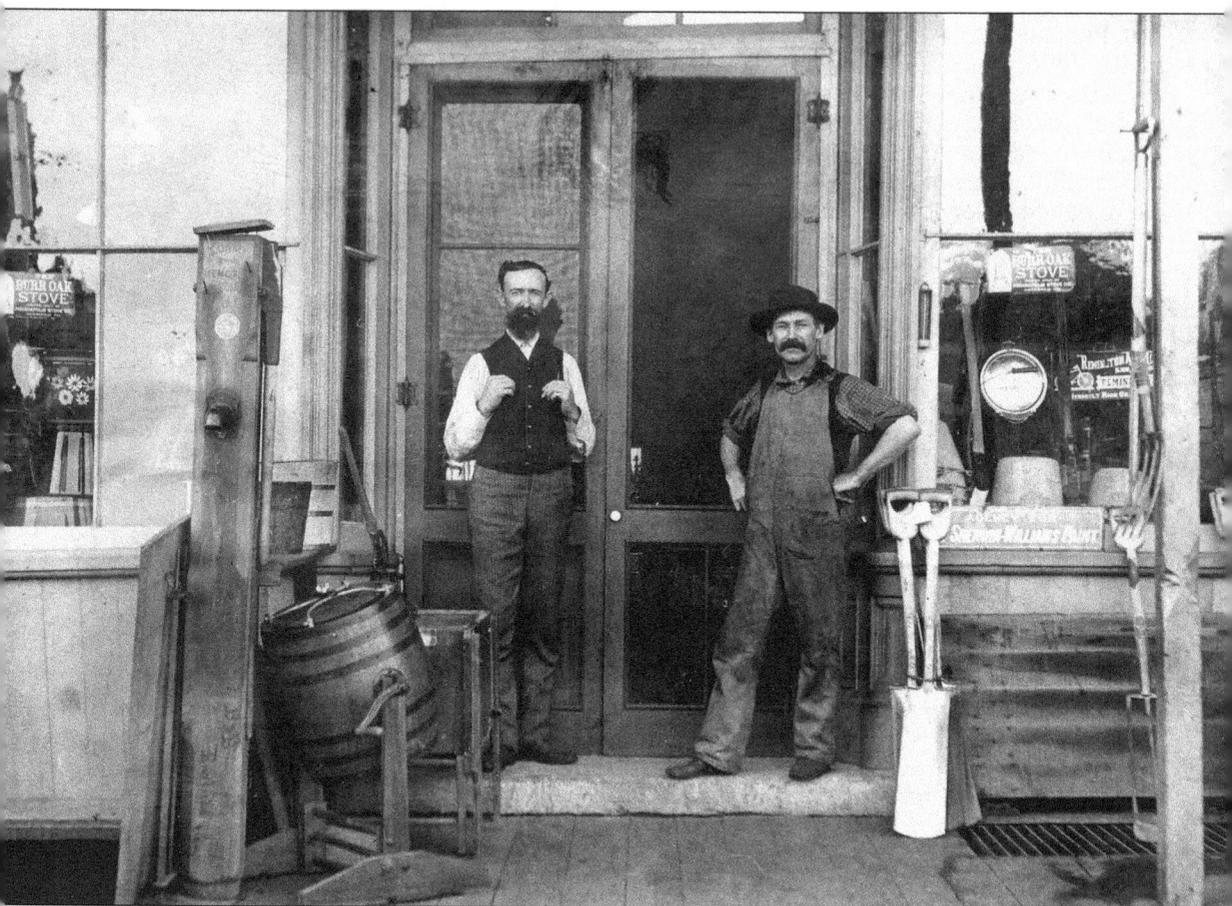

WITH A NAME LIKE BOLTZ, THIS MUST BE A HARDWARE STORE. This 1899 photograph of Boltz's Hardware Store shows it to be an agency to purchase Sherwin-Williams paints, which had been available for sale since 1866. Burr Oak Stoves were also sold at Boltz; they were manufactured in Indiana. A competitor of the same time period in the nearby town of Peru had this advertisement in the 1876 Peru Directory, "M. J. Bungart & Bro., dealers in shelf hardware, cutlery, nails and glass. Wood and iron pumps. Ranges and stoves. Tin, copper, and sheet iron ware. Manufacturers of Galvanized iron cornice and window caps. Guttering, tin and iron roofing. Satisfaction guaranteed on all job work. Agents for LaSalle and Peru for the Gothic Ventilator and chimney top, warranted to make all chimneys draw or no pay." (Courtesy Earlville Community Historical Society.)

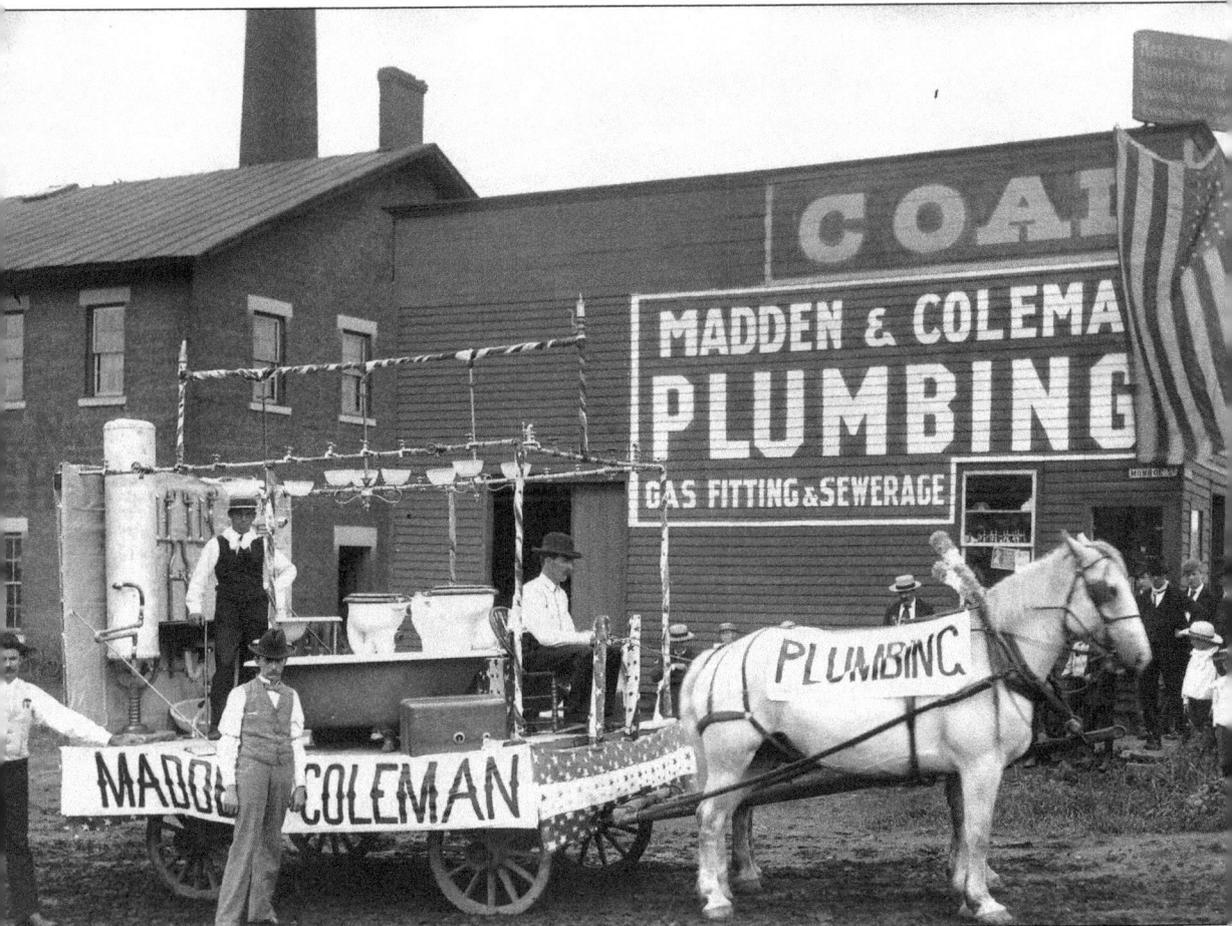

HAVE YOU EVER SEEN A PLUMBING BUSINESS FLOAT? All decked out for the parade, Madden and Coleman's float has all the necessities for the modern 1900s bathroom. The framework for the float is made up of pipes, with a variety of valves and lighting fixtures connected to it. The pipes connect, in the back of the float, to a water heater; there is also a sink with faucets and pipes showing plumbing connections above and below the sink. Their sign, at the top of the building above the American flag in front, advertises "Madden and Coleman sanitary plumbers, bath tubs, closets, basins, hydrants, pumps and sinks." This plumbing business also offered gas fitting and sewerage connections. The business was situated on Monroe and Main Streets in Mendota. (Courtesy Mendota Museum and Historical Society from Leo and Norma Muhlach Collection.)

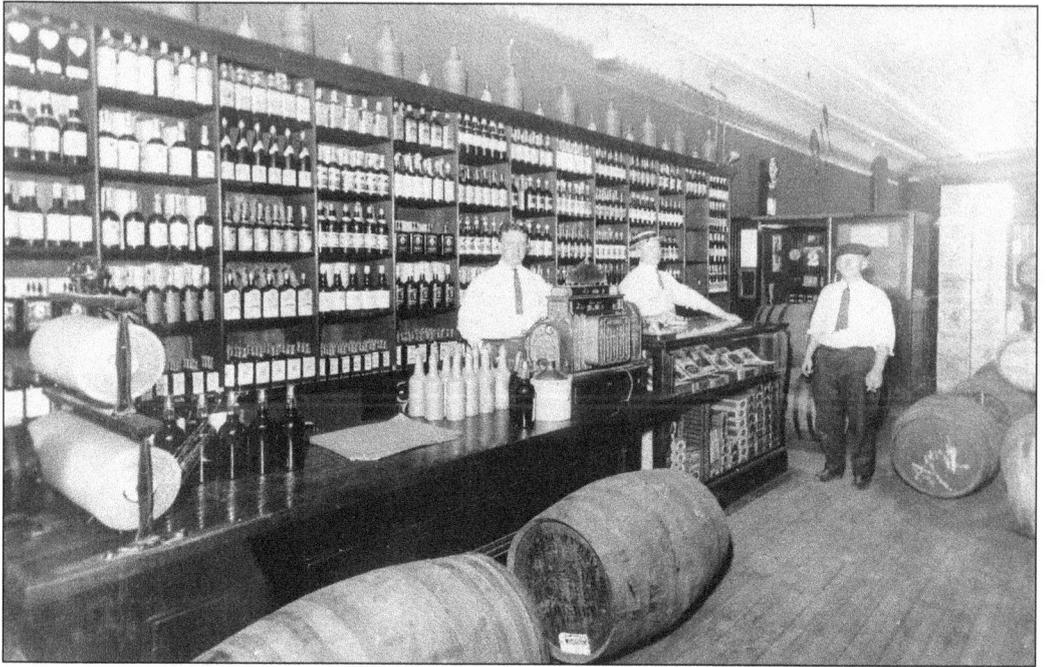

THIRST EMPORIUM, C. 1900. Whiskey barrels on the floor, cigars behind the counter glass, a corked jug on the wooden counter, and paper to camouflage a purchase are seen here. This Mendota liquor store was located at 811 Washington Street. Arthur Eckart is behind the cash register and Perry Safeblade, proprietor, is in the straw hat behind the counter. (Courtesy Mendota Museum and Historical Society from Leo and Norma Muhlach Collection.)

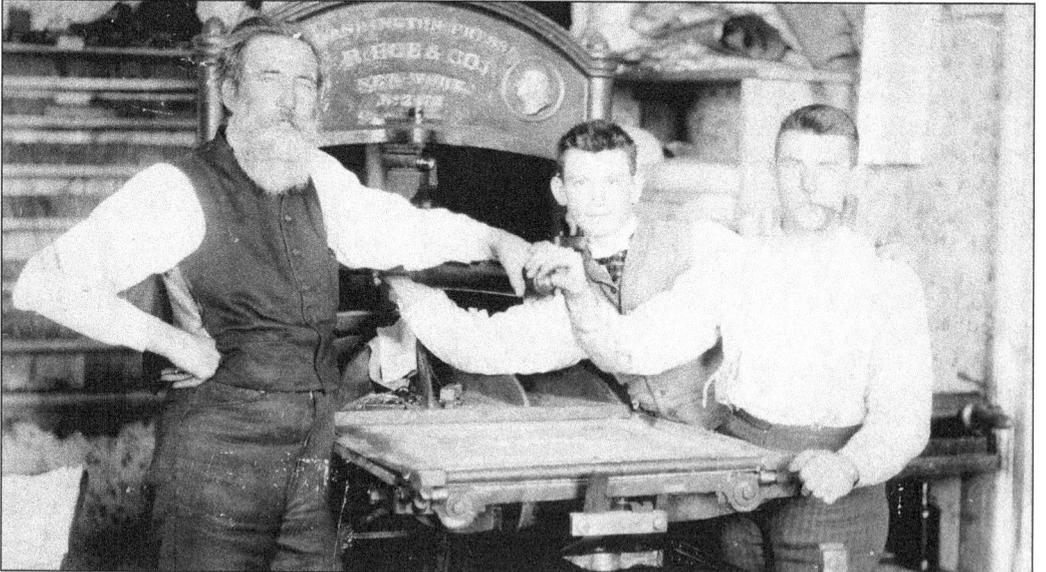

CHASE'S PHOTOGRAPHIC STUDIO, C. 1900. George Nolan and Hal Arrio are also pictured standing next to the Washington Press. In a January 17, 1902, newspaper advertisement the Chase studio advertises, "If you will sit for your negative we are positive we can please you with our latest styles which are always up to date. Visiting cards are 35 cents for 50." (Courtesy Earlville Community Historical Society.)

A HARDWARE STORE PASSED DOWN. This photograph of the George Binder Hardware store, thought to be taken in the early 1900s, shows a brick building with the offices of Dr. F. E. Blakeslee, a dentist office being run above. The 1877 LaSalle County Directory listed Fred T. Binder in Earlville, selling hardware including, stoves, cutlery, tinware, and more. Fred came to the county in 1856. (Courtesy Earlville Community Historical Society.)

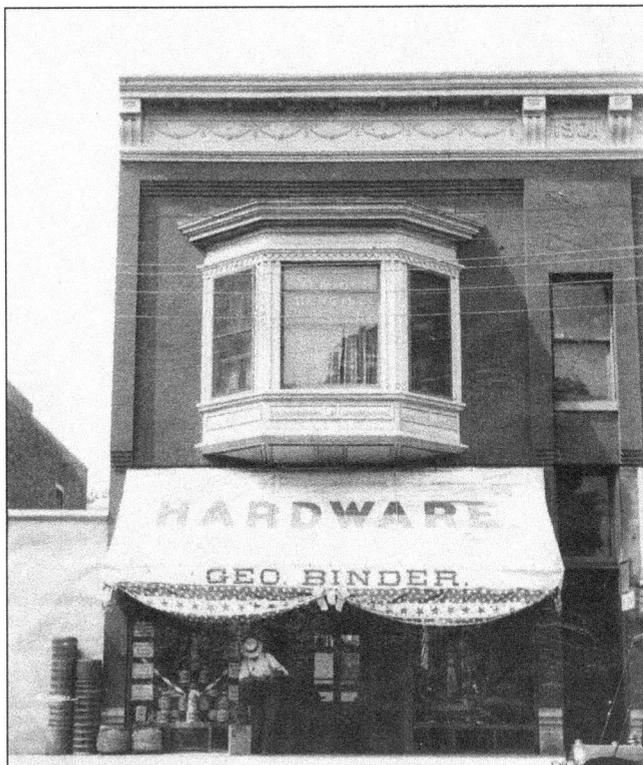

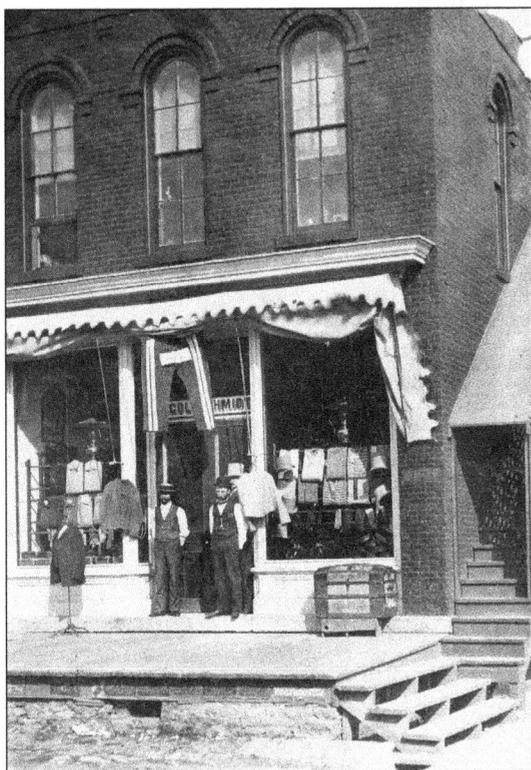

GOLDSCHMIDT'S MEN'S CLOTHING. Thought to be in business in Earlville from 1880 through 1905, the store's windows display men's clothing. A 1902 directory held this advertisement, "By far the biggest handlers of . . . Cloaks, Suits, etc., of any other firm in the county. Buying goods direct from the manufacturer. . . . We are the leaders for fine dress goods, always a beautiful line of exclusive styles in stock." (Courtesy Earlville Community Historical Society.)

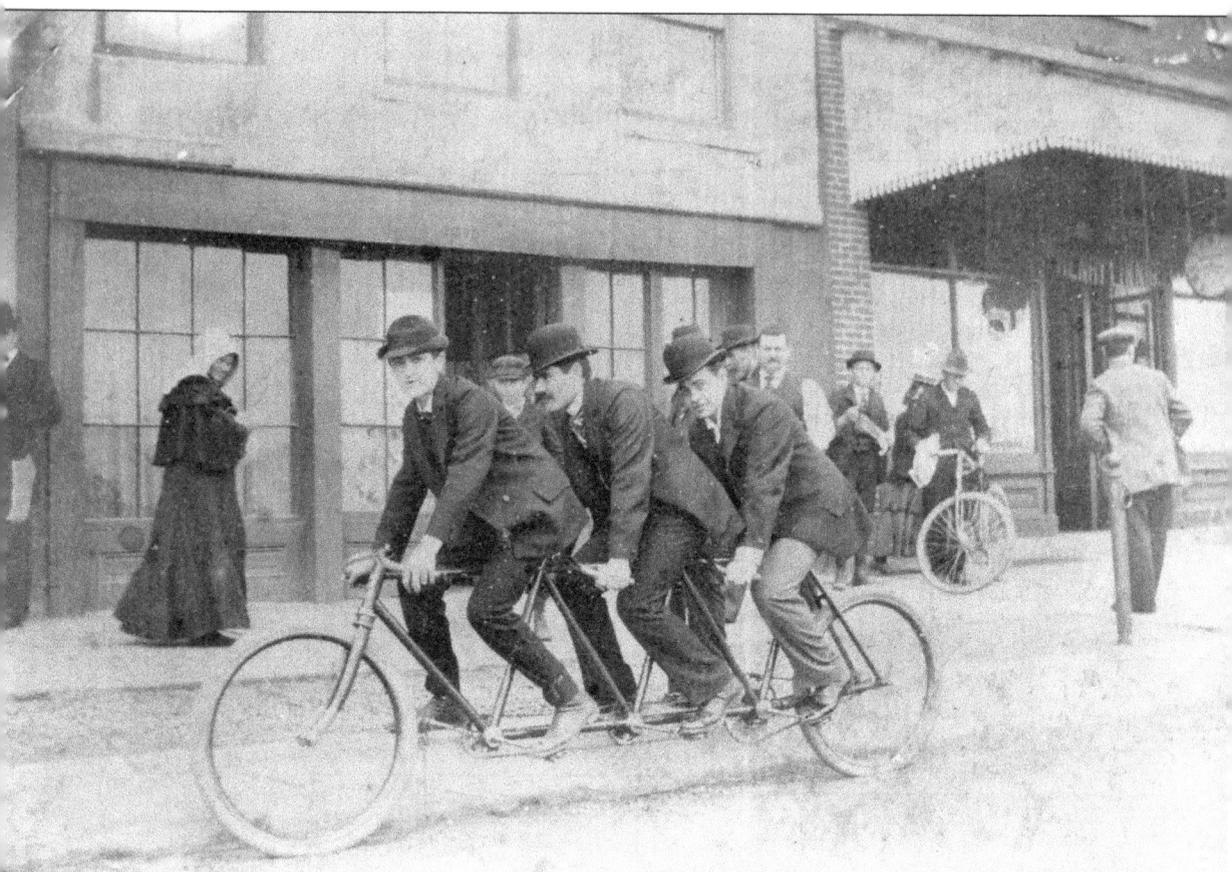

THREE MEN ON A BIKE, C. 1900. Henry Frank Linnig is seated in the front of the bicycle, in the middle is possibly a brother, and Charles Edward Linnig is on the back. In 1921, Henry served as the Peru Chamber of commerce president. Their father, Heinrich, opened a jewelry shop in Peru; it is on the far right, bicycles were also sold. Their grandparents came to Peru in 1852 and died a short time later due to a cholera epidemic. Linnig Brothers Jewelers and Opticians ran an advertisement in the LaSalle County Farm Directory in 1917 that stated in part; "We save you money on Diamonds, watches, silverware, cut glass and jewelry. We sell Victor Talking machines and records, Victrolas from $15.00 to $400.00, records 75 cents to $7.00 each. Eyes tested, glasses fitted, we stop your headaches, no drops—no drugs. Our Optician Mr. Charles E. Linnig gives personal attention to all cases. If you have eye troubles or need spectacles, come to us, consultation free. Linnig service means quality and satisfaction." (Courtesy Peru Public Library Local History Room.)

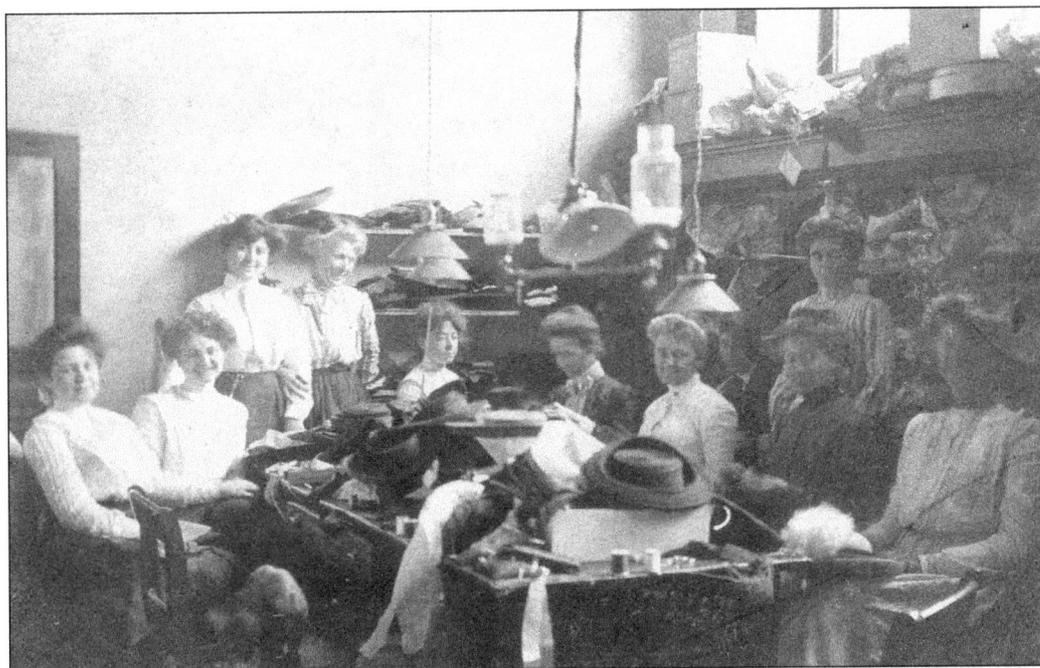

THE EARLVILLE LEADER. An advertisement in the *Earlville Leader* newspaper, in the year 1900, said this about M. J. Mosley's millinery establishment, "They have a nice line of fall millinery, school hats and caps." Designing, making, and selling hats is the job of the millinery; these ladies are making and decorating hats to sell. Hats, bonnets, and trimmings were sold at quality stores like the ones pictured above. A milliner might have also carried a line of hair goods as well as fabrics, ostrich feathers or other items that a fashionable lady would be looking for. The photograph below, also from Earlville, was taken earlier than the photograph above, in 1894. (Courtesy Earlville Community Historical Society.)

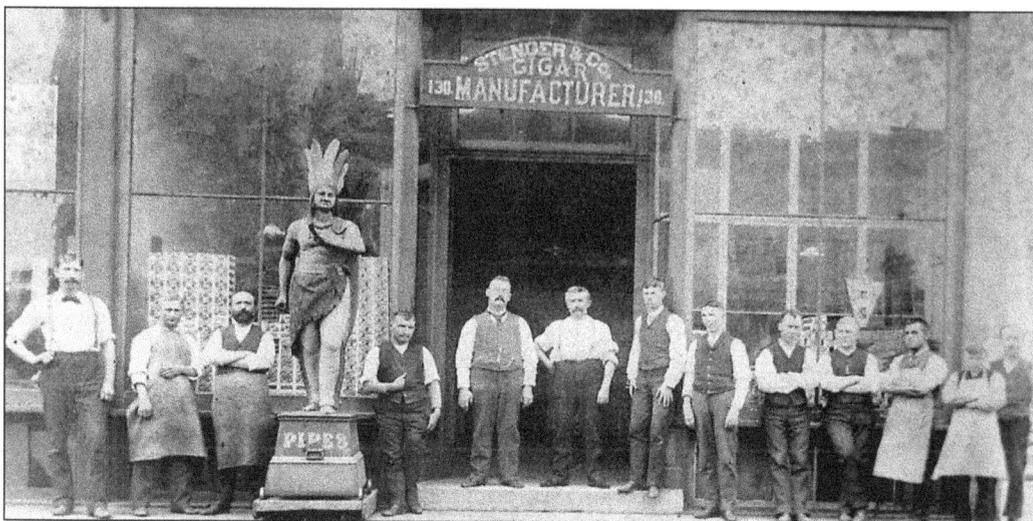

STENGER CIGARS, C. 1900. The Mendota directory of 1903 showed Stenger's advertisement "Old smokers know that H. P. Stenger on Illinois Street makes and sells the finest brands of cigars on the market." The figurine above could have been made in Chicago. It is similar to the Captain Jack model that the Metzler, Rothschild, and Company's catalog showed in 1879. (Courtesy Mendota Museum and Historical Society from Leo and Norma Muhlach Collection.)

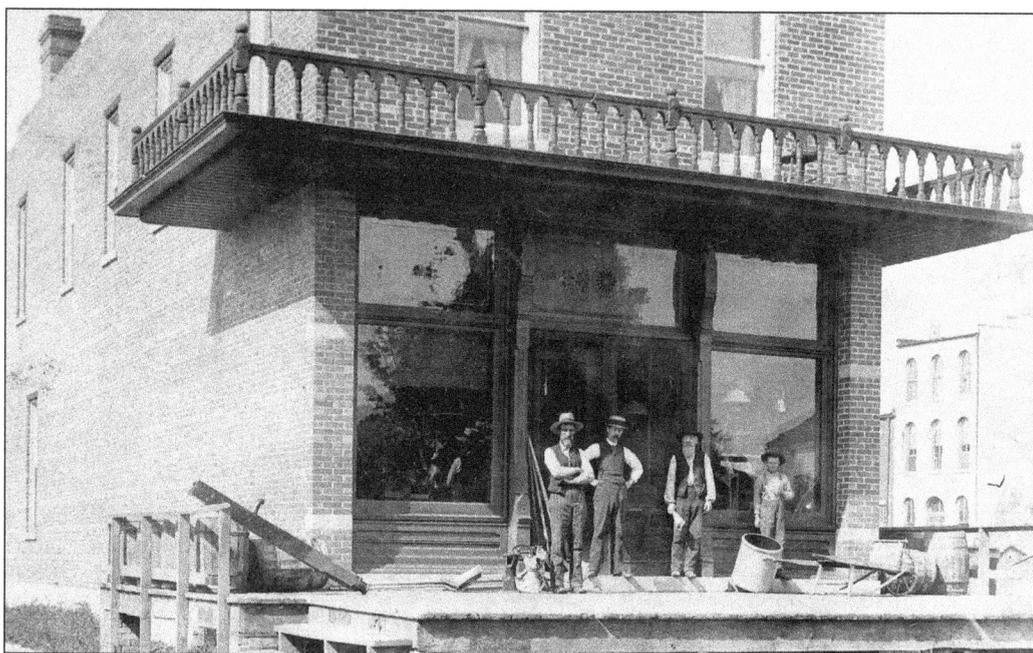

"HERE IT COSTS NOTHING TO LOOK AND LITTLE TO BUY," C. 1900. Gettemy's store sold shoes, dry good, and groceries. The quote above came from a 1900 advertisement in the Earlville newspaper. Looking more like a hardware store, there are shovels, a wheelbarrow, and barrels on the walkway in front of and around the Gettemy store. (Courtesy Earlville Community Historical Society.)

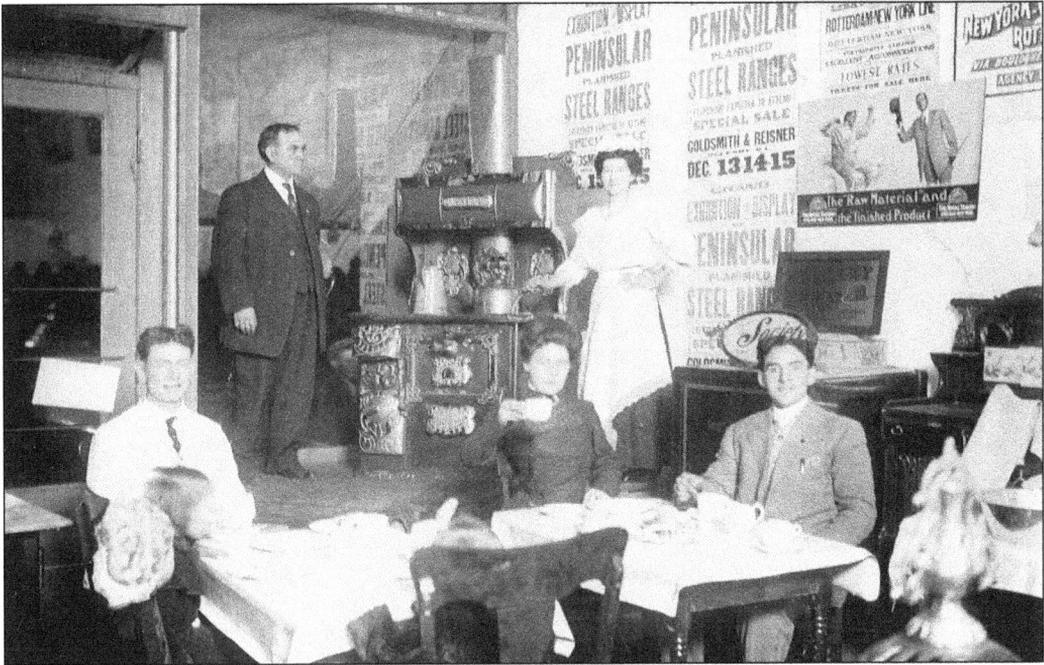

GOLDSMITH AND REISNER'S GENERAL STORE, C. 1909. Mr. Goldsmith and Mary Campbell are standing next to the Peninsular Steel Range in the background. Orville Campbell is seated wearing a white coat, the lady in the middle is unidentified, and Jacob Reisner is seated to her left. The children are Inez and Bernice. Other advertisements on the walls are for Society Shoes and the Royal Tailors. (Courtesy Oglesby Historical Society.)

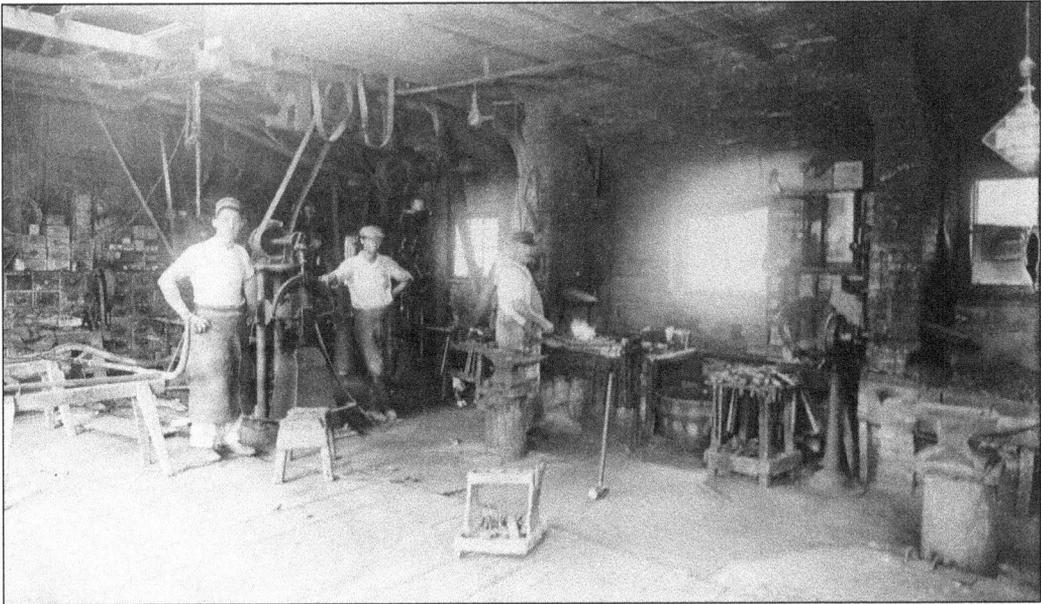

THE MIGHTY SMITH HE STANDS ON THE LEFT. The blacksmith of Earlville in 1915 was Rudolph Markos; here his son Harold stands to his left. No longer making as many horseshoes nor shoeing as many horses, the blacksmiths in the 20th century kept busy fashioning gates, lighting fixtures, and decorative items to name a few. (Courtesy Earlville Community Historical Society.)

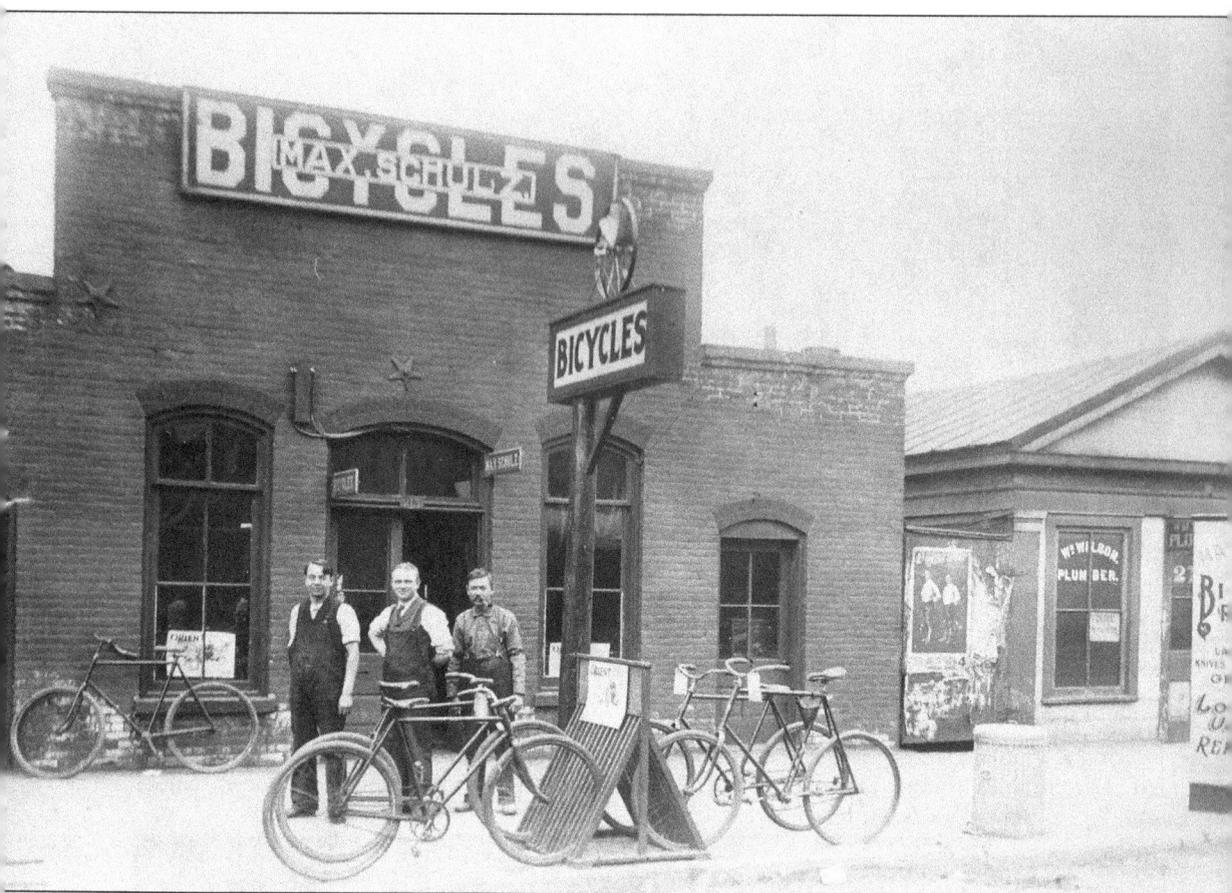

MAX SCHULZ'S BICYCLE SHOP, C. 1915. Max Schulz is standing in front of his shop in the middle of the three men standing out front. He was a resident of Ottawa and owned this bicycle shop on West Madison Street in Ottawa. The sign out front offers bicycle repair, lawn mowers, knives and scissors ground, and locks and umbrellas repaired. Biking was a popular activity. In 1895, the League of American Wheelman had planned a bike ride from Chicago to Ottawa with the route's end in the town of LaSalle. The LAW bicycle organization was credited with helping to get roadways improved. There is a sign in the shop window selling a car called the "Orient Buckboard." It was a two-passenger car on a wooden platform with a rear engine. The car weighed less than 400 pounds and cost less than $400. The shop next door on the right of the photograph is a plumbing shop owned by William Wilson, and a small sign in its window shows that the shop is for rent. (Courtesy Helen Crawford.)

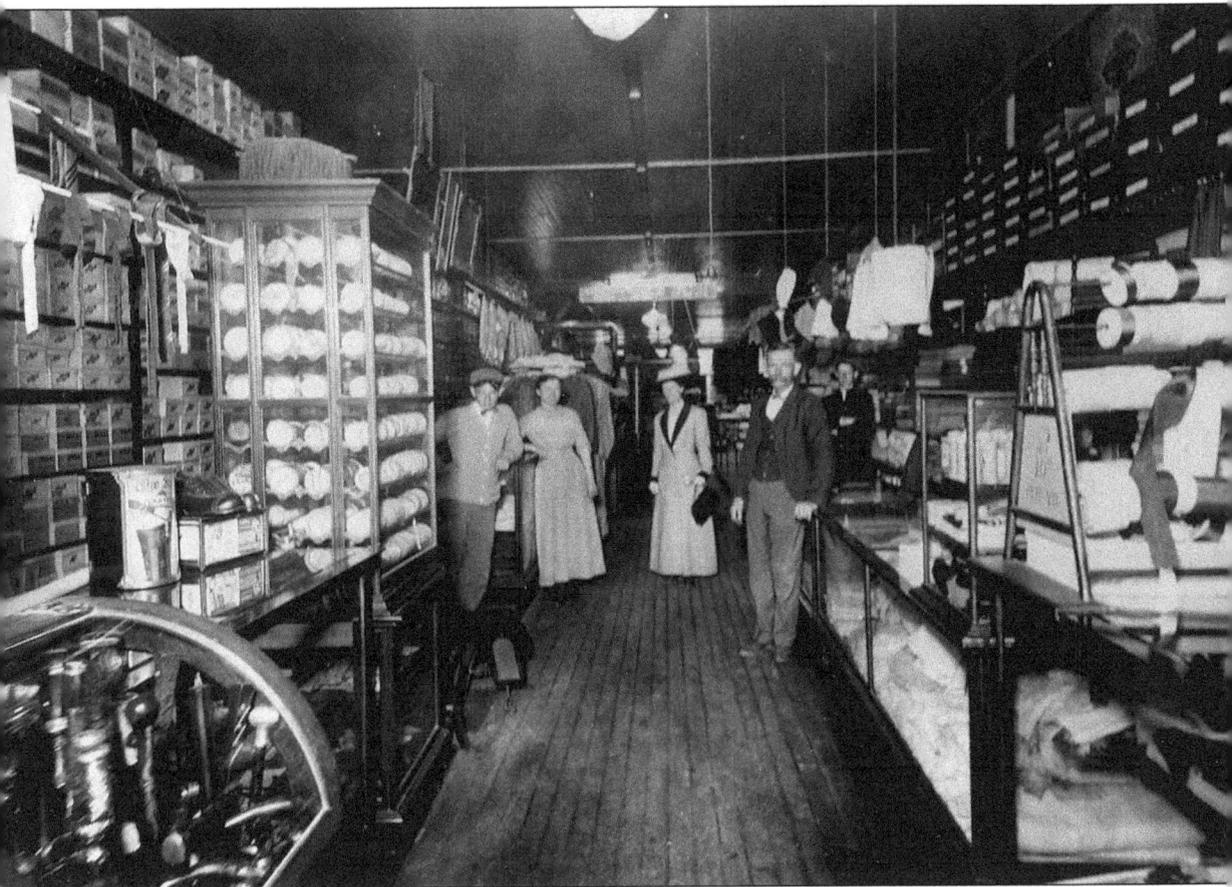

LANDERS AND SHEEHY'S UTICA STORE. This photograph, taken before 1923, shows a general store packed to the ceiling with merchandise. In business since 1885, the Landers name has always been associated with this store; it was the partners that kept changing. After the sons of William Landers reached an age to enter the business world, the stores name was again changed to reflect that, becoming Landers and Sons, until they went out of business in 1942. This store kept the people of Utica supplied with groceries and clothing and, as can be seen in the photograph, shoes and ribbons at the price of 5¢ and 10¢ per yard. Other products that a store of the early 1900s might have sold are postage stamps, farm equipment, hardware, and (depending on what local farms might sell to the store) milk, eggs, fresh meat, and vegetables. (Courtesy LaSalle County Historical Society Museum.)

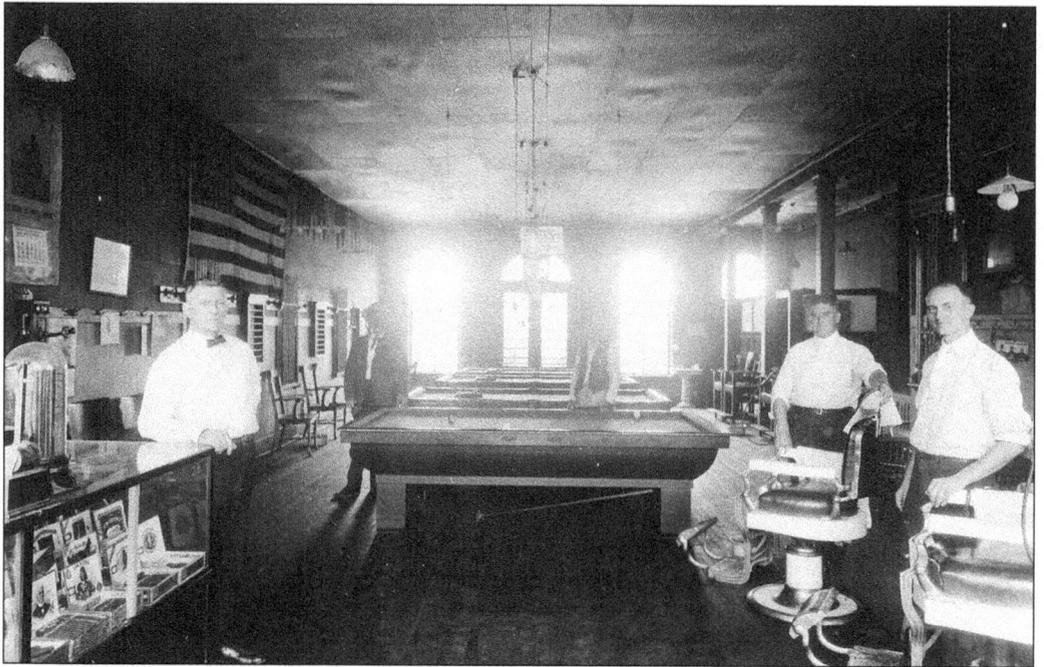

NINE YEARS BRINGS CHANGES. William Dolder is the proprietor of a pool hall and barbershop that sells cigars, cigarettes, pipes, and Snickers and Milky Way on ice. William Dolder is on the left in both photographs with a bow tie and a shoe preference that did not change. Below, the barbershop is gone and the pool hall is behind the patrician wall. There is no credit given at this establishment, and a sign below reads, "If we trust it gives us sorrow, so pay today trust tomorrow." Another sign below helped to date the photograph, advertising the opening of the Paramount Theatre in Aurora, Illinois, it claims to be "The Showplace of the Fox River Valley" opening September 3, 1931. The photograph above is from September 1922, which is shown on the calendar behind Dolder. (Courtesy Earlville Community Historical Society.)

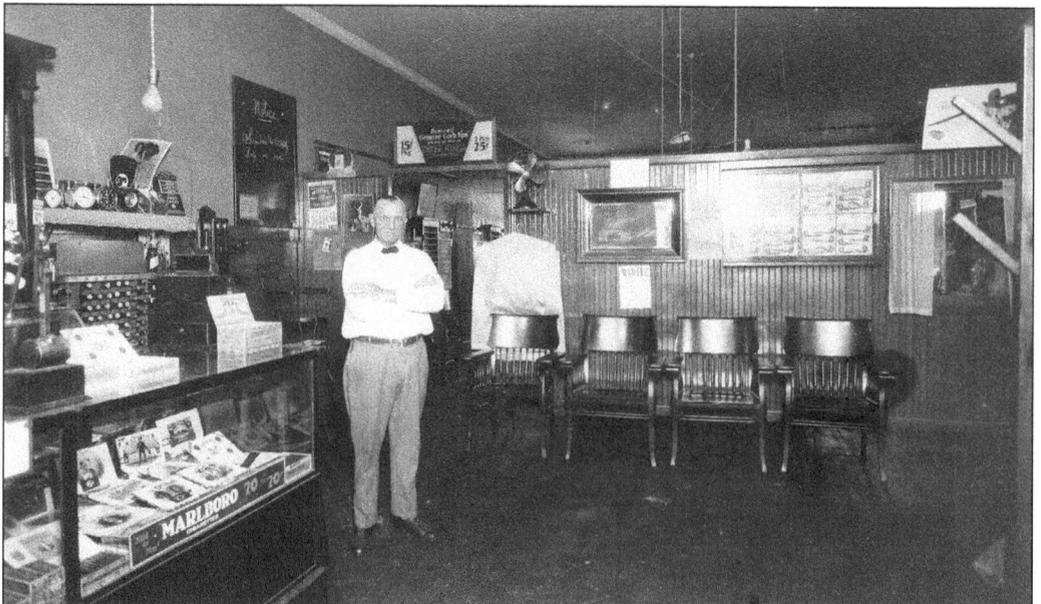

Four

SCHOOL DAYS, HOLIDAYS, AND SUNDAYS

CHRISTMAS IN LaSALLE COUNTY, c. 1877. Lillian Swingler sits beside her presents under the Christmas tree. The gifts include a teddy bear, doll stroller, drum, and miniature tea and baking set. The Christmas tree was widely used in the 1800s and sometimes was hung from the rafters. The tree here is a small tree set upon a table. There are garland and glass ornament decorations. The size and placement of the tree is also very typical of the time period. The tree stand could have been a wooden stand that was nailed to the bottom of the tree or a pail was often used filled with sand and rocks to hold the tree in place. There are many family portraits sitting on the fireplace mantel and a large embroidered pillow with flowers on the right of the photograph. Swingler was born in 1870 and became a schoolteacher in her later years. She lived in Marseilles, dying in 1946. (Courtesy Helen Crawford.)

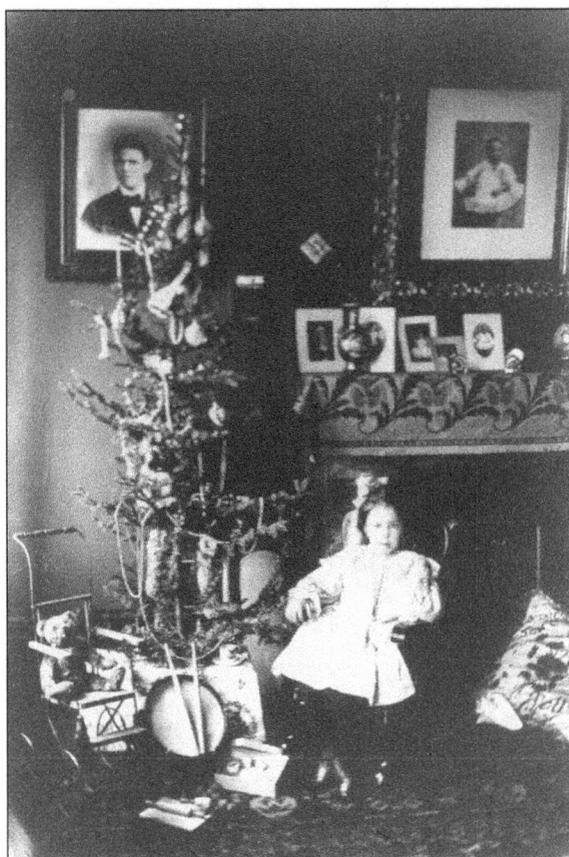

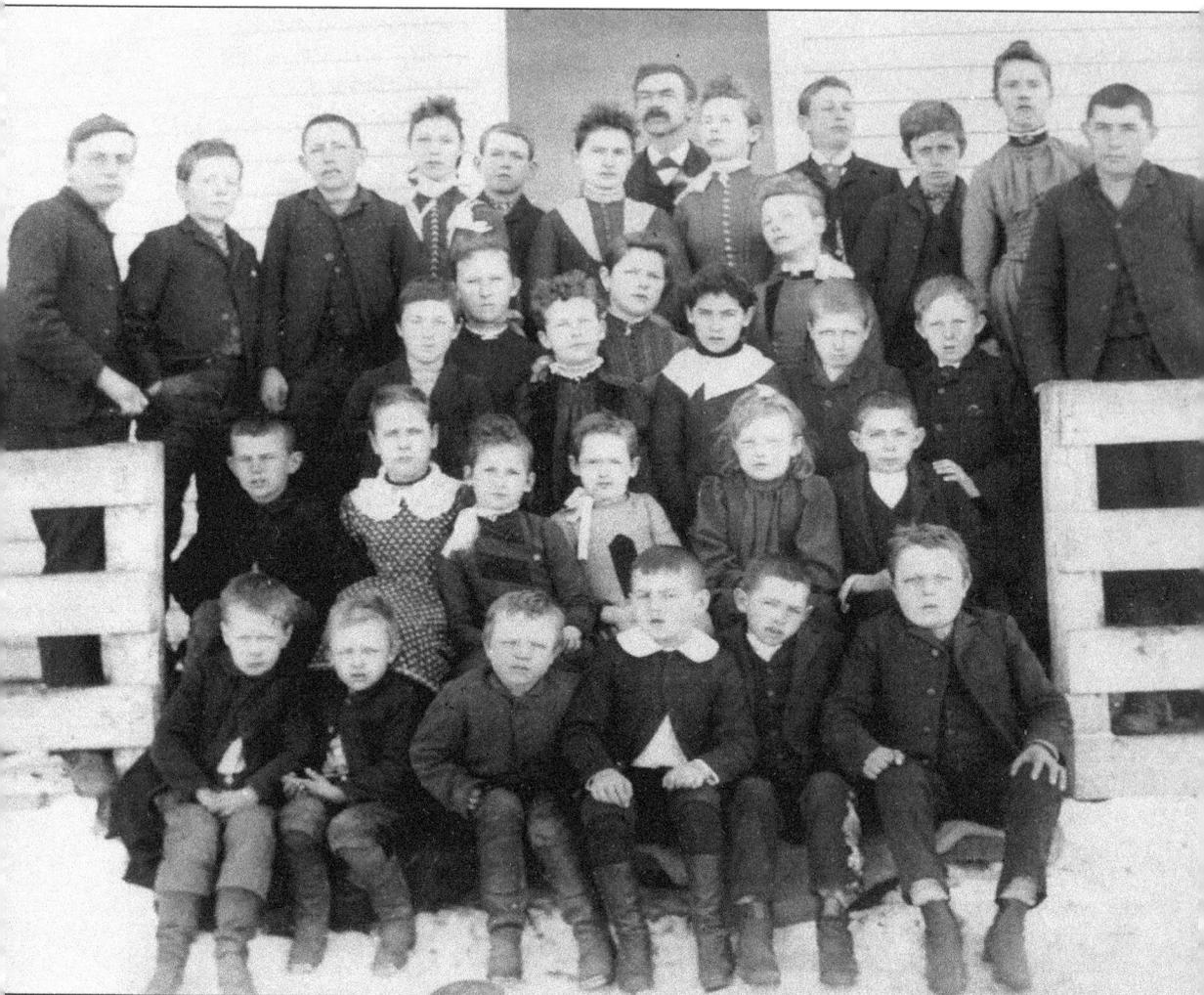

THE BARBER SCHOOL, CLASS OF 1887. Many a one-room schoolhouse was built on private land so that the children of the farmer could send his children to school. Other farmers with children who were close by and helped to pay for the building of the school and paid the teacher also sent their children. This school had six Barber children but also six each of Bourne and Killelea along with four Schaefer children, two Loring, and three each of Gallup and Boyd. The teacher in this case was Sam Makeever, who might have lived alternately with the families of these children over the school year. The traditional one-room schoolhouse often had a potbellied stove for heat and use as a kitchen to heat soup on cold days. There would have been a separate boy and girl outhouses. The kids would have brought food from home in a pail, and water would have come from an outdoor well. (Courtesy Seneca Public Library District.)

THE FIRST CONGREGATIONAL CHURCH OF
MARSEILLES. It was September 1860 when
this congregation was organized by the
Reverend H. C. Schofield. There were just
over 200 members. Services were first held in
a public schoolhouse. Seven years later the
church pictured here was built and dedicated.
This church was part of the Fox River Union of
Congregational Churches. (Courtesy Marseilles
Public Library.)

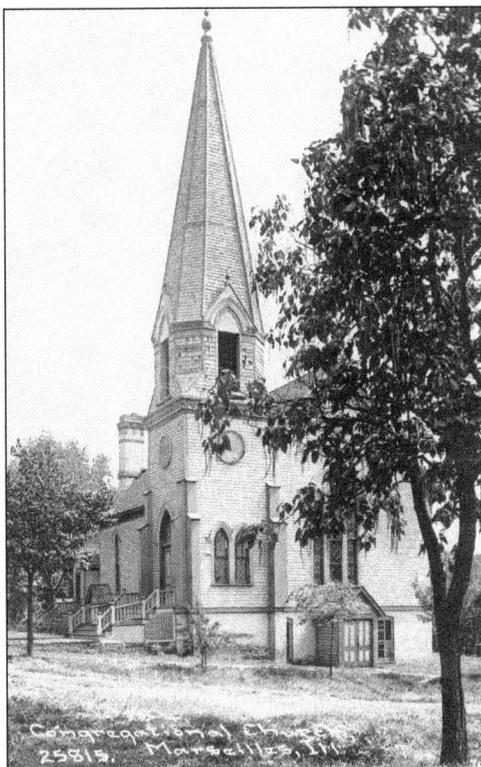

GRADUATION DAY. It is 1881 and high school
graduation day for the beautifully attired Emma
Lauber. Her diploma is held in her left hand.
Peru's high school at the time of this photograph
was held in a building that started out as a
church. The church building served as the school
until 1898 when the LaSalle-Peru township high
school was ready. (Courtesy Peru Public Library
Local History Room.)

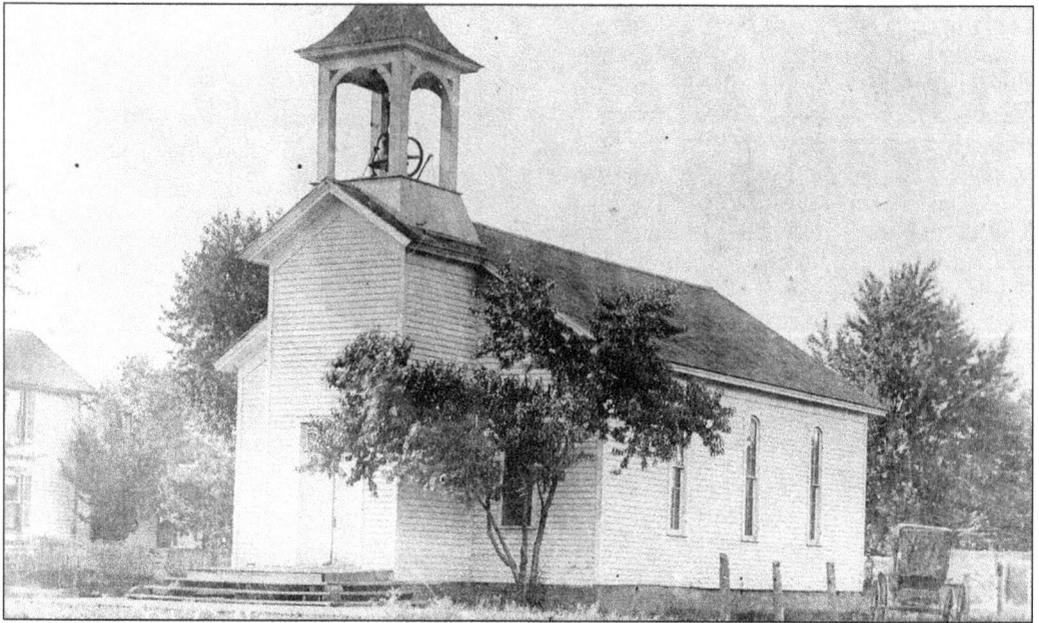

TRIUMPH'S METHODIST CHURCH, 1880s. This place of worship was built in 1864. The town of Triumph moved east because of railroad placement. Parishioners wanted the church moved to continue to be a part of the town. The move was achieved by using skids, rolling the church to its new home, using the power of a mule team. (Courtesy Mendota Museum and Historical Society from Leo and Norma Muhlach Collection.)

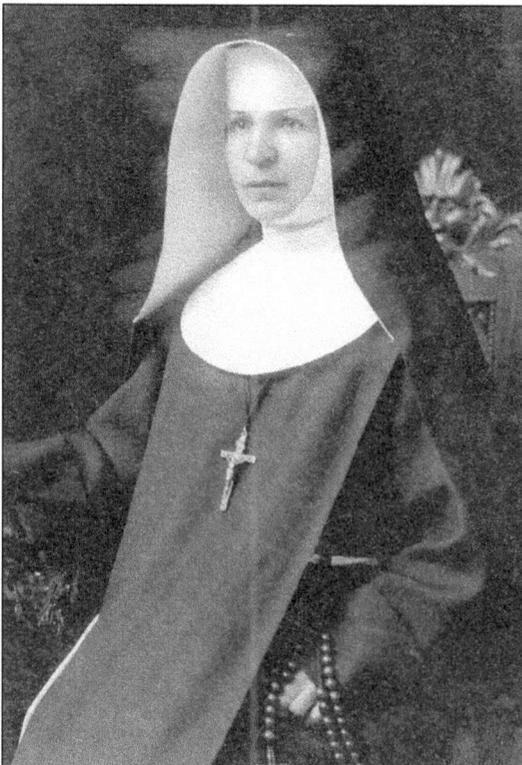

SR. MARY STANISLAUS. In 1882, Sister Mary became the first member of St. Joseph's Church in Peru, Illinois, to enter the St. Francis Convent in Joliet, Illinois. The name Stanislaus has its meaning derived from Slavic and Germanic origins. The first half of the surname Stanislaus means "to become" and the second half means "glory, fame, or praise." (Courtesy Peru Public Library Local History Room.)

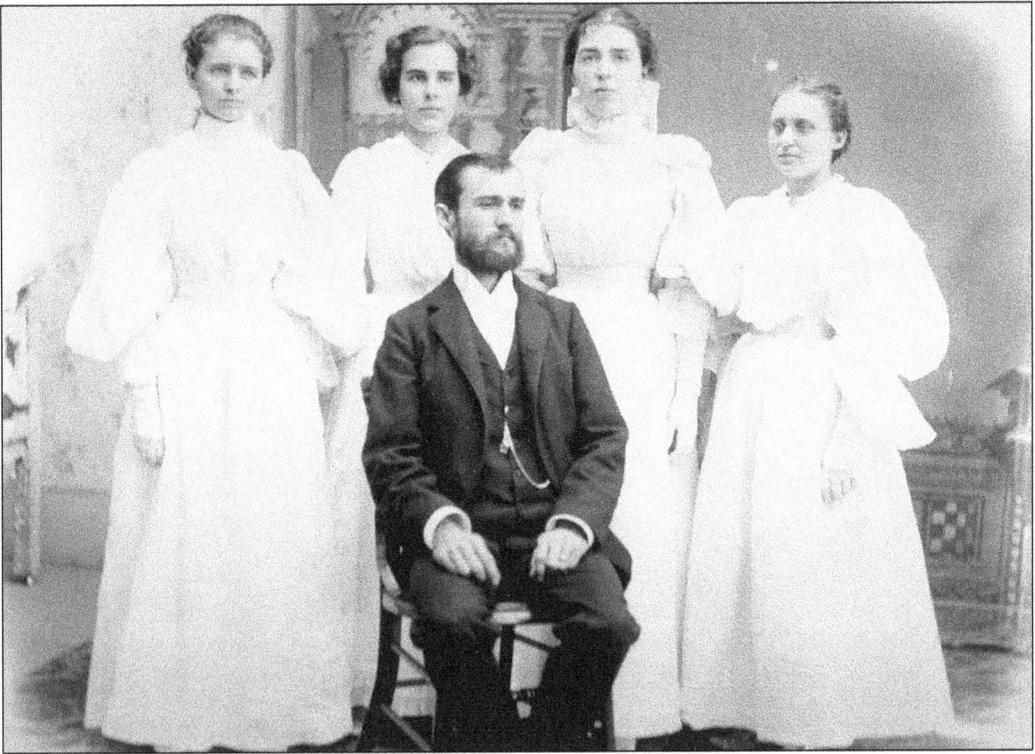

TWO GRADUATION DAYS IN EARLVILLE. The graduating class of 1896 is what the top photograph depicts. The Earlville High School graduating class is, from left to right, Gertrude Goss, Elizabeth Barnard, Katherine Goble, Josephine Norton, and Professor Robinson sitting in front. Sixteen years later the graduating class is slightly larger, in the photograph below, there are 15 students. The year is 1912, and this graduating class, also from Earlville, appears to be a grade school graduation. Notice the sign that the boys in front are holding; the sign does not read graduation but gradatim, which means to advance by steps gradually. (Courtesy Earlville Community Historical Society.)

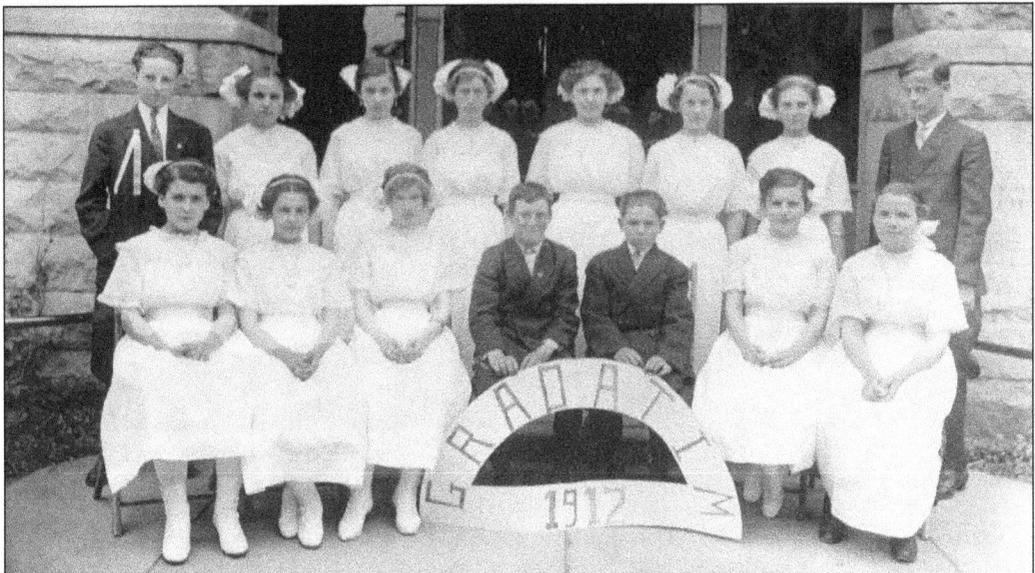

THE LINCOLN SCHOOLHOUSE IN MARSEILLES, C. 1900. This wood structure was built in 1898, known as east end school, as it was situated in east Marseilles. In 1912, an addition was added to the building and then around 1924 the building burned down. This prairie-style or four-square-style structure has a hipped roof and low dormers with narrow siding. Notice the large bell tower. (Courtesy Marseilles Public Library.)

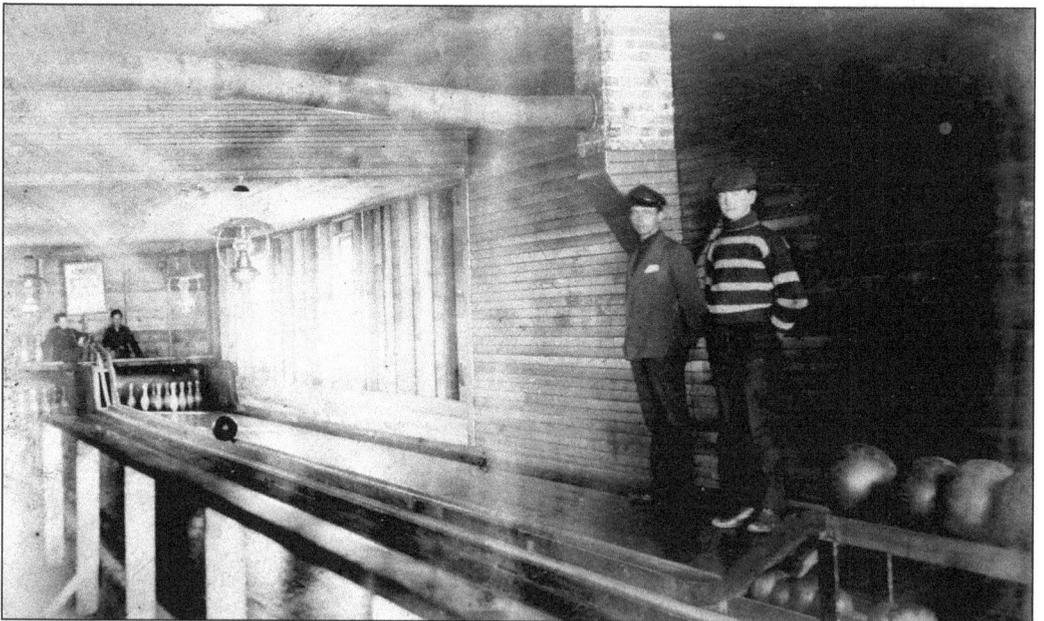

BOWLING LANES BENEATH A DEPARTMENT STORE. These bowling lanes were under Bent's Department Store, Oglesby. Notice the two boys sitting at the end of the lane by the pins, these are the pinsetters. Dangerous work, pin setting had to be done by hand before modern machinery lifted the pins, righted them, and returned the ball. Pinsetters were often hit by bowling balls. (Courtesy Oglesby Historical Society.)

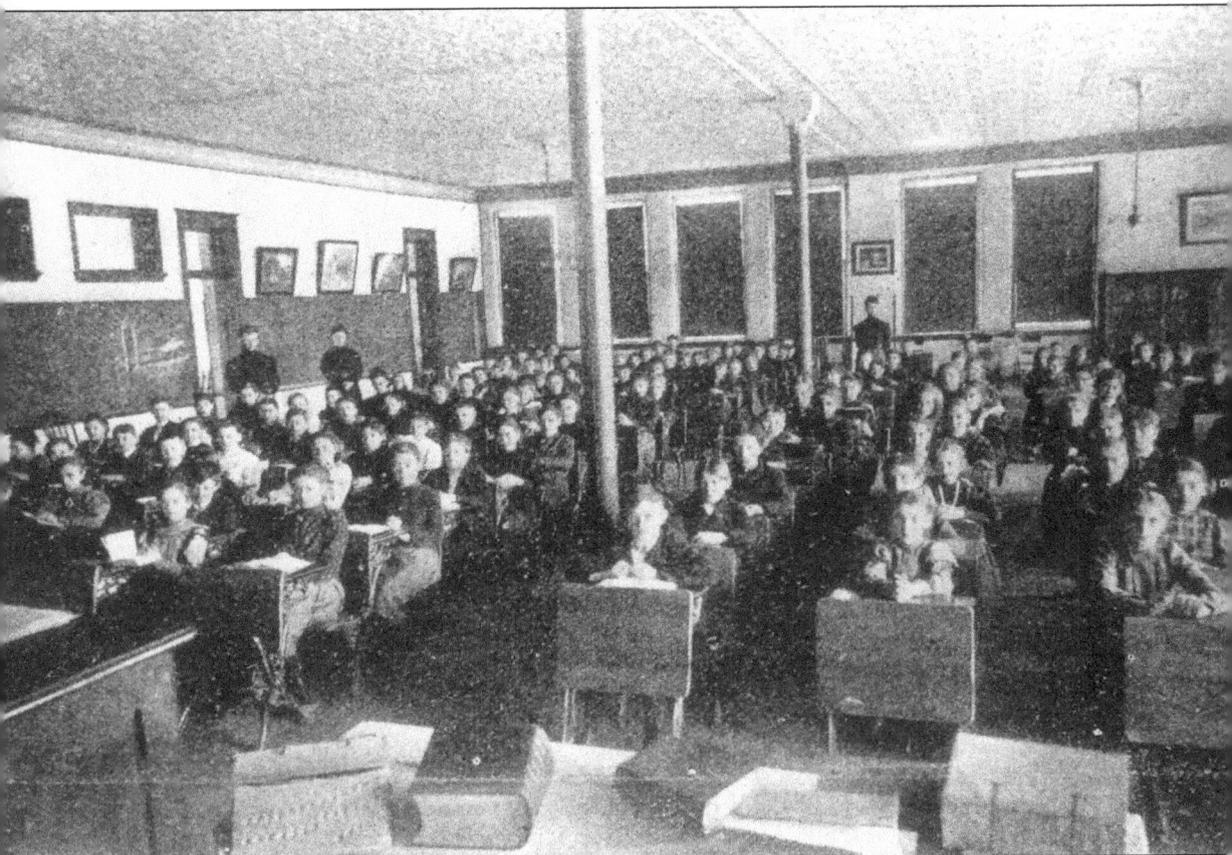

PERU SCHOOL DAYS. Pictured here is the Peru Public School's central building and the departmental plan in use with grammar grades. There are over 125 students pictured in this one large classroom. The precise year of this photograph is unknown but something is known of the rules teachers had to follow in the later part of the 19th century. One rule stated, "Women teachers who marry or engage in unseemly conduct will be dismissed." Another rule reminded the teachers to save for the future, "Every teacher should lay aside from each pay, a goodly sum of his earnings for his benefit during his declining years so that he will not become a burden on society." Teachers' salaries varied, but in the early 1900s the pay was approximately $40 a month; after 1915, $50 a month was common, and then in the later 1920s one could earn a pay check as high as $120 per month. (Courtesy Peru Public Library Local History Room.)

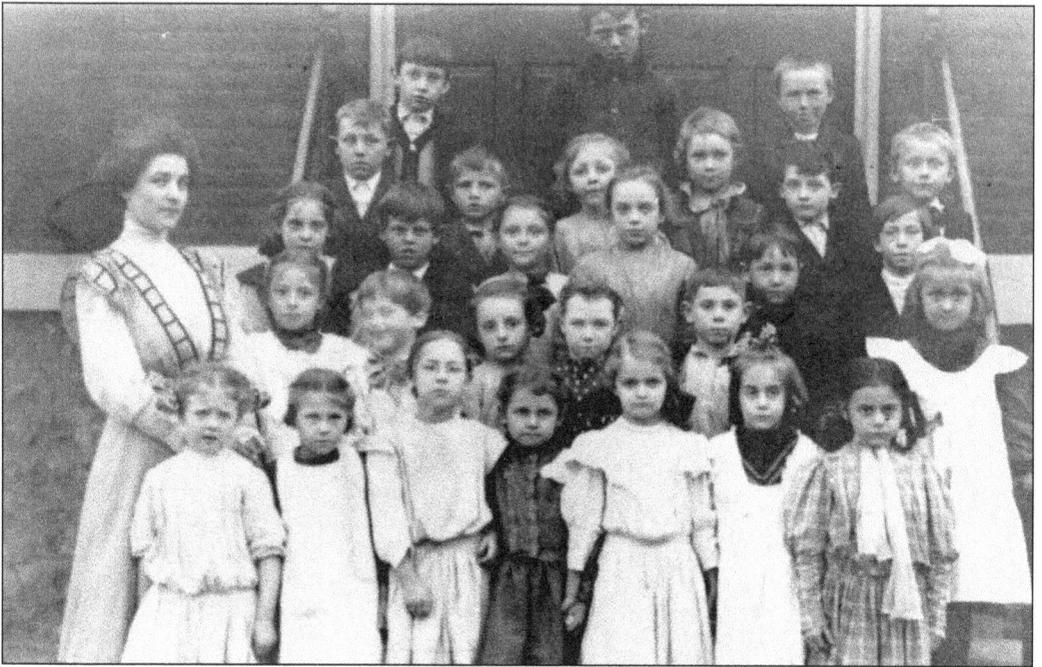

TWO SCHOOL PORTRAITS. Norma Zubrod is the teacher at the Utica School house with 27 pupils pictured here. This class photograph is from the 1909–1910 school year. Below, Agnes Meagher is the teacher at the Seneca School, a one-room schoolhouse in district 161. These 22 school children are, from left to right, (first row), Ole Gunderson, Charles Chapman, Donne Chapman, Stasis Higgins, Willard Bagby, Hildegard Maier, Ed Peddicord, Joe Peddicord, Lloyd Bagby, Charles Higgins, and Alice Higgins; (second row) Franes Maurhofer, Nelson Chapman, Carrie Chapman, Myrrah Higgins, Eunice Peddicord, Mae Olsen, Isabelle Peddicord, Bertha Higgins, Edna Bagby, Gus Gunderson, Barney Gunderson, and Meagher. (Above, courtesy LaSalle County Historical Society Museum; bottom, courtesy Seneca Public Library District.)

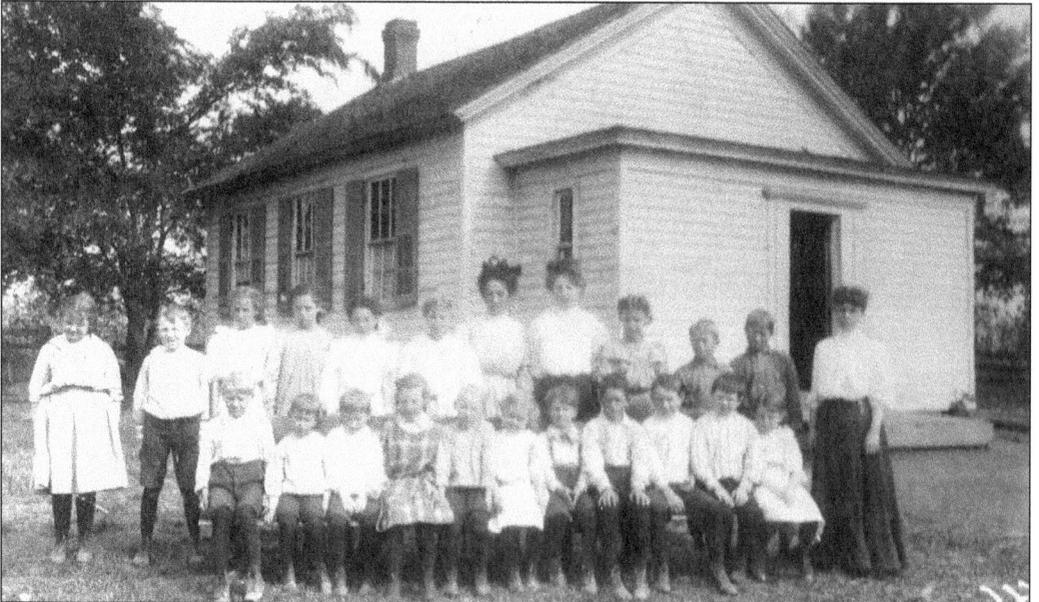

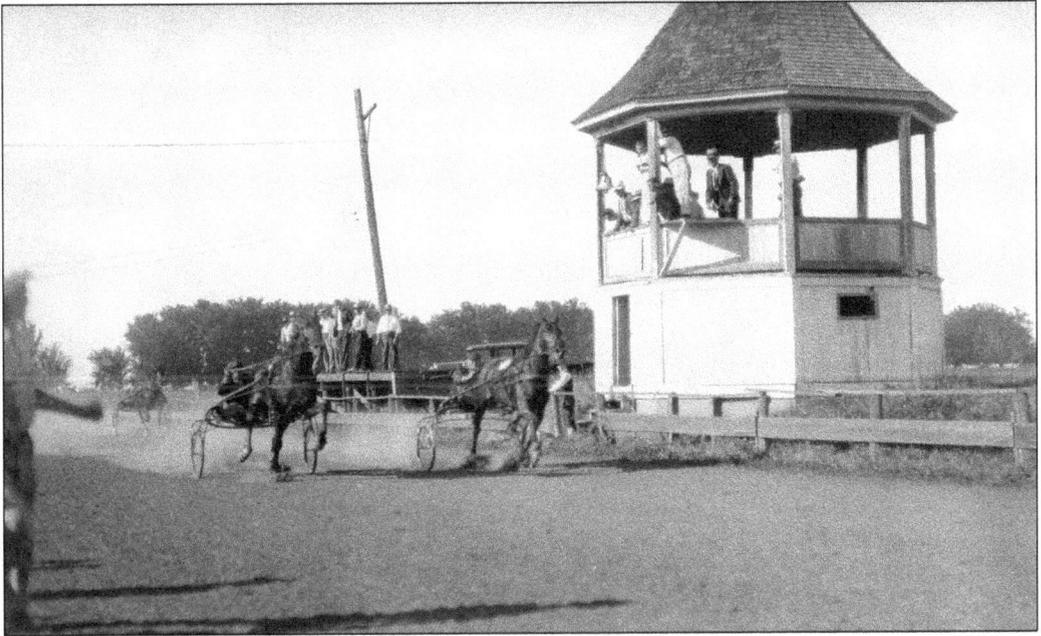

HARNESS RACING AROUND THE COUNTY. A very popular sport in the 1800s, races were often spontaneous without the formality of the fair grounds. When the above photograph was taken, in 1930, the sport was actually on the decline. Harness racing was replaced in popularity by the automobile; it came back into favor after 1940. The Standard-bred horse, which was used for this type of racing, came into being by combining the blood of the Morgan and the Narragansett thoroughbred breeds. The cart that the horse pulls is called a Sulky; it weighed about 40 pounds before modern improvements helped to lighten it, with smaller wheels and wind resistant modifications. The photograph below is from October 14, 1910, and was taken in Earlville. (Above, courtesy Mendota Museum and Historical Society from Leo and Norma Muhlach Collection; below, courtesy Earlville Community Historical Society.)

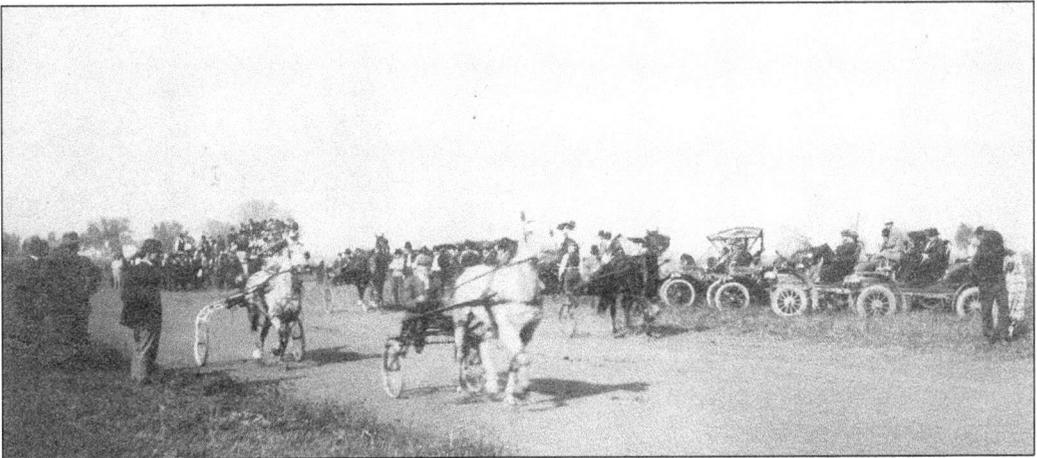

FOURTH OF JULY CELEBRATIONS. Just north of Marseilles on the Lev Butterfield farm this group gathered to celebrate Independence Day. The Butterfield ancestors first came to the county in 1835 settling in Rutland Township. Below, in Earlville, the celebration takes to the streets of the town. Notice the precarious perch that two men have taken to see the celebration, atop the telephone pole, while others are watching the going's on far down on the street. Notice the water tower in the rear left of the photograph; it was the last of its type in the state, called a column. (Above, courtesy Marseilles Public Library; below, courtesy Earlville Community Historical Society.)

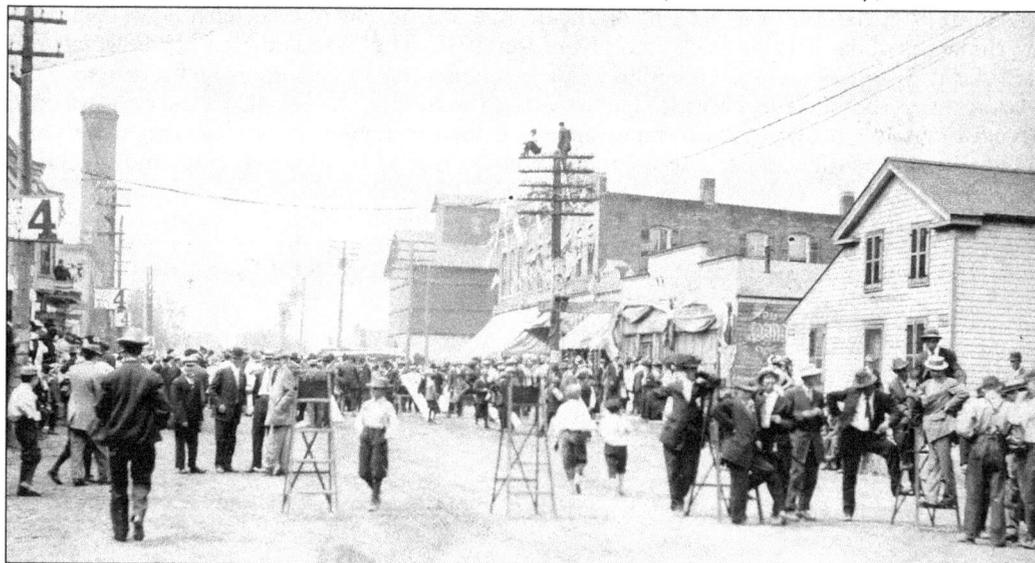

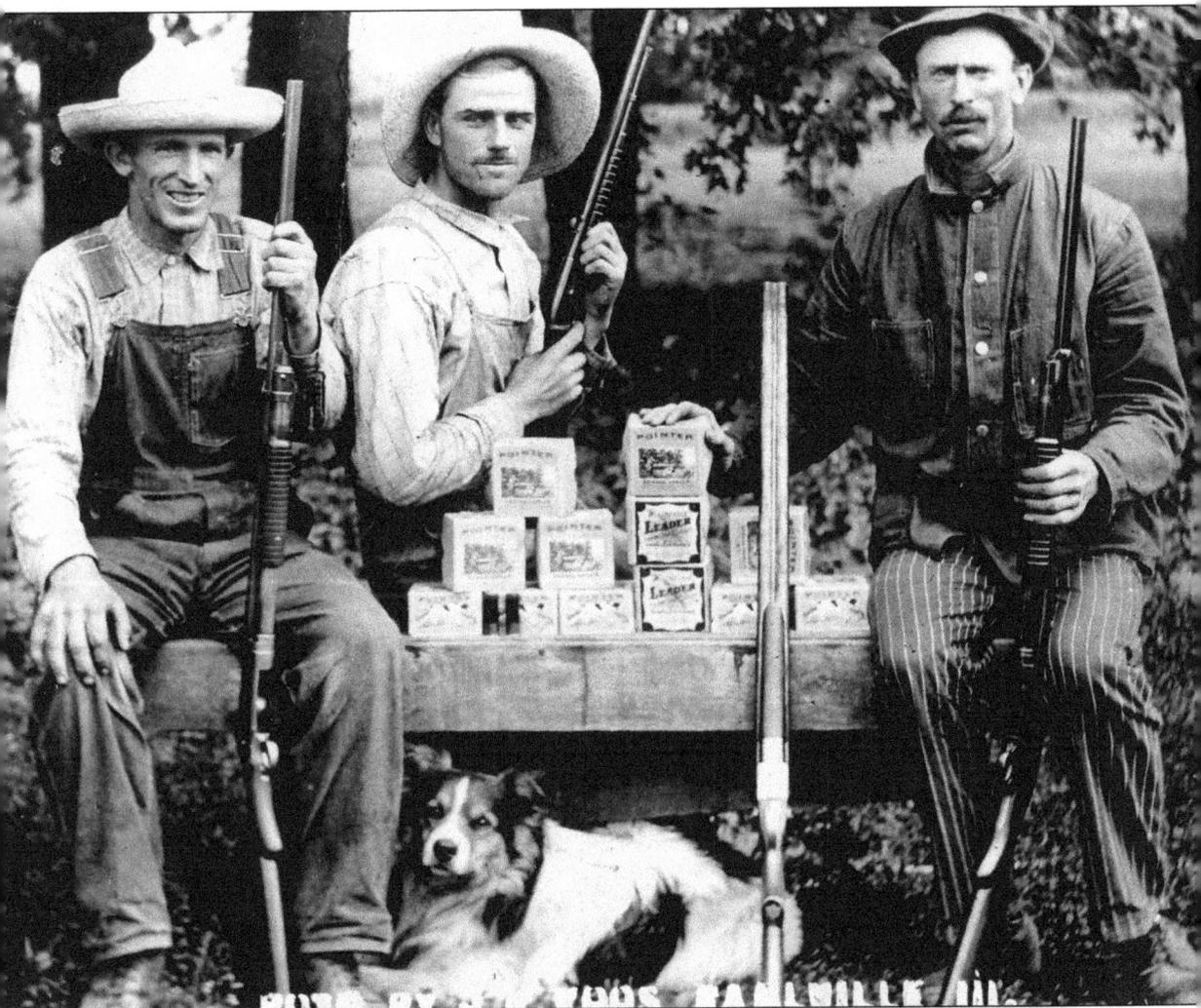

READY TO GO HUNTING, C. 1912. These three hunters are holding Winchester's model 1912 shotgun, which was one of the company's most popular models made at the time. The Winchester Company was founded in 1866 and the name is still known today. The shotgun was made chiefly for hunting birds or other small animals, but during World War I this model was also advertised with others as helping on the home front. The advertisements told of Winchester's involvement in the war effort through engine parts that they made for warplanes. The boxes, shown on the bench, are Pointer and Leader shot gun shells also made by the Winchester Company. This photograph, taken in Earlville, is thought to have been made for an advertisement, maybe for the Winchester Company or possibly for a local business. (Courtesy Mendota Museum and Historical Society from Leo and Norma Muhlach Collection.)

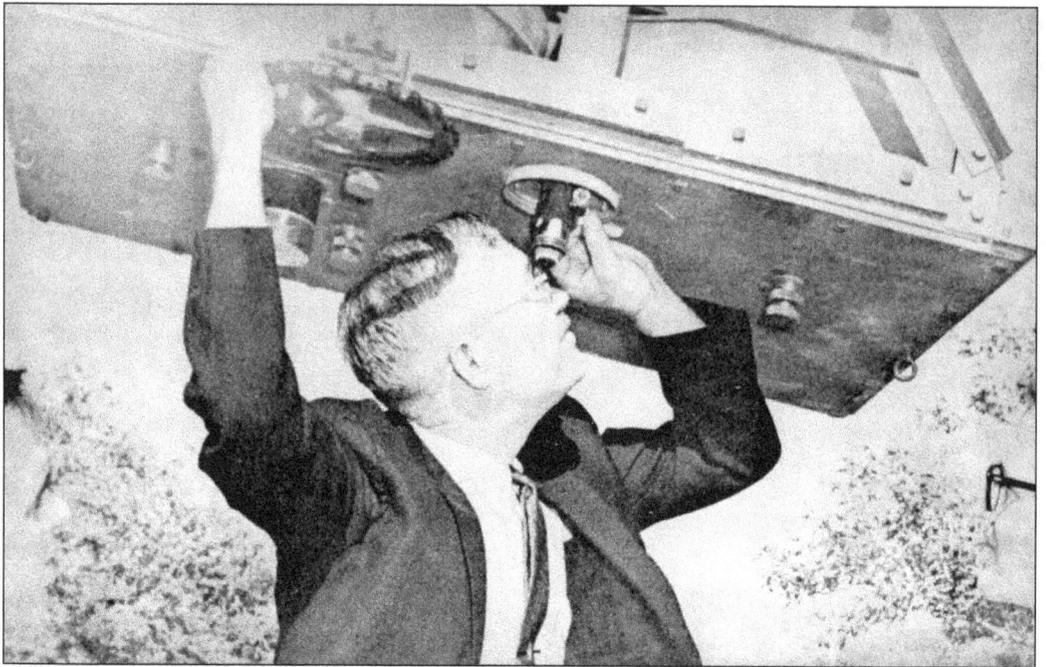

THE DISCOVERER OF PLUTO WAS BORN IN STREATOR, ILLINOIS. The eldest of six children, Clyde W. Tombaugh, was born to Muron and Adella Tombaugh on February 4, 1906, on a farm in LaSalle County near Streator. His early interests in geography soon lead him to a wonder about the geography of other planets. His parents encouraged his interests and he credits an Illinois teacher, Sue Szabo, with encouraging him to study science. At 20 years of age, Tombaugh built a telescope. The photograph below shows Clyde Tombaugh sitting second from the left; he is about eight years old in this 1914 photograph. (Courtesy Streatorland Historical Society.)

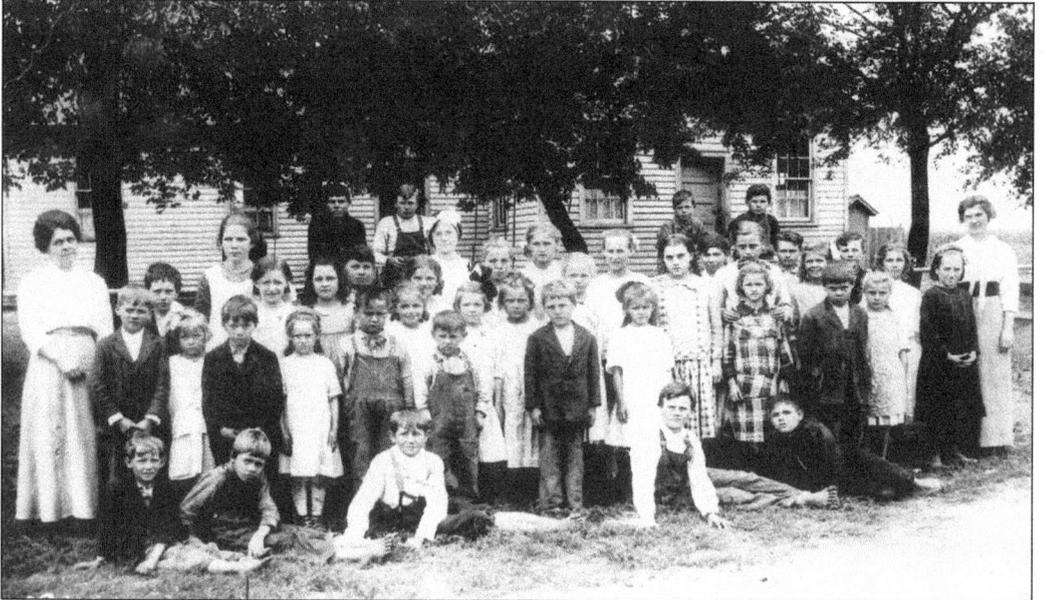

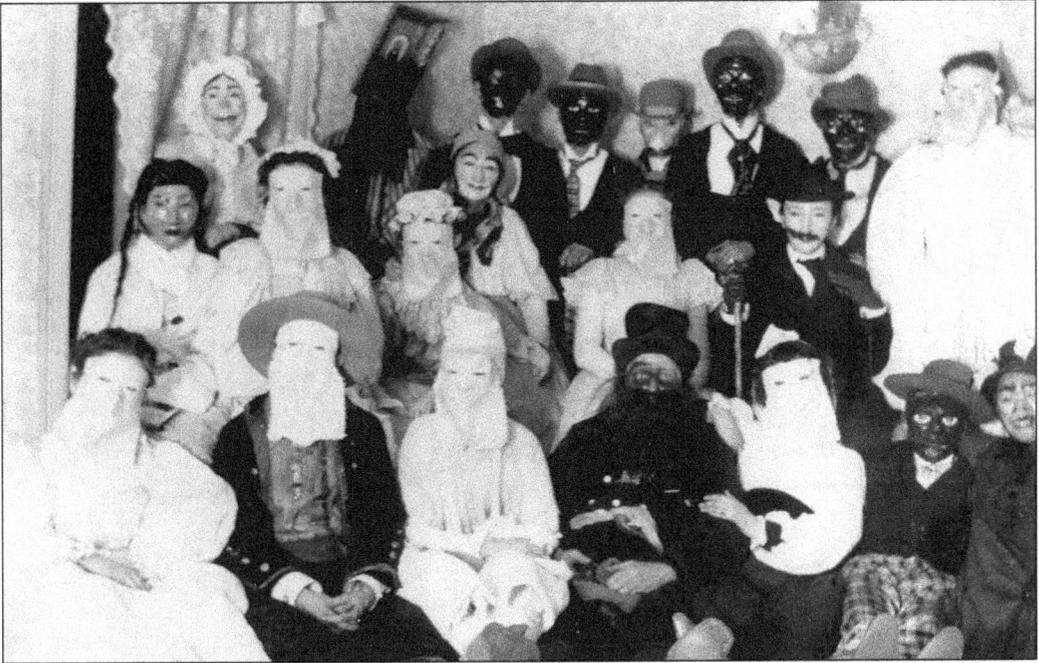

A COSTUME PARTY. In January 1909, a local newspaper told of a character party. It described "fifty or more friends and neighbors were guests . . . those participating in the affair were uniquely and some grotesquely costumed to represent different characters and vocations." The party also featured the reading of poems, music and songs, and duets on violin and piano; refreshments were served at midnight. (Courtesy Helen Crawford.)

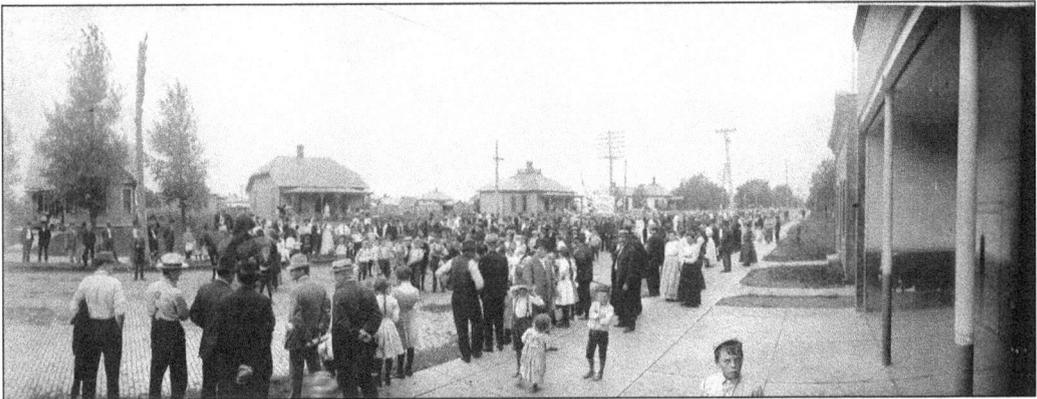

LABOR DAY CELEBRATIONS, SEPTEMBER 1915. On this brick-paved street in the town of Oglesby, the people take to the street to see the parade and celebrate. It was 1894 when Labor Day was made a legal holiday by the United States, and an act of Congress. (Courtesy Oglesby Historical Society.)

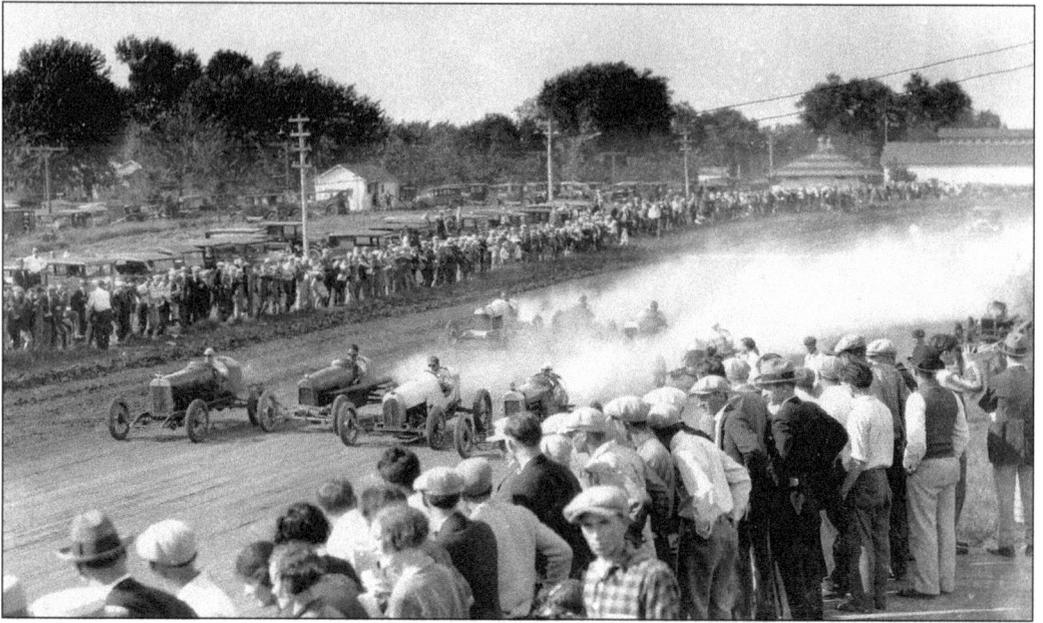

THE EARLY DAYS OF CAR RACING. Car racing in the 1920s on this dirt track drew a large crowd here in Mendota. Notice the lack of safety measures; a car crash here would have gone into the gathered crowds. (Courtesy Mendota Museum and Historical Society from Leo and Norma Muhlach Collection.)

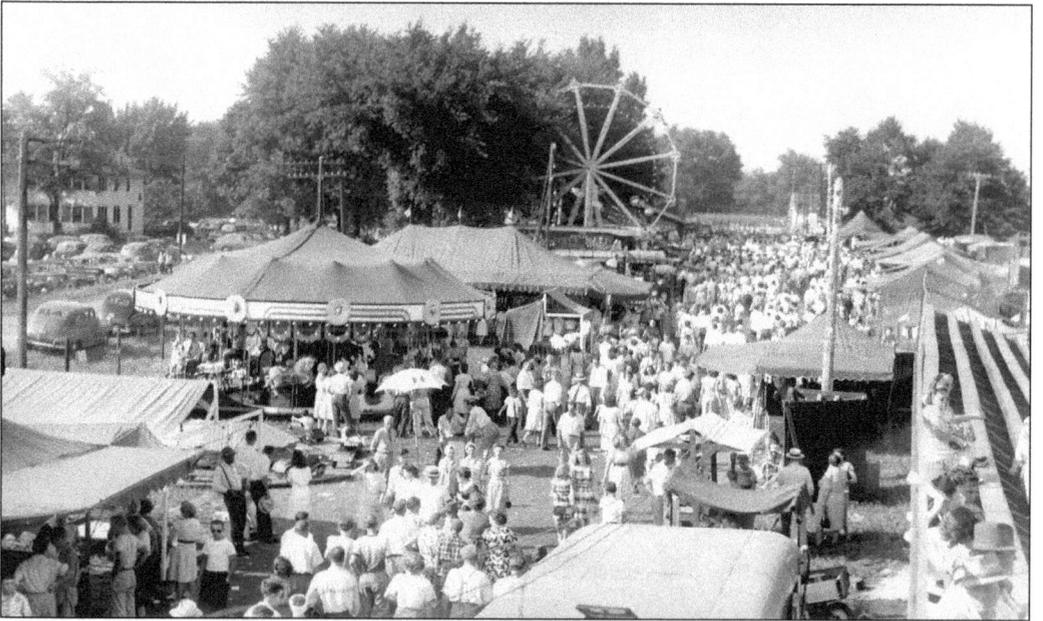

THE TRI-COUNTY FAIR MIDWAY, 1947. The cars on the far left of this photograph may well be the only way to tell the difference between this 1947 county fair, being held in LaSalle County, and a county fair of today. (Courtesy Mendota Museum and Historical Society from Leo and Norma Muhlach Collection.)

Five

FARMING AND INDUSTRY

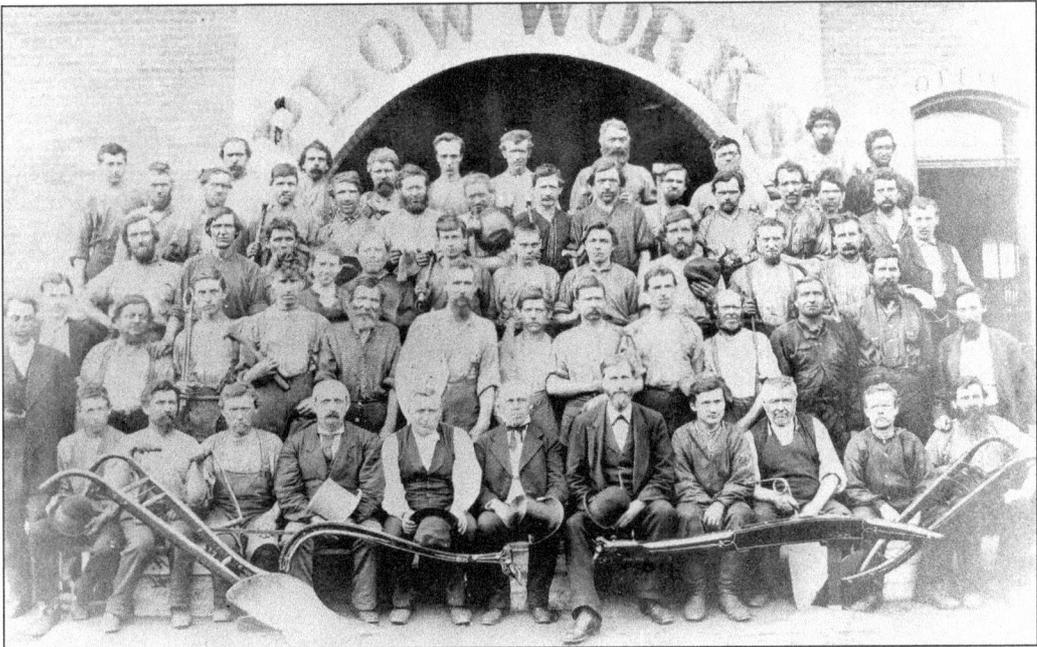

THE PERU CITY PLOW WORKS, LATE 1800S. In 1851, the Peru Plow and Wheel Works was established, and in 1882 they incorporated in Peru, Illinois. This photograph shows the company's workers and some of the company's products. Many of the men in this photograph are holding the tools of the trade, hammers and wrenches. Originally the company was built in an inconvenient location, away from the railroad tracks and the Illinois River. A new factory was built on Water Street. The LaSalle County Directory of 1915 told that the company manufactured gasoline engine trucks, Sulky and Gang plows, riding and walking cultivators, disc and drag Harrows, Harrow cars and tongue trucks, Rotary Harrow attachments, stalk cutters and potato diggers, farm trucks in many styles, and steel wheels for all purposes. The 1938 Sears catalog showed a Peru-made tractor called the New Economy Tractor. It listed for $495 and would be shipped from the factory near LaSalle, Illinois. (Courtesy Peru Public Library Local History Room.)

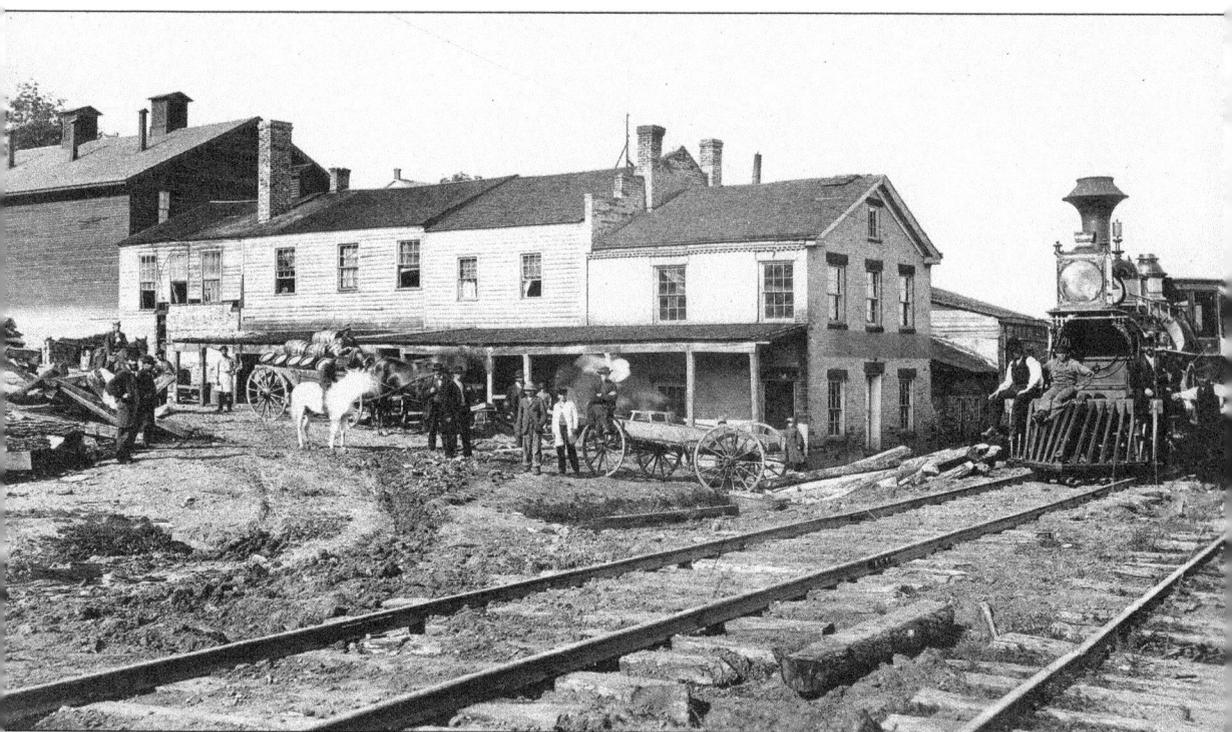

A Brewery on the Rock Island Line, early 1860s. This grouping of buildings is that of the Bhrend's Brewery in Peru owned by a Mr. Bhrend. The brewery changed hands and eventually became the Peru Beer Company in 1889. Citizens of Peru bought the business in 1868, and in 1872 Hebel and Brunner bought them out. After Brunner's death, his son took over his share of the business. It was not until 1889 and another buy out that the company was incorporated and became the Peru Beer Company. The locomotive is from the Chicago and Rock Island Pacific Railroad line. In April 1853, the Rock Island Line started its trek through Peru, but not without upheaval in the neighboring town of LaSalle. The course of the tracks was of concern to the citizens of LaSalle, but finally the railroad prevailed and the line went through. (Courtesy Peru Public Library Local History Room.)

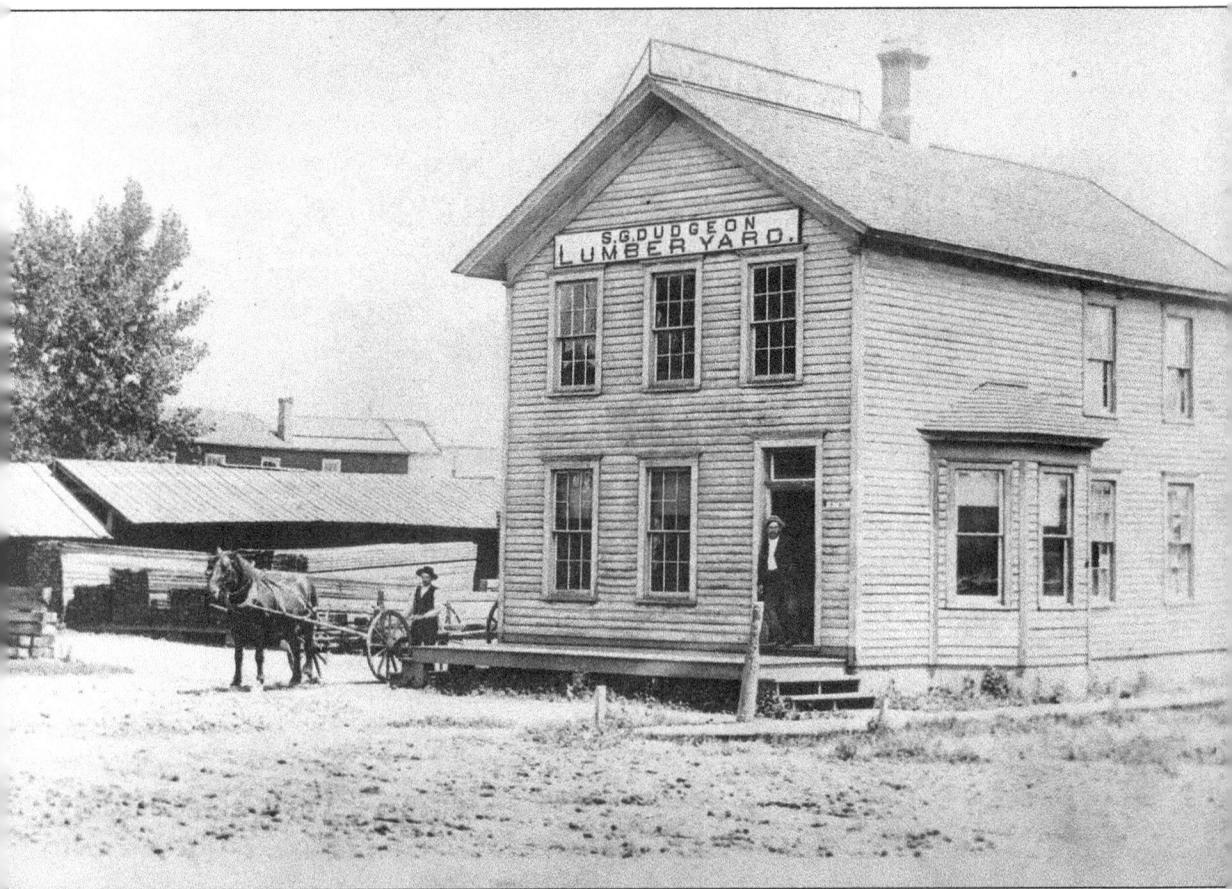

THE DUDGEON LUMBER YARD. This photograph was taken in about 1890; the lumberyard did business at 807 Sixth Street in Mendota. A lumberyard was a very lucrative business to have at the time, as everyone needed milled lumber. It was used for homes, out buildings, businesses, wagons, sidewalks, barrels, and many other items. In 1854, Samuel Dudgeon came to LaSalle County and was trained in the carpentry trade. He was said to have put up some of the best buildings built in the area. The Mendota directory of 1903 had this ad for the Mendota Lumber Company on Sixth Street. "Dealers in highest grade lumber. Sash, doors, moldings, posts, shingles, poles and lime. Goods high grade. Prices right. Call and get our prices. Contractors and builders estimates furnished." (Courtesy Mendota Museum and Historical Society from Leo and Norma Muhlach Collection.)

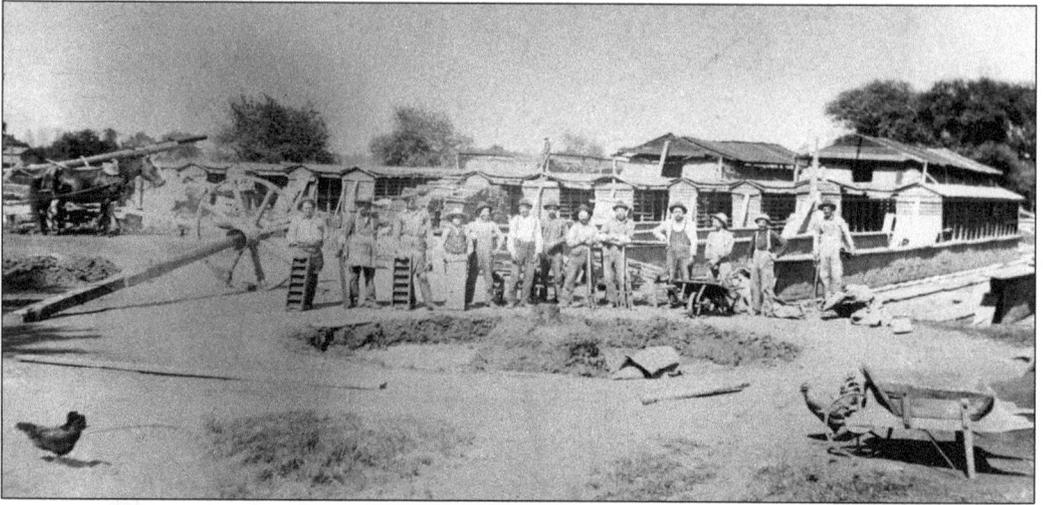

WHEELBARROW YARD. The men of the Goodwin Brickyard in Mendota posed for this photograph sometime between 1860 and 1870. The yard did business at Thirteenth Avenue and Fifteenth Street. The name Wheelbarrow Yard came from the fact that most of the time all the equipment needed for the job could be carried in a wheelbarrow. (Courtesy Mendota Museum and Historical Society from Leo and Norma Muhlach Collection.)

THE MILL STREET COOPER SHOP, C. 1898. Church and Mill written on this photo are the streets in front of the shop where barrels were made in Utica. Barrels were one of the most airtight containers of the time. Salted foods were kept in them as well as water, wine, breakable household goods, and foods that needed to be kept dry. (Courtesy LaSalle County Historical Society Museum.)

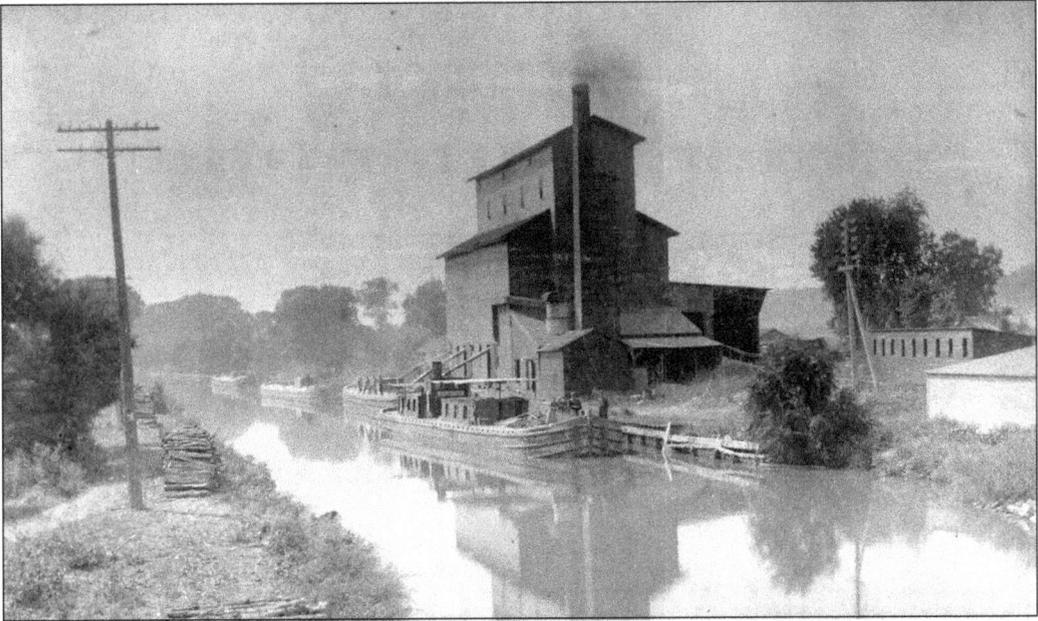

BARGES LOADING GRAIN, C. 1870. This photograph shows barges lined up at the M. T. Hogan grain elevator on the Illinois and Michigan Canal in Seneca. They are being loaded with grain probably for transport to Chicago. The stacked logs on the bank most likely supplied fuel for the steam-powered engines of these barges. The elevator is listed on the National Register of Historic Places. (Courtesy Seneca Public Library District.)

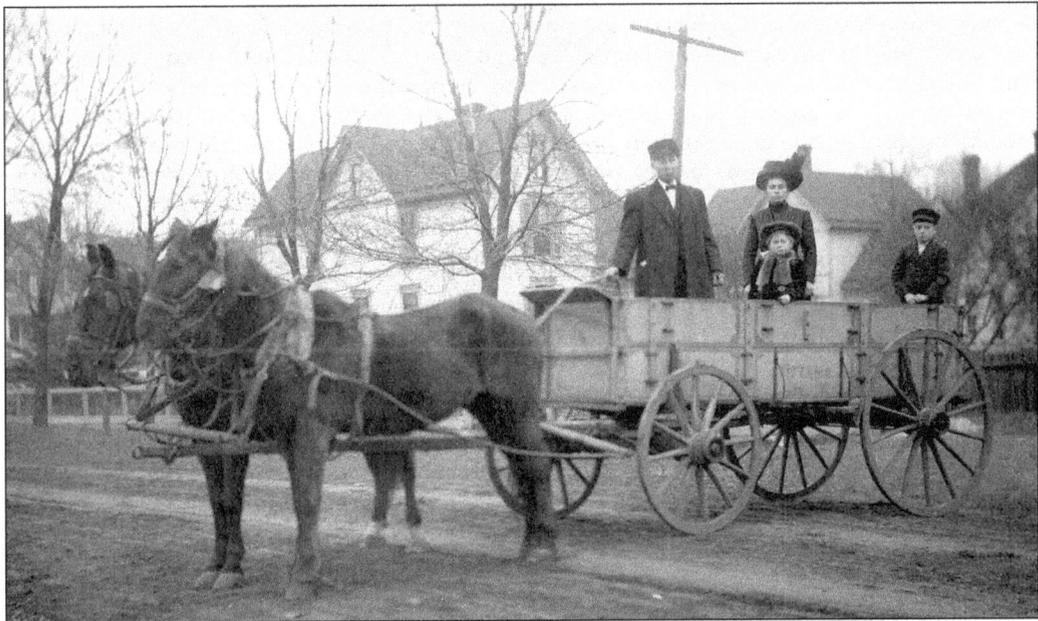

A NEW WAGON, C. 1890. This wagon has the name Ottawa printed on its side and could have been made by the King Hamilton Company. The Ottawa directory of 1888 lists King and Hamilton as wagon makers. In 1915 they were also selling cup elevators. This farm wagon's deep body was built to carry freight and a cover could be easily attached to the wagon's sides. (Courtesy M. Dorothy Clemens.)

CATALOGUE N⁰. 30

"OTTAWA" DUSTLESS CORN SHELLERS

KING & HAMILTON COMPANY

OTTAWA, ILLINOIS · COUNCIL BLUFFS, IOWA · SIOUX FALLS, SOUTH DAKOTA · DES MOINES, IOWA

LARGEST MANUFACTURING COMPANY IN OTTAWA. The *Ottawa Free Trader* newspaper of 1858 had this advertisement, "King, Gilman and Company would inform the farming community that they are manufacturing a very superior Corn Sheller . . . Having had it well tested the past season, by numerous farmers and warehouse men, we are prepared to speak advisedly of its merits, and can refer to all who have used it for the proof of what we say. We therefore challenge competition with any other machine in use. All we ask is a trial, being willing for the machine to stand upon its own merits. We are also manufacturing large . . . threshers of the most approved kind in use. All kinds of repairs done on short notice and reasonable terms." In 1866, combined efforts brought King and Hamilton's money together with William Gilman's expertise in inventing. This cover for the company's corn shellers pamphlet gave information to the company history and showed products. A piece of equipment like a corn sheller could cut farm work with their ability to shell approximately 300 bushels per hour. (Courtesy M. Dorothy Clemens.)

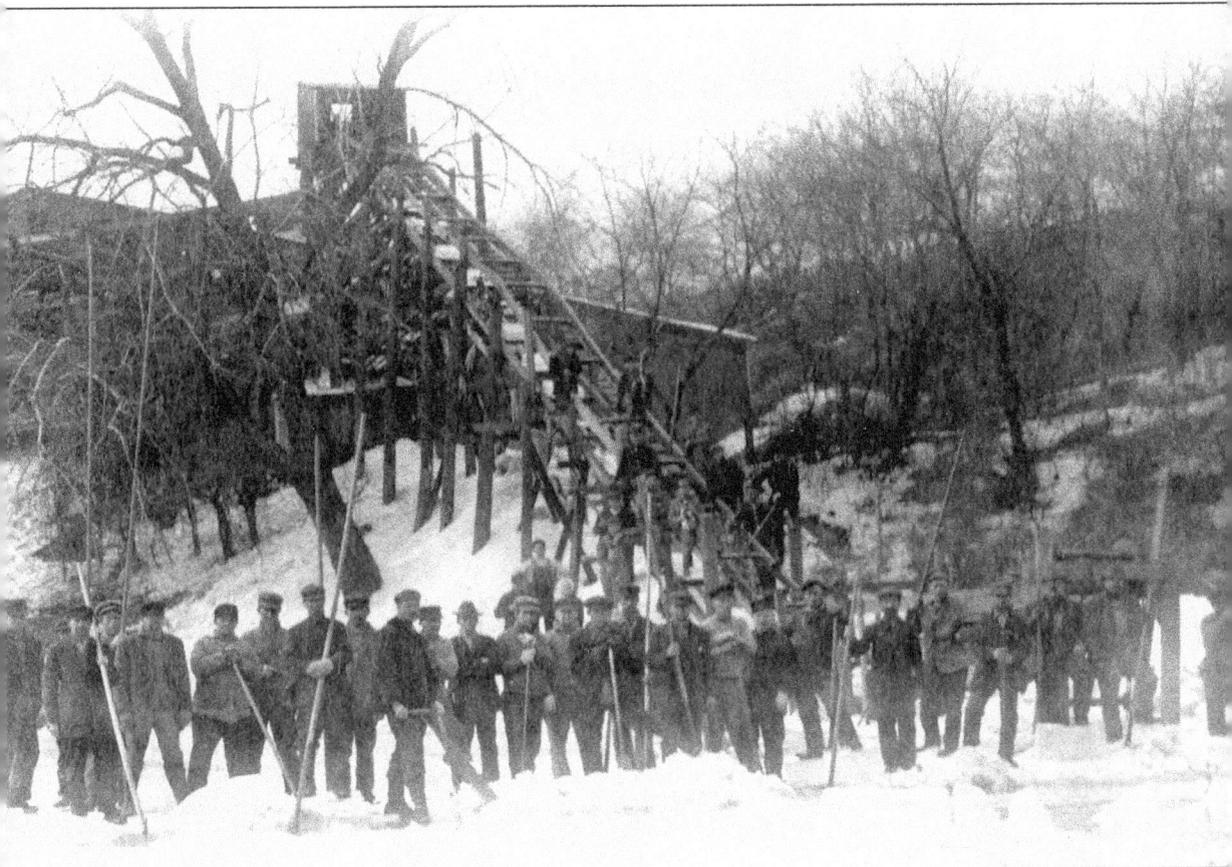

CLEARING THE ICE. These men are not gathered on Spring Lake to skate, they are clearing it for ice cutting. A very important occupation, before the home refrigerator had a freezer, ice cutting for preservation of food was done each year. First the ice would be cleared of snow, six inches or more of ice thickness was desirable. The ice would then be marked for cutting into blocks. Teams of men like the ones pictured above, 20 to 100 men, would be needed for up to four weeks. Once the blocks were cut they were floated to the icehouse where they then traveled up a chute and were stored with layers of sawdust packed around them for insulation. The ice was used commercially in breweries and dairies and for transporting food by train. For the family who did not own an icehouse, they could use their barn, cellar, or well for ice storage; as long as the ice was well packed with sawdust it would last a long time. (Courtesy Streatorland Historical Society.)

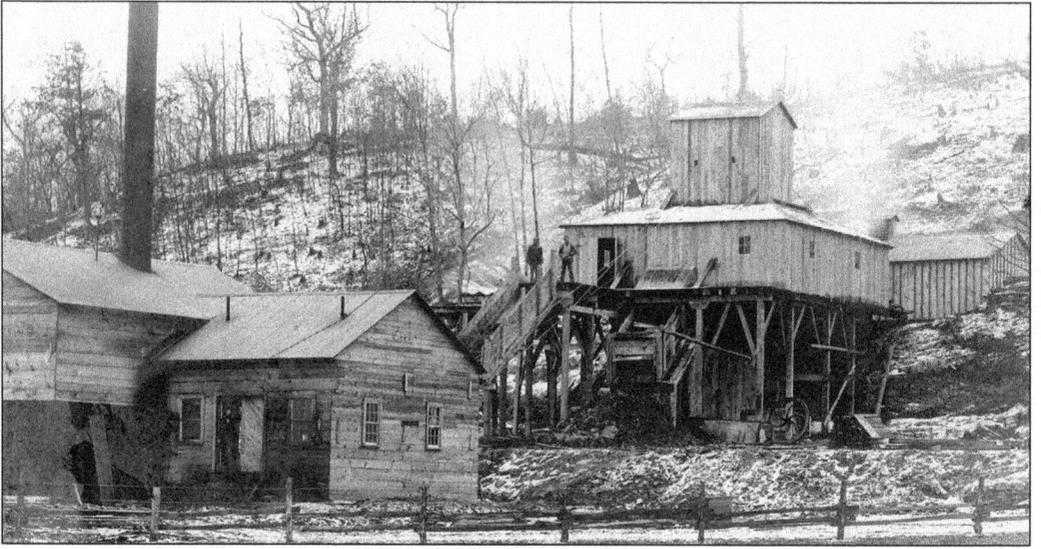

AREA COAL MINING. In 1673, the explorers Marquette and Joliet reported seeing veins of coal in Illinois. The Manufacturers Coal Mine, above, started operating 1896, one mile from Marseilles. Under Streator are many coal mining tunnels, and, in 1909, the Cherry mine disaster, just north of the town of LaSalle, saw the death of over 250 men. For Oglesby, below, it all started with the Kenosha Coal Company. In 1865, one of the investors, T. T. Bent, was appointed to raise money and manage the mine; it became the Bent Mine. By the 1890s, the mine was called the Oglesby Coal Company. Bent concentrated on making a profit, as his many endeavors showed he did. One advertisement for hogs he bred stated, "breeding four types for their profit making ability." (Above, courtesy Marseilles Public Library; below, courtesy Oglesby Historical Society.)

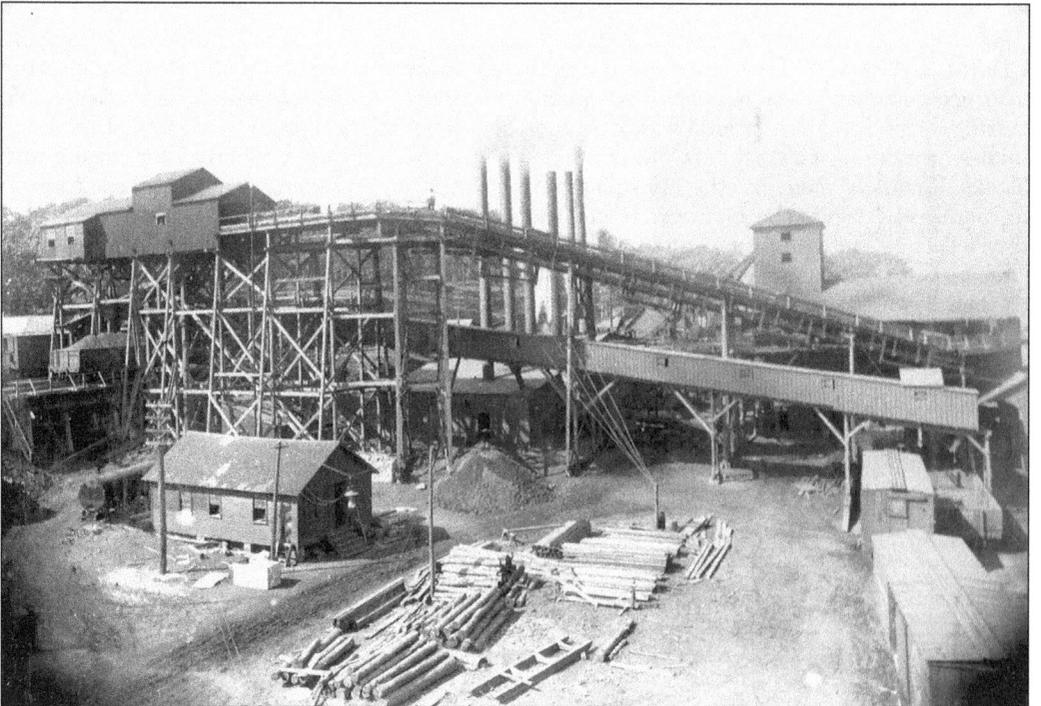

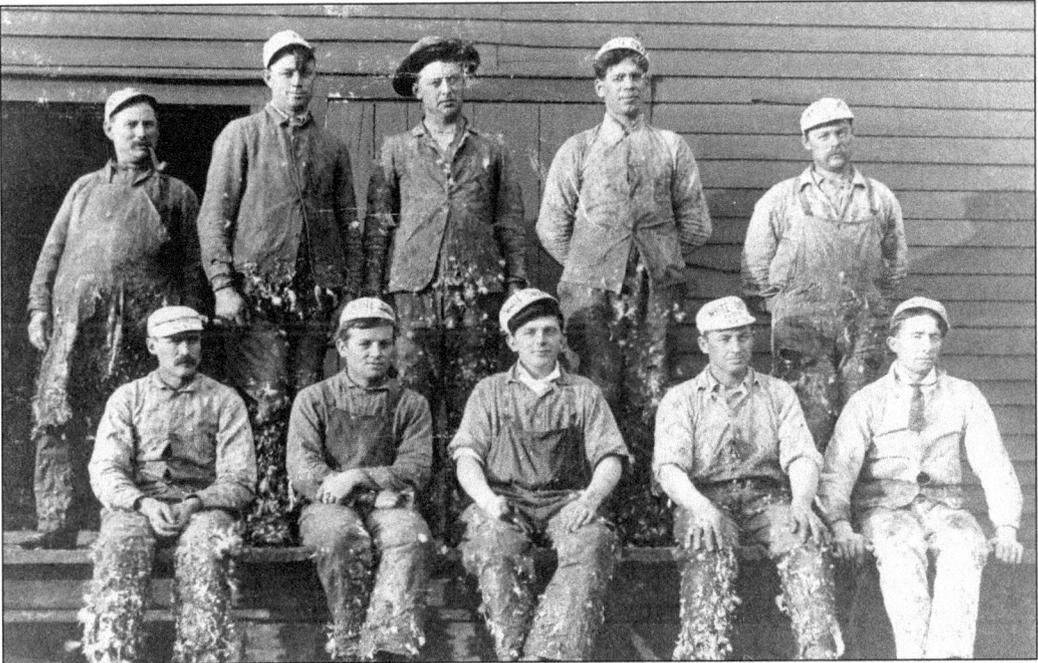

COVERED IN FEATHERS. The photograph of these men had Frey Chicken pickers written on it, taken in the early 1900s. The white hats worn by most of the men have White Company Flour printed on them. White Swan Flour was advertised in the Ottawa Free Trader in 1907 for $1.50 per sack, coming from the Springfield Milling Company of Minnesota. The George W. Frey Poultry Company was listed in the Mendota directory of 1903, as a wholesale poultry company with packinghouses in Mendota and Earlville. The photograph below shows G. W. Frey driving his produce wagon in the streets of Earlville. There are chickens at the very top of the wagon and stacked neatly underneath them are many rows of eggs. (Above, courtesy Mendota Museum and Historical Society from Leo and Norma Muhlach Collection; below, courtesy Earlville Community Historical Society.)

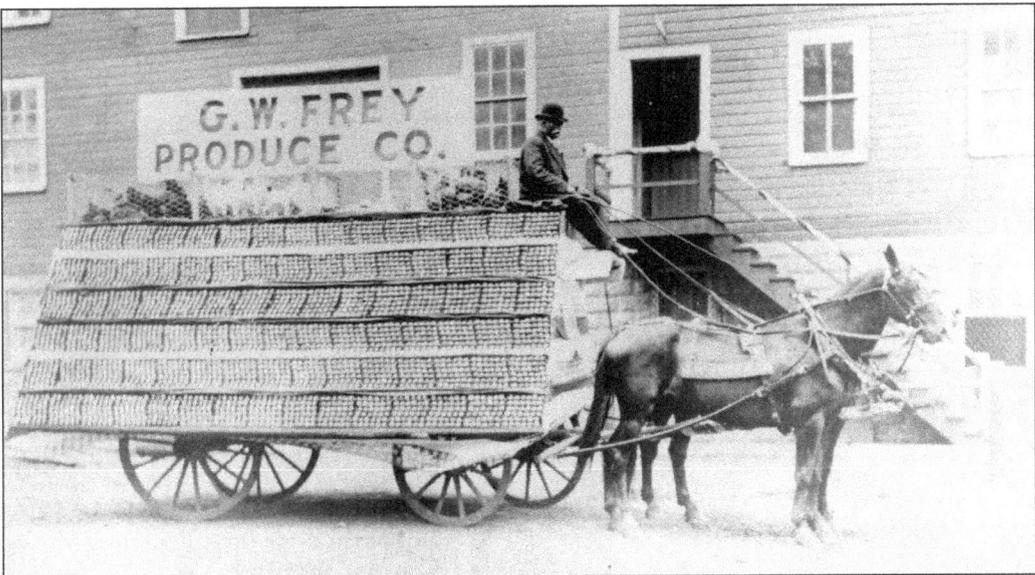

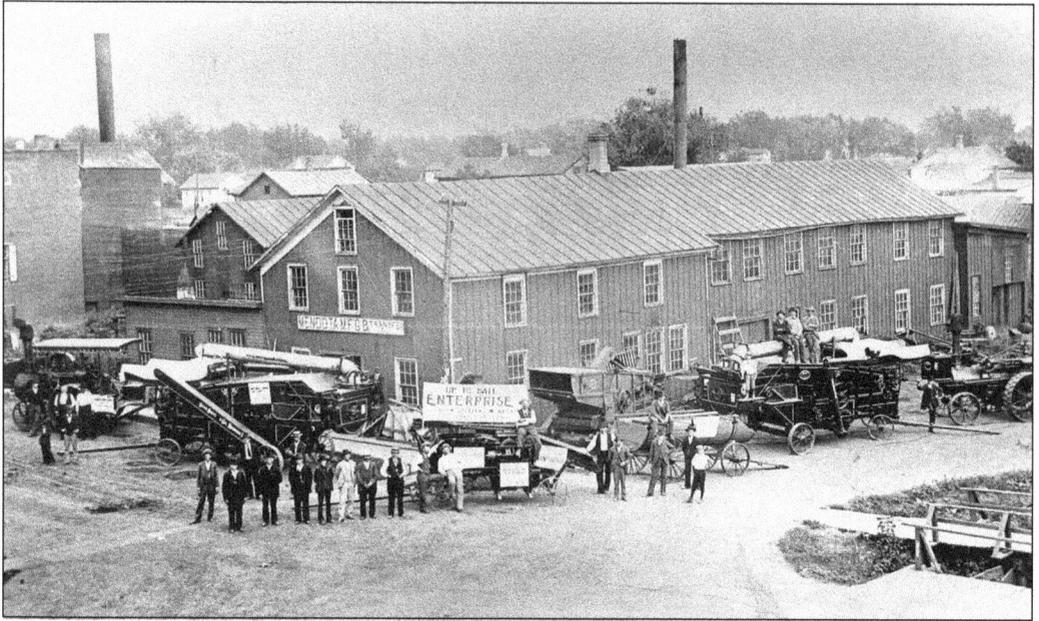

THE MENDOTA MANUFACTURING AND TRANSFER COMPANY. Proud of the large machinery this company made, everyone turned out for the photographer in early 1900. This business was located at 713 Sixth Street in the heart of Mendota. Steam tractors and threshing machines are among the machinery that were made and pictured here. (Courtesy Mendota Museum and Historical Society from Leo and Norma Muhlach Collection.)

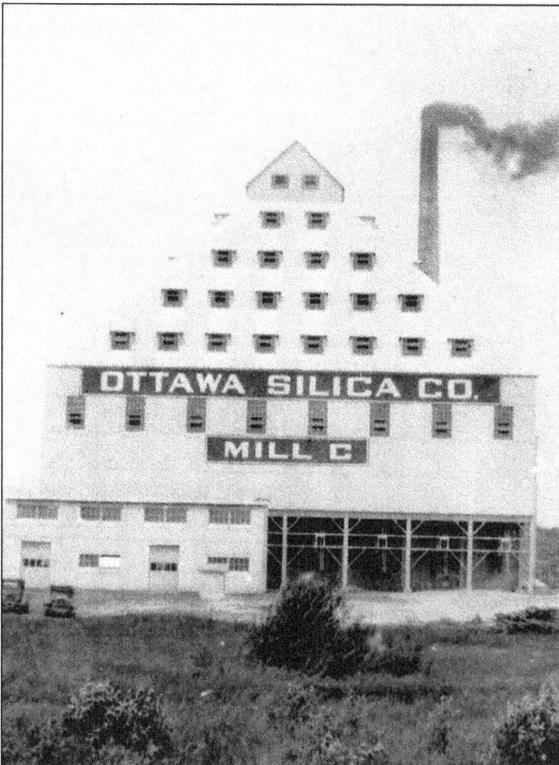

THE OTTAWA SILICA COMPANY, c. 1900. On the west side of Ottawa, since the early 1900s, is the Ottawa Silica Company. Silica is mined locally and used in the manufacture of glass and glass products, as well as being used as an abrasive with many other uses. There were at least seven other silica companies operating in the Ottawa area at the same time. (Courtesy M. Dorothy Clemens.)

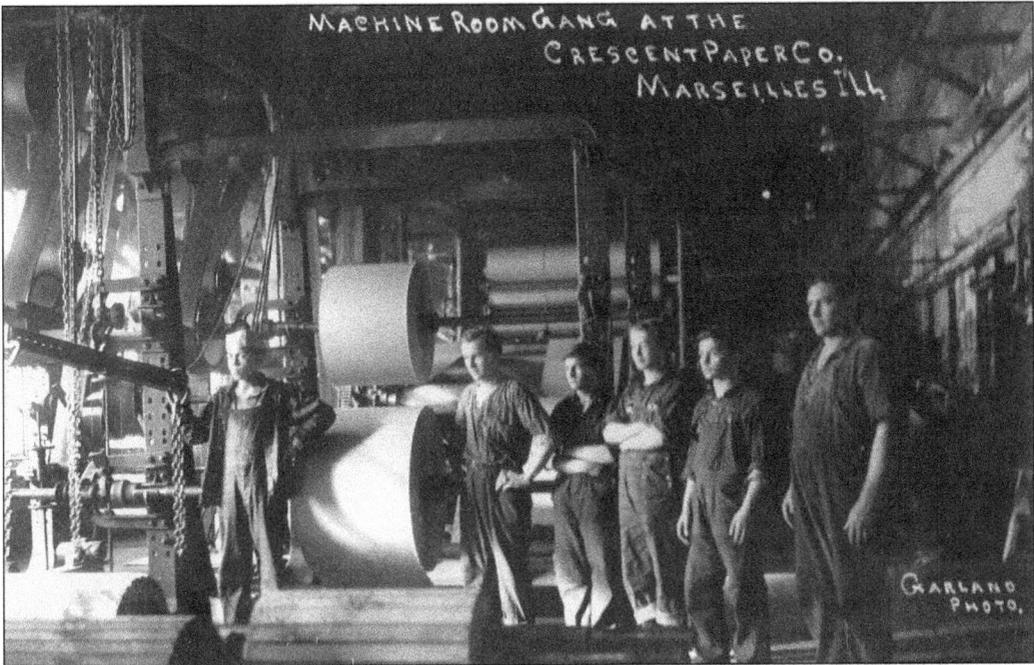

THE PAPER INDUSTRY, C. 1900. The top photograph shows the machine room gang. Only two names are known, second from left is Andy Sobinsky Sr., and the last man on the right is Milo Richardson. This is the Crescent Paper Company, which was started in 1898 in Marseilles, along the Illinois River. The company had two warehouses for storing paper and was known as one of the best manufacturers in the city. Below, the paper company is viewed from the Illinois River. The building to the left in the background is the office of the Marseilles Manufacturing Company, which was incorporated in 1870, making power corn shellers, later making windmills and eventually power windmills. In 1908, the John Deere Company purchased Marseilles Manufacturing during a slow economic period for the county moving production out of the area. (Courtesy Marseilles Public Library.)

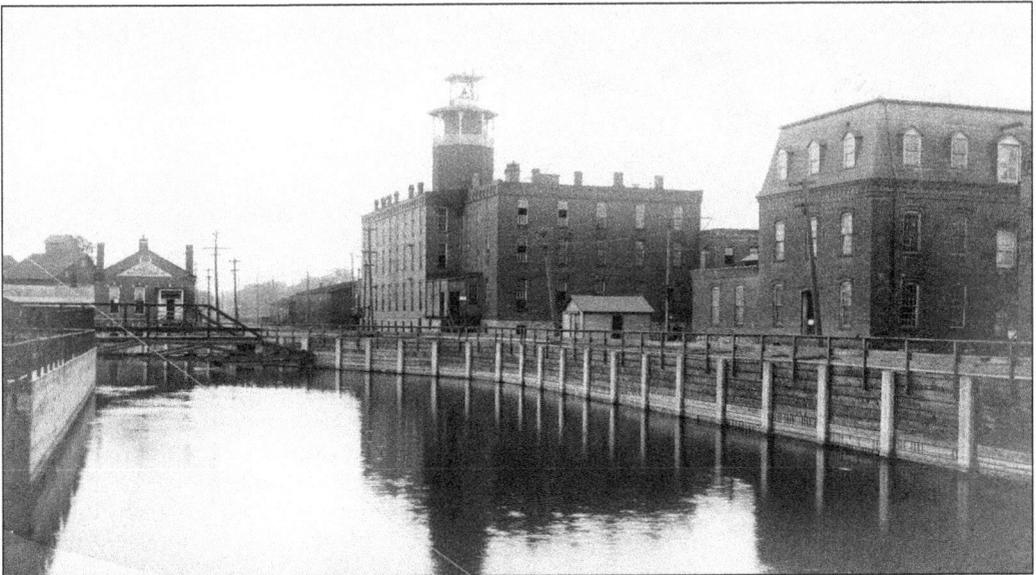

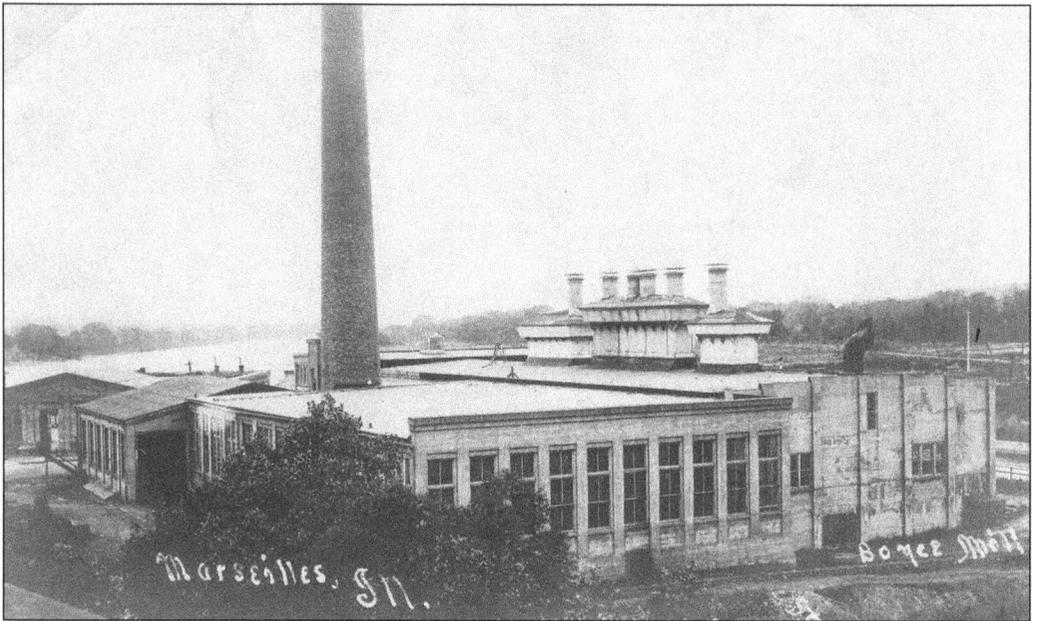

BOYCE MILL. William Dickson Boyce was a reporter, publisher, businessman, world traveler, and lover of the outdoors. He is credited with starting the Boy Scouts in America. The Boyce Mill in Marseilles, a paper manufacturing mill, was started while Boyce was publishing four newspapers, in Chicago, that had a circulation of a half million copies per week at the end of the 1800s. (Courtesy Marseilles Public Library.)

WILSON LOWMAN ON HIS FARM, C. 1900. This county native sits on his corn planter. The Sears catalog sold this item, in 1902, for just over $40 and stated it "will outwear any other two-horse corn planter made." Notice Lowman's proud stance; he's holding a pipe between his teeth and wears a serviceable farm hat. (Courtesy Wilson Everett Shaver.)

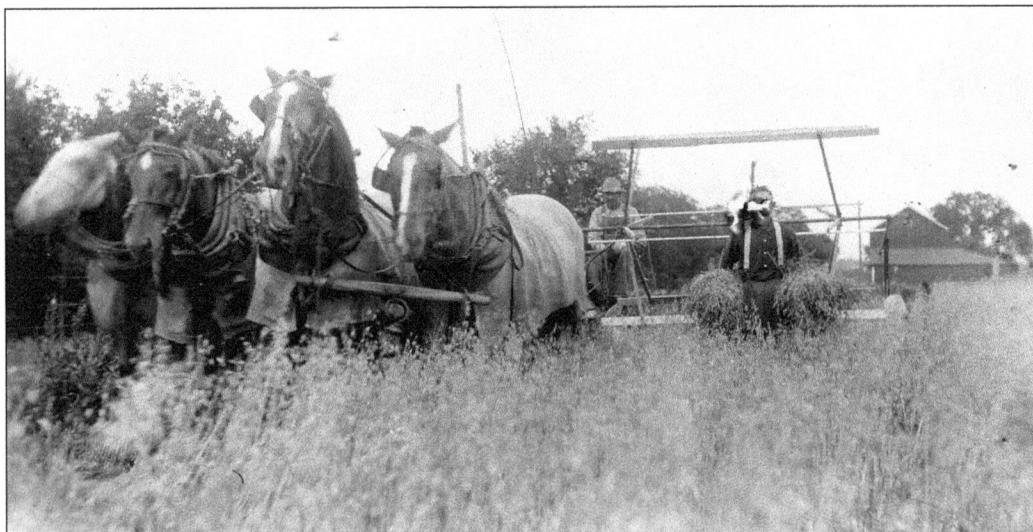

A FARMERS PARADISE. The fertile lands of LaSalle County brought thousands of people west. The land found here could support almost any kind of crop a farmer cared to grow. The 1920s photograph above shows a crop being cut with a reaper. (Courtesy Peru Public Library Local History Room.)

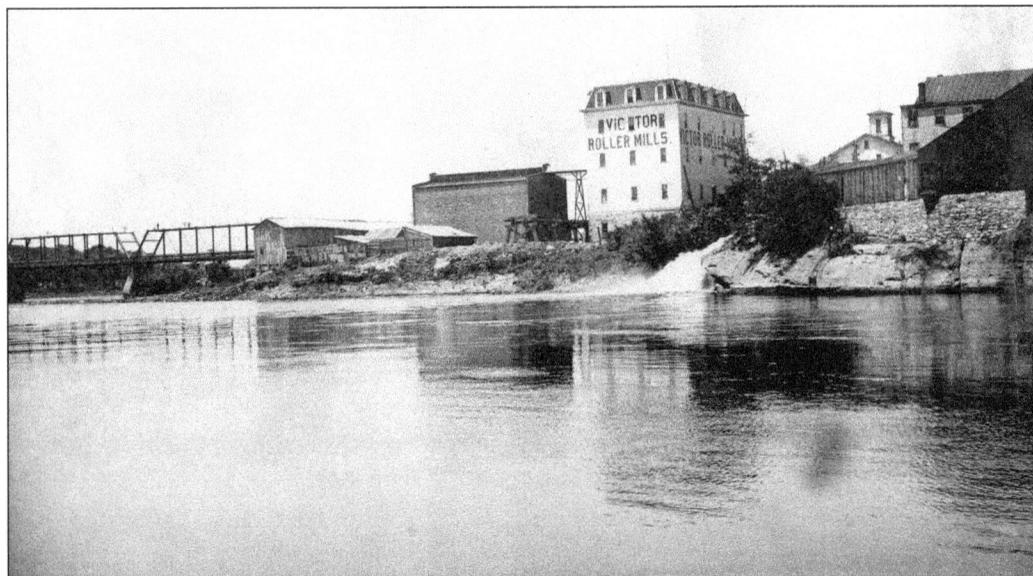

THE WINDING FOX RIVER. This photograph was taken before 1915, when the area was flooded. Victor Roller Mills, the white building, was a grain processing business that opened in February 1882. The company took out an advertisement in the *Ottawa Free Trader* on February 25, 1882, and advertised their company as having the "True Hungarian process, the whitest flour, the strongest flour, the best flour." (Courtesy M. Dorothy Clemens.)

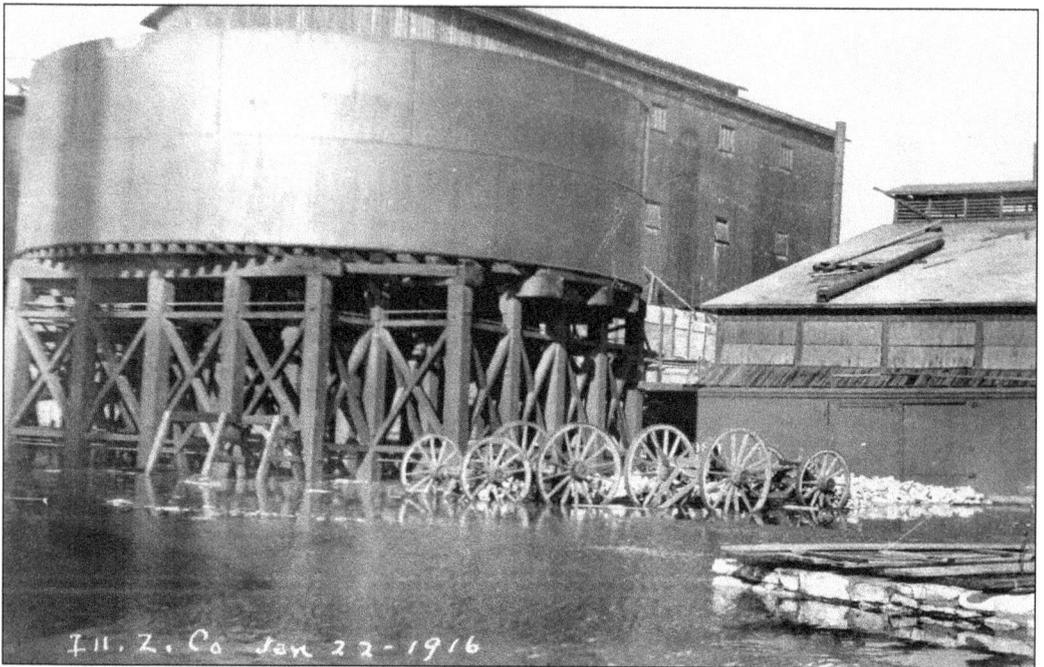

ILLINOIS ZINC COMPANY, 1916. The company was in Peru on Brunner Street, with the Illinois and Michigan Canal and the Illinois River running along the south side of the company. In operation for approximately 70 years, this business ceased operations in the 1940s. The LaSalle County Directory of 1915 listed the company as manufacturers of Spelter sheet zinc, strip zinc, and sulfuric acid. (Courtesy Peru Public Library Local History Room.)

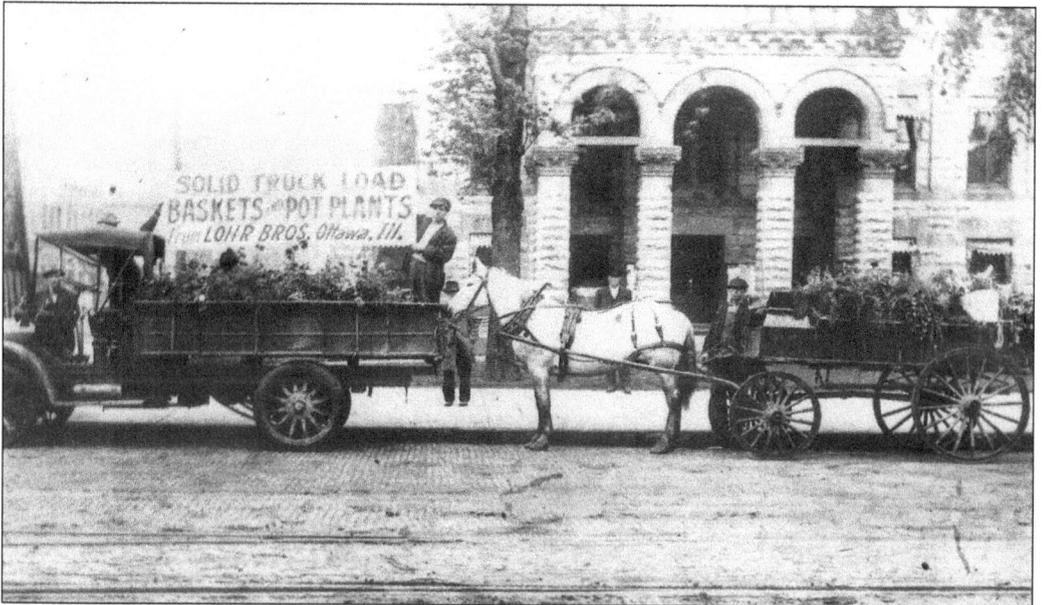

LOHR BROTHERS WITH THEIR BEAUTIFUL BASKETS AND POTTED PLANTS, C. 1920. This photograph of the Lohr Brothers delivery truck and wagon was taken on Main Street in Ottawa in front of the Court House. The Ottawa directory of 1922–1923 lists William Lohr as a florist living on Ottawa Avenue in Ottawa. (Courtesy M. Dorothy Clemens.)

PUBLIC SALE OF FARM LANDS. It was September 10, 1919, when the J. R. Shaver farm was auctioned off to the highest bidder in Rutland Township. Some farms were sold to settle estates, others because of the depression. The makeshift table in the photograph holds household items. Behind the table are cages and harnesses to the left. Another sale just six miles north of Ottawa had these items for public sale: eight horses, farm implements and machinery, Deering harvester, McCormick mower, Easy-Way hay loader, Rock Island side delivery rake, 23 head of bred ewes, one buck, two milch cows, and 10 head of young pigs—averaging 100 pounds each. Household furniture for sale included stoves, beds, tables, and chairs. All sums of $10 and under were to be paid in cash. For all sums over $10, a credit of nine months would be given on notes with approved security, without interest, if paid when due. There was a discount for cash on sums over $10. No property was to be removed until it was settled for. Lunch was served. (Courtesy Wilson Everett Shaver.)

FOOT-AND-MOUTH DISEASE POSTER, 1920S. This poster warns the farmer, and any one else with farm animals, of "an outbreak of foot and mouth disease. The most contagious animal disease known has occurred in this county. Prompt action now will stamp this out, if neglected the pestilence will spread all over the country." It goes on to tell the farmer how to help and how to report cases. The farmers are asked to report all cases at once. Foot-and-mouth, also known as hoof-and-mouth disease, is a very contagious disease and could effect many other hoofed animals, with the exception of horses. It was characterized by sores in the mouth, on the utters, and around the hoofs. The last outbreak of this disease in the United States was in 1929. (Courtesy Peru Public Library Local History Room.)

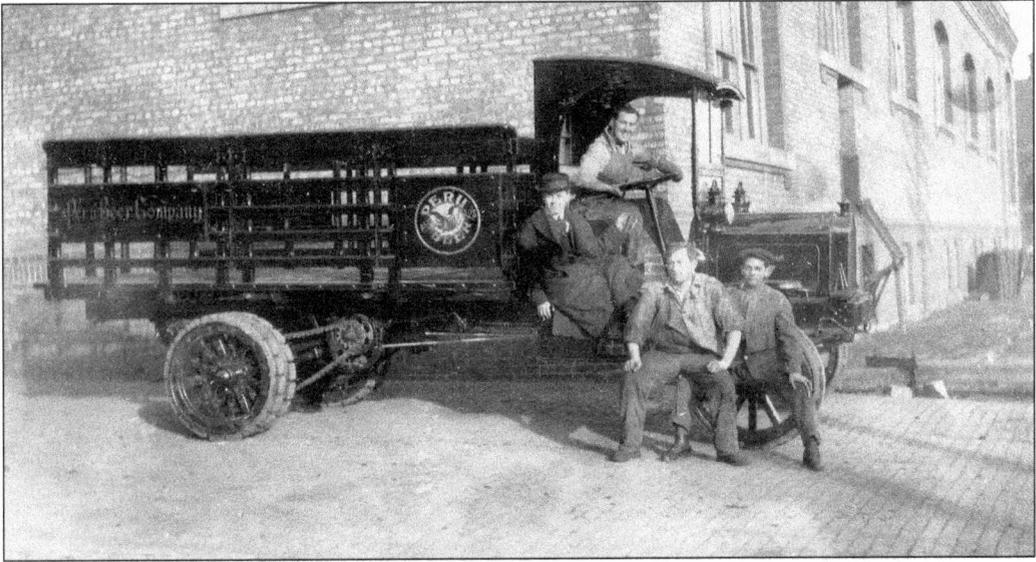

THE COBBLESTONE STREETS OF PERU, C. 1920. The Peru Beer Company, doing business on 1001 Center Street in Peru was established in 1868 and incorporated in 1889. The LaSalle Peru twin cities directory of 1921–1922 listed this advertisement, "Try our Special Brew, in bottles for family use." Andrew Hebel (below, with wife Rose) was the president and general manager. Peru Beer Company was a brewer and bottler of "Genuine Lager Muenchener Beer, malt extract, 'favorite stock' bottled beer for family use, the most popular beer in the twin cities." The competition offered this, "Henning Brewing Company, True merit will win! That is why Henning's beer has now such a large patronage. Don't drink poor beer, when you can obtain the best for the same money. The beer that cheers, pure, clean, wholesome. Has no equal." (Courtesy Peru Public Library Local History Room.)

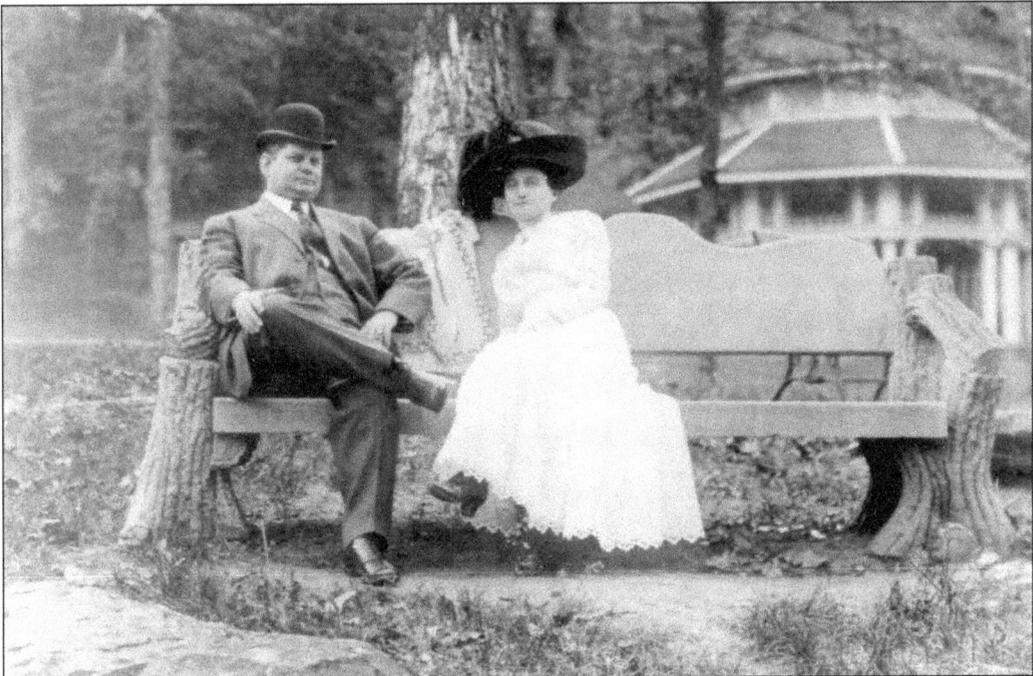

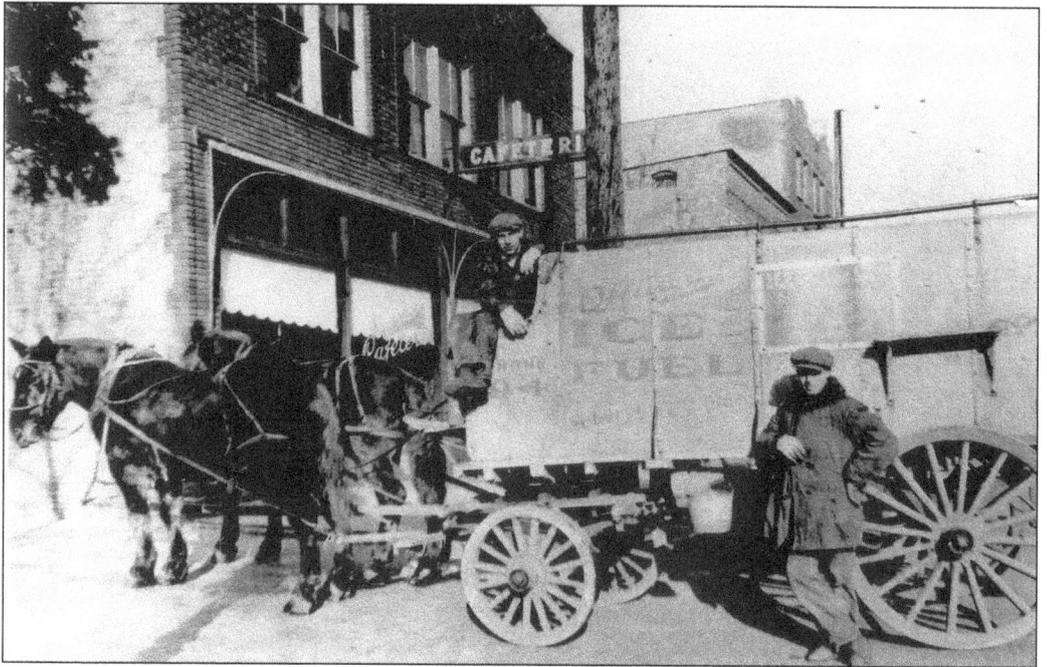

HOT AND COLD DELIVERIES. No matter the time of year, Ottawa Ice and Fuel Company delivered what you needed. Before freezers were common, ice was harvested from a lake and saved in an icehouse for the summer. The Ottawa City Directory of 1922–1923 listed the company as having natural and artificial ice at wholesale and retail prices. The business had offices at Superior Street and a factory at 1000 West Main Street in Ottawa. This photograph was taken in Ottawa on January 17, 1927, in front of the Englefield Cafeteria on LaSalle Street. Adoras Wilcox is seated on the wagon and Lloyd Lawrence stands at the wagon's side. The lower photograph was taken after 1895 and is of the J. J. Becker Ice Company operating in Marseilles. (Above, courtesy M. Dorothy Clemens; below, courtesy Marseille Public Library.)

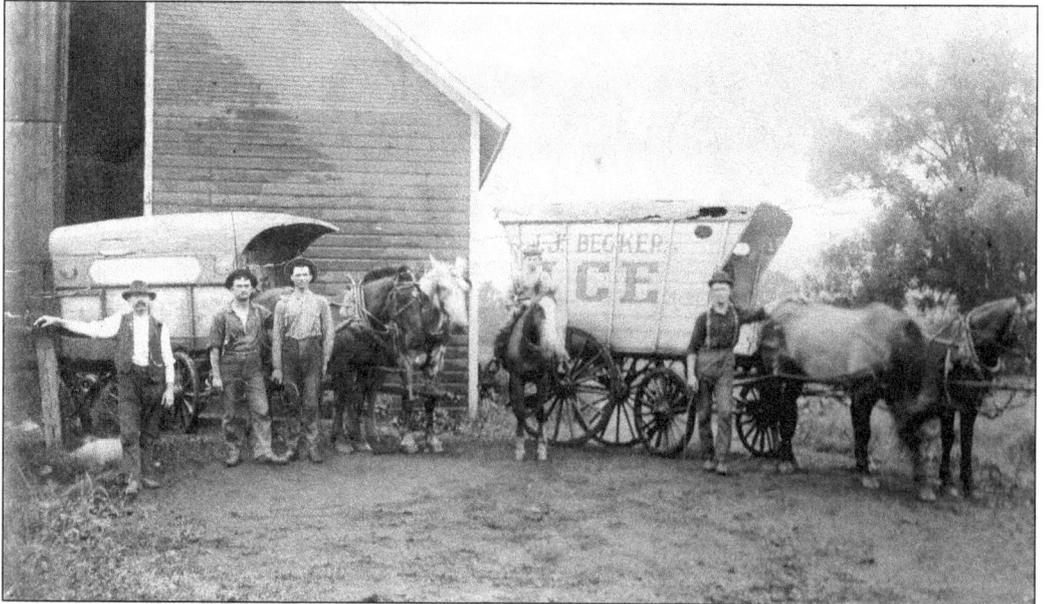

Six

GROUPS AND TROOPS

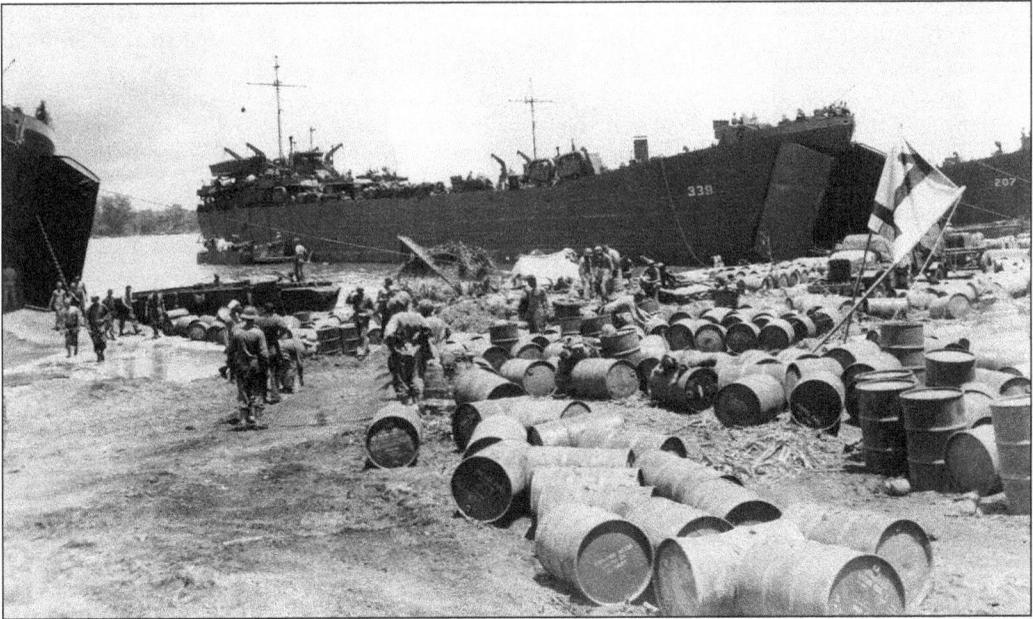

LANDING SHIP TANKS. November 6, 1943, saw these ships off of Papua, New Guinea, the South Pacific. Ship number 207, on the far right, made in the Seneca shipyard, was ready to take to the waters on September 7, 1942. The Landing Ship Tanks were also known by their nickname "Large Slow Target," but the versatility of these ships, also used as hospitals and to carry troops, cargo, and other vehicles, made them valuable and urgently needed. More than 1,000 ships were made during World War II, in shipyards around the country as well as Seneca. Skilled workers built these ships in as little as four months. During the D-Day invasion, over 40,000 injured troops were transported from Normandy to safety and care aboard Landing Ship Tanks. Seneca's contribution started in June 1942. After that beginning, they launched one ship per week. Employment for the area, because of the shipyard, reached 27,000 people in 1944. These people, the greater amount being women, came from all over to build the ships and help the war effort. (Courtesy Seneca Public Library District. Official Photograph U.S. Navy.)

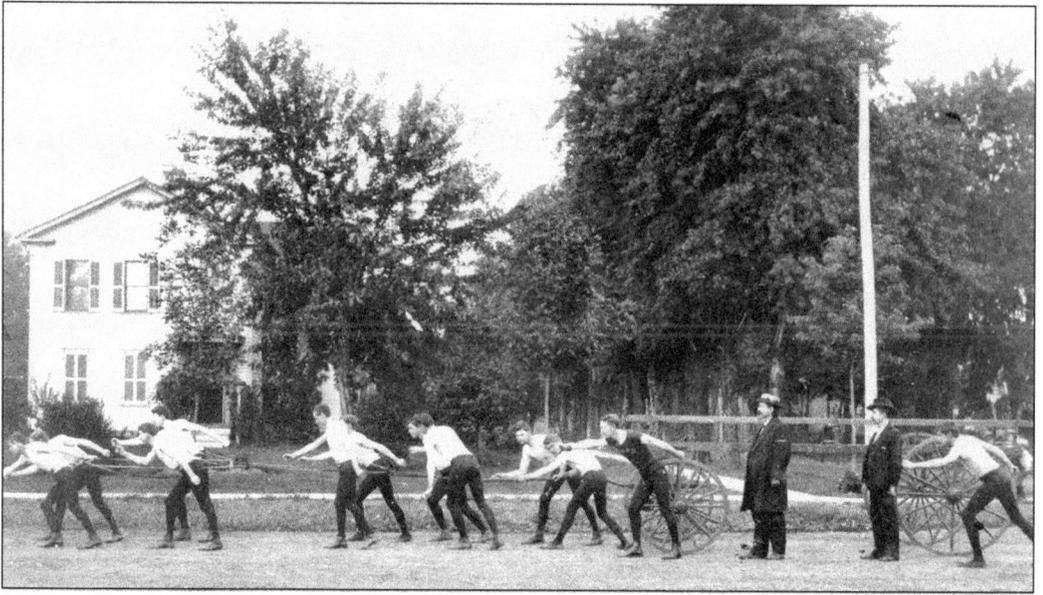

MENDOTA FIREMEN. Above, the *c.* 1890 photograph shows that the fire department can have fun too. Since the time of this photograph, fire alarm boxes have been in use. The Mendota directory of 1903 gave these directions for their use, "Keys to boxes can be found at the nearest residences. After opening the box pull the lever down as far as it will go. The alarm whistle inside will blow the number of from which the alarm is sent, each figure of the number with a short blast and a short pause between first and second figure of number on box. . . . Keys remain in box until released by Marshall." The photograph below is also of Mendota firemen from the late 1800s and is possibly a pre–Civil War photograph. (Courtesy Mendota Museum and Historical Society from Leo and Norma Muhlach Collection.)

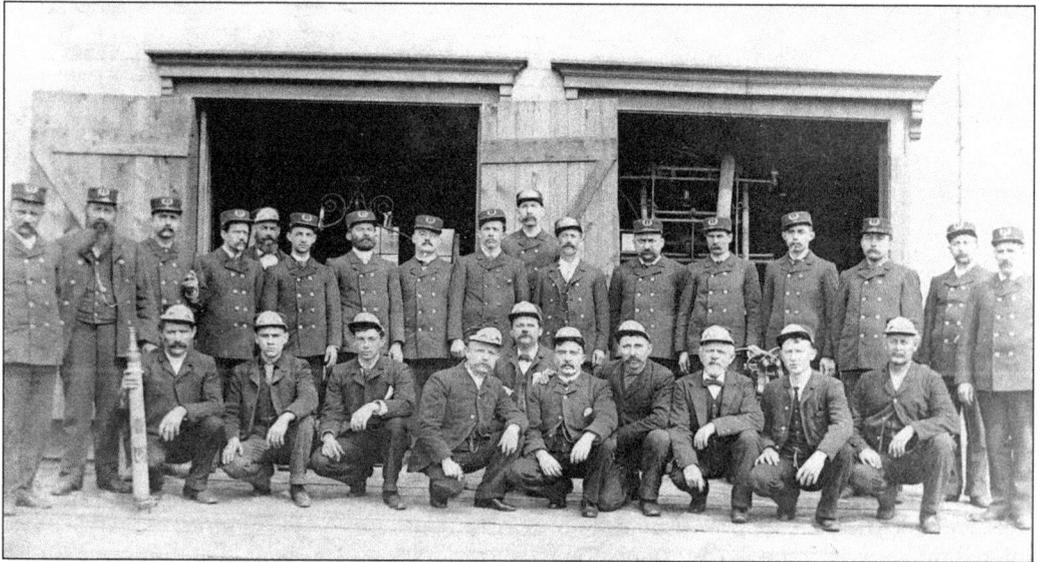

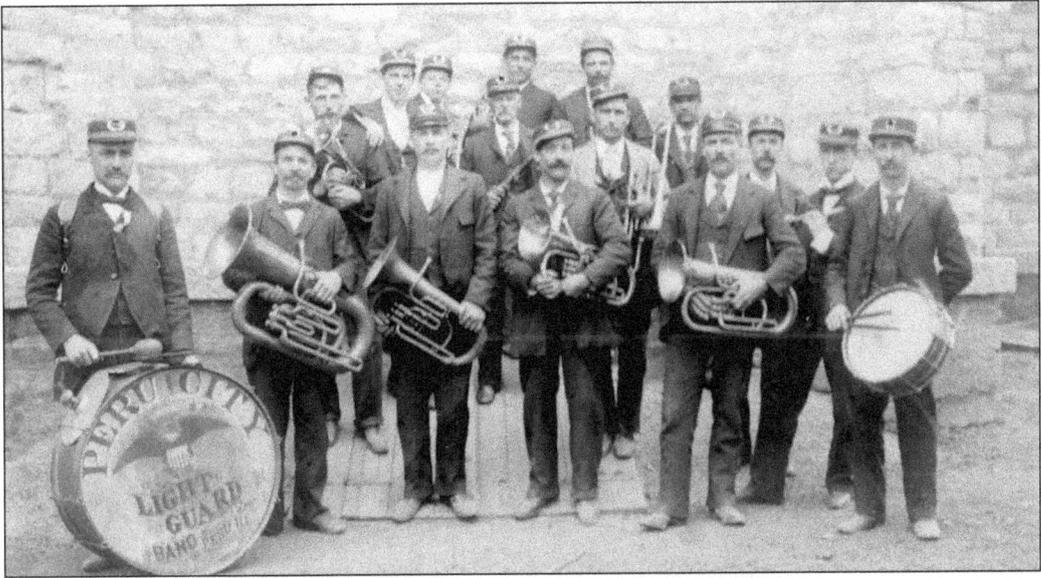

THE MEMBERS OF THE PERU CITY LIGHT GUARD BAND, MID-1800S. Pictured are, from left to right, as follows: (first row) Joseph Schneit, Henry Lenzen, Cornelius Baxter, Christian Lindenmeyer, Robert Baxter, Rudolph F. Streuver, Edward Hoscheit, and John Stedman; (second row) Joseph Schultz, Ferdinand Meyer, Charles Fehr, and E. J. Lenzen; (third row) William Hanney, William F. Meyer, Arthur Bouchy, and A. C. Lenzen. (Courtesy Peru Public Library Local History Room.)

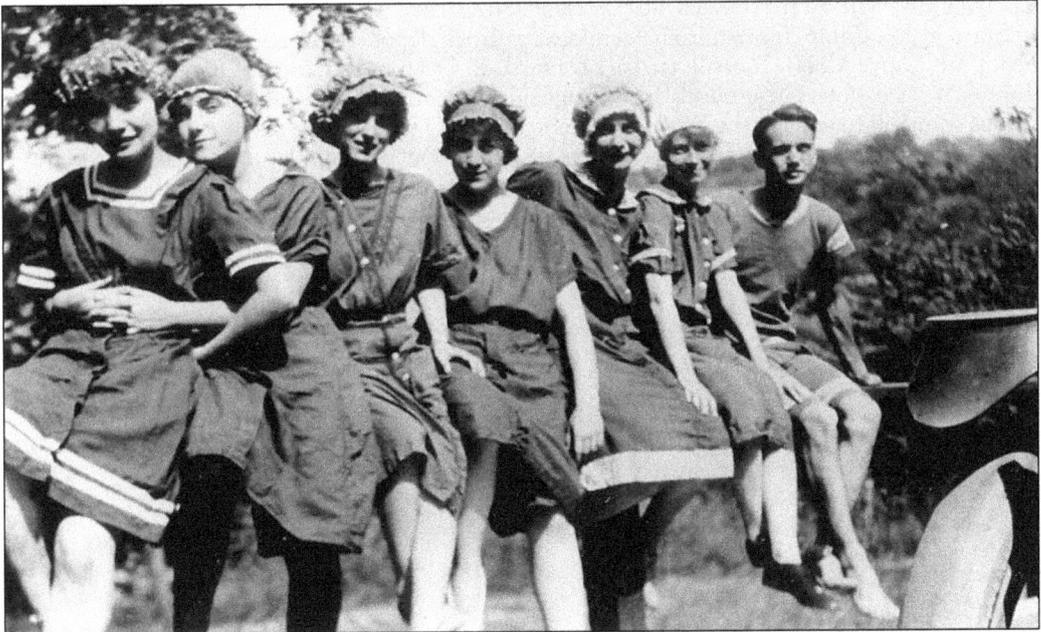

FIVE BATHING BEAUTIES. In the late 1800s, these are the swimwear costumes one would have worn to the beach. A little house or cabana may have been provided to change clothes in if one was visiting a resort. These ladies are bathing beauties from the area of Peru, Illinois, and are properly escorted by Helen Hardebeck and Andrew Hebel on the far right. (Courtesy Peru Public Library Local History Room.)

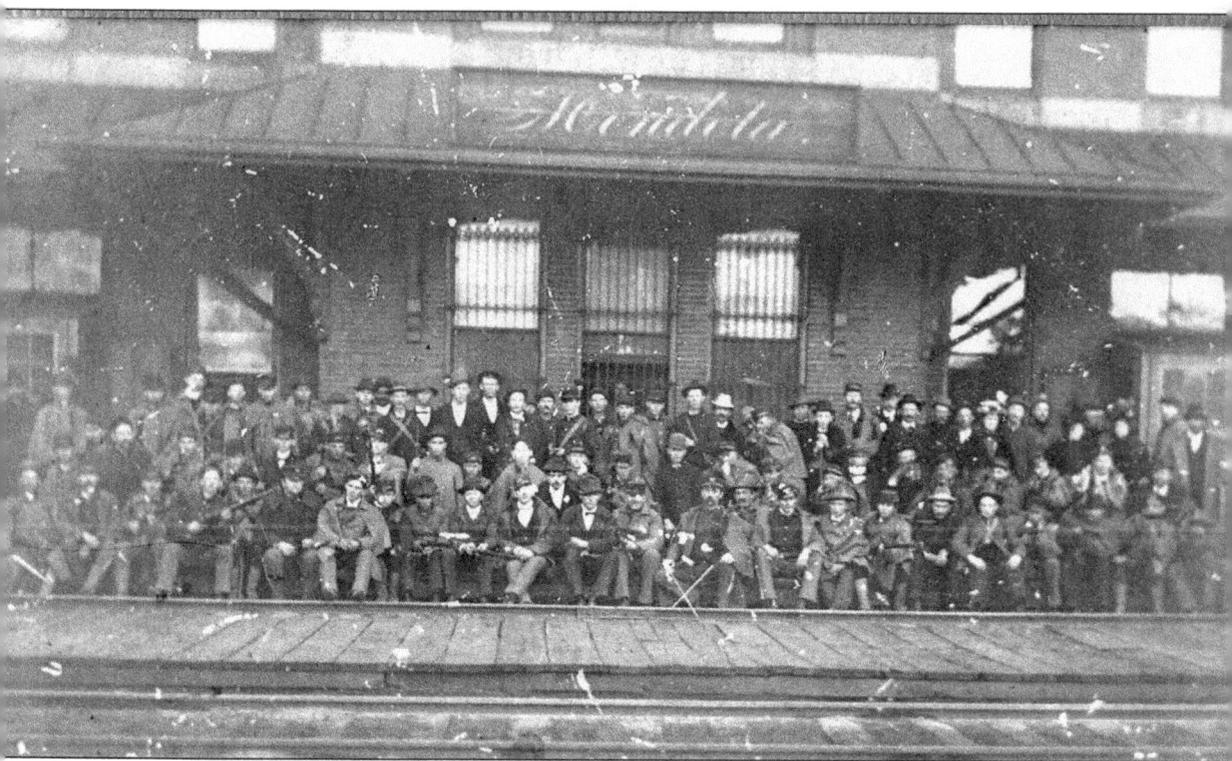

COMPANY K, THE 6TH ILLINOIS VOLUNTEER INFANTRY. April 17, 1898, sees these troops off to Springfield's Camp Tanner, from Mendota's railroad depot. Among the men gathered at the depot are Capt. Albert Tourtillott, 1st Lt. Frank E. Dayton and 2nd Lt. Elmer Girsey. Camp Tanner, as the state fair grounds in Springfield was called, was a mobilization point for the troops going off to fight in the Spanish-American War. The 6th were stationed at Camp Russell A. Alger in the state of Virginia, which was situated about seven miles from Washington, D.C. They had 973 enlisted men in the 6th, and 24 died in battle and 23 succumbed to disease during their time of service. The Spanish-American War lasted 10 years. Most of the Illinois troops never participated in battles but parts of the 6th did. (Courtesy Mendota Museum and Historical Society from Leo and Norma Muhlach Collection.)

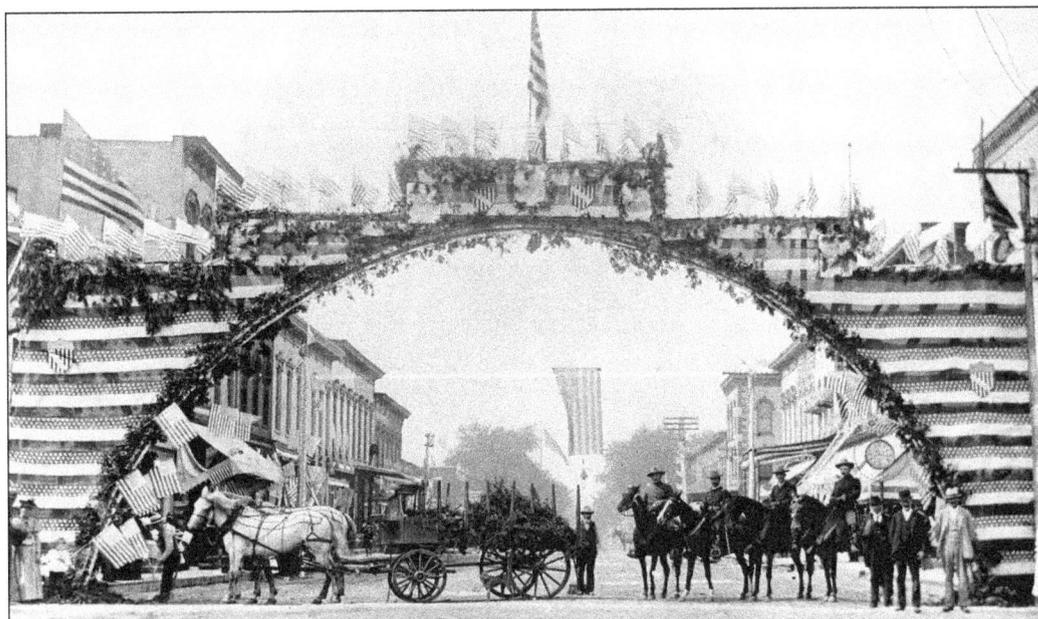

MENDOTA'S PEACE ARCH, 1898. The men returning to Mendota from fighting in the Spanish-American War passed through their city's show of support. This peace arch was constructed by Bierworth and Janowitz, free of charge, to celebrate the safe return of troops. The arch was built on Washington Street; this photograph was taken looking west. (Courtesy Mendota Museum and Historical Society from Leo and Norma Muhlach Collection.)

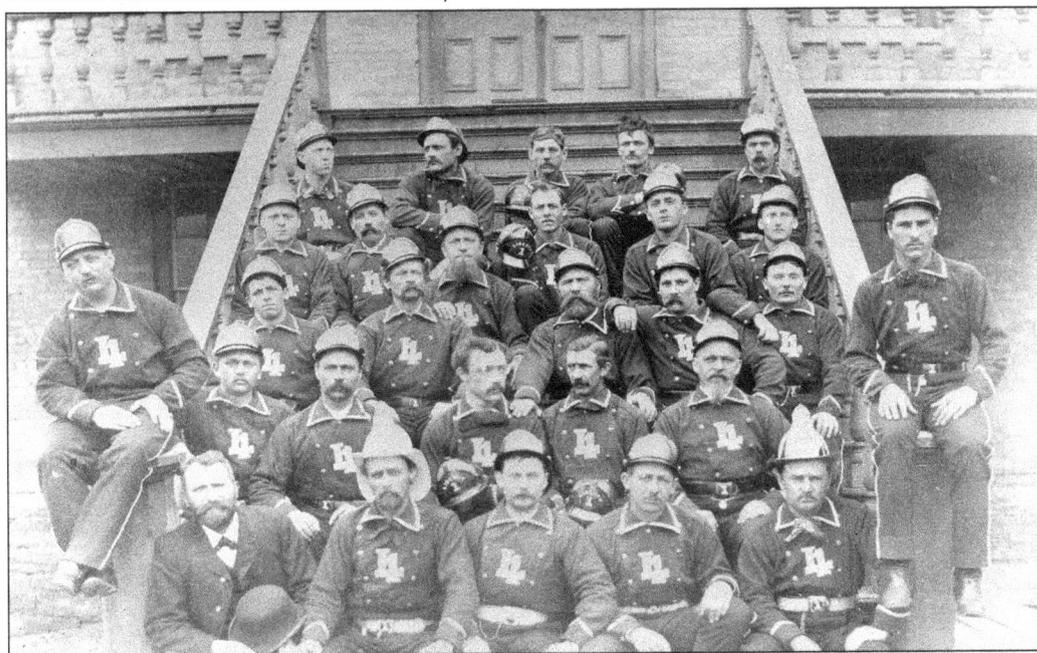

TWENTY-EIGHT PERU FIREFIGHTERS. This photograph was taken in the early 1900s on West Street on the steps of Peru City Hall. These heroic firefighters, whose names are not known, are wearing uniforms with L 1 on them, which stand for Liberty 1. (Courtesy Peru Public Library Local History Room.)

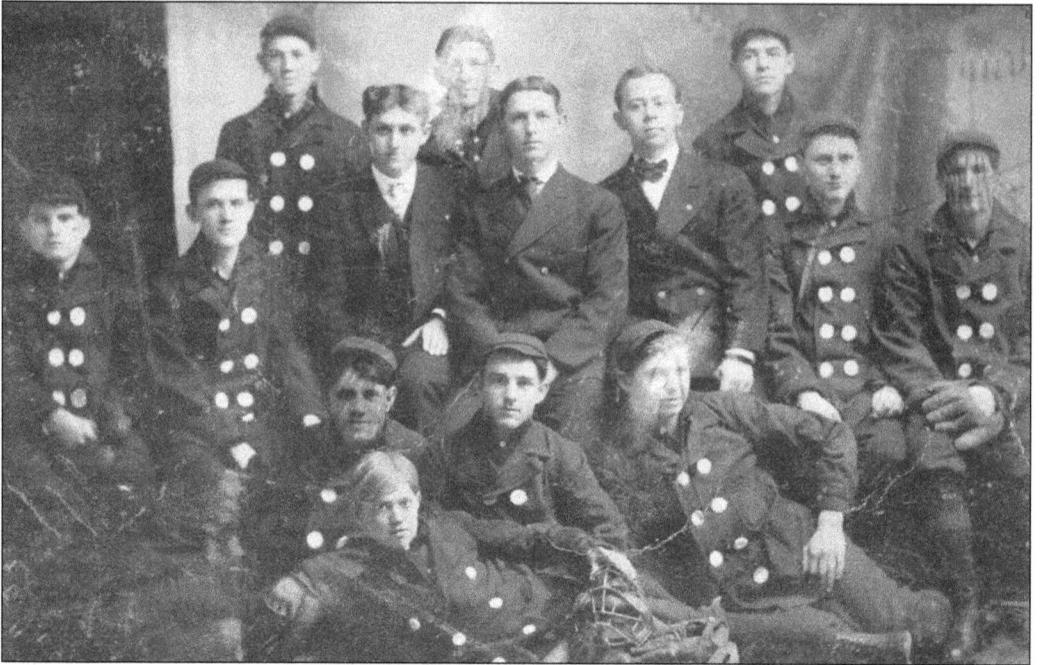

PERU BASEBALL TEAM, C. 1900. These handsome young champions are, from left to right, as follows: (first row) Edwin Lange; (second row) Alex Duzulka, Charles Mauritzen and William Russell; (third row) George Wilmeroth, William Radtke, George Halm, Harry Debo, William Hoberg, Martin Camenisch, and Frank Trompeter; (fourth row) Carl Lange, Elmer West, and Charles Hoscheit. (Courtesy Peru Public Library Local History Room.)

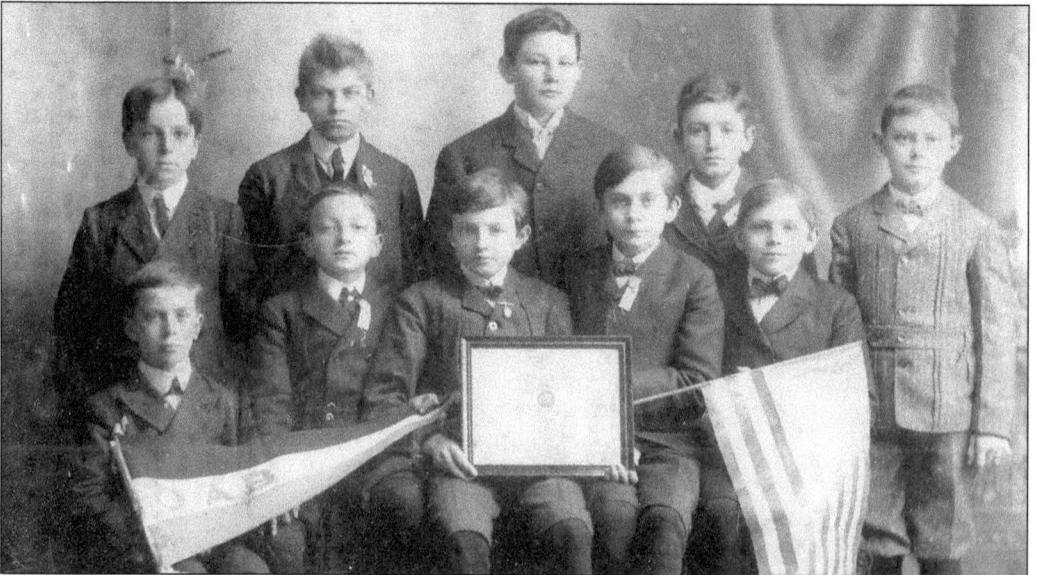

THE ORDER OF AMERICAN BOYS, C. 1900. These young gentlemen are, from left to right, as follows: (first row) Hamilton Maze, Arthur Zimmerman, Otto Castondyck, Fred Van Horn Braun, and Edward Breuning; (second row) Edward Kreis, Liszt Lenzen, William Phillips, Edward Zacher, and Benjamin Linnie. The Order of American Boys was the predecessor to the Boy Scouts, which was organized in 1910. (Courtesy Peru Public Library Local History Room.)

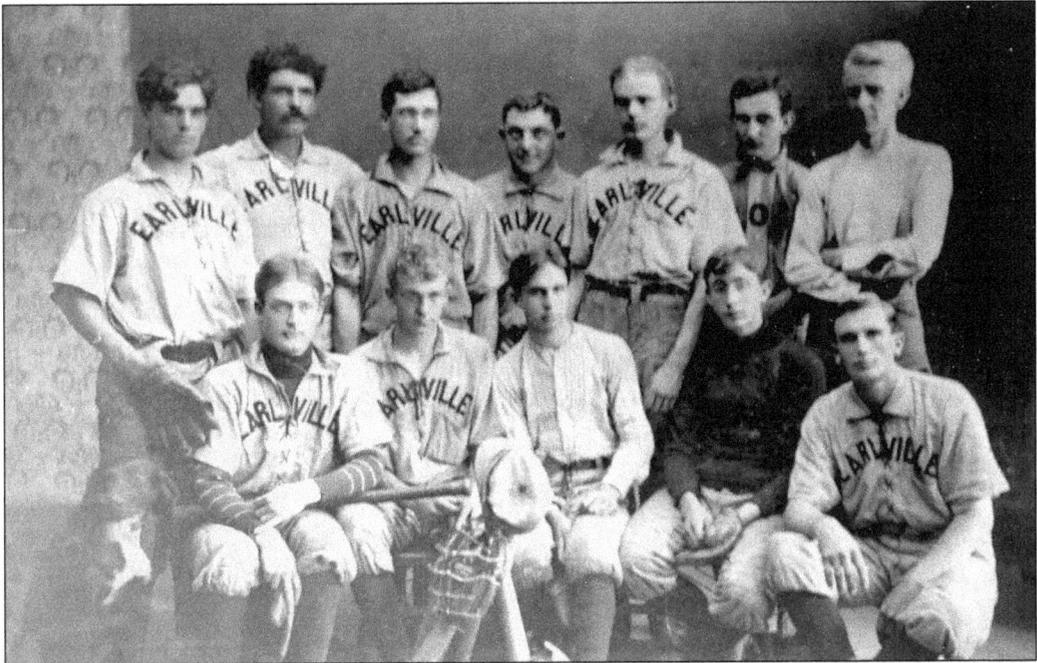

EARLVILLE BASEBALL TEAMS. The gentlemen above are, from left to right, as follows: (first row) George Wiley, Cedge Taylor, Gurden Ginder, Halley Dickerson, and Jack Atherton; (second row) Jay Barnard, John Smith, Frank Dupee, Bill Schmidt, Jim Taylor, John Dupee, and L. I. Taylor. Below is the Earlville Rangers Baseball team of July 1910. Only one of the men of this team is known and he is Dale Thompson, the man in the very middle standing against the fence. The above team is believed to be the high school team and below could be a minor league team. The National Association of Professional Baseball Leagues, for the minor leagues, was formed in 1901 in Chicago, with only 14 leagues and 96 clubs. By 1909, the association had grown to over 30 leagues and 246 clubs. (Courtesy Earlville Community Historical Society.)

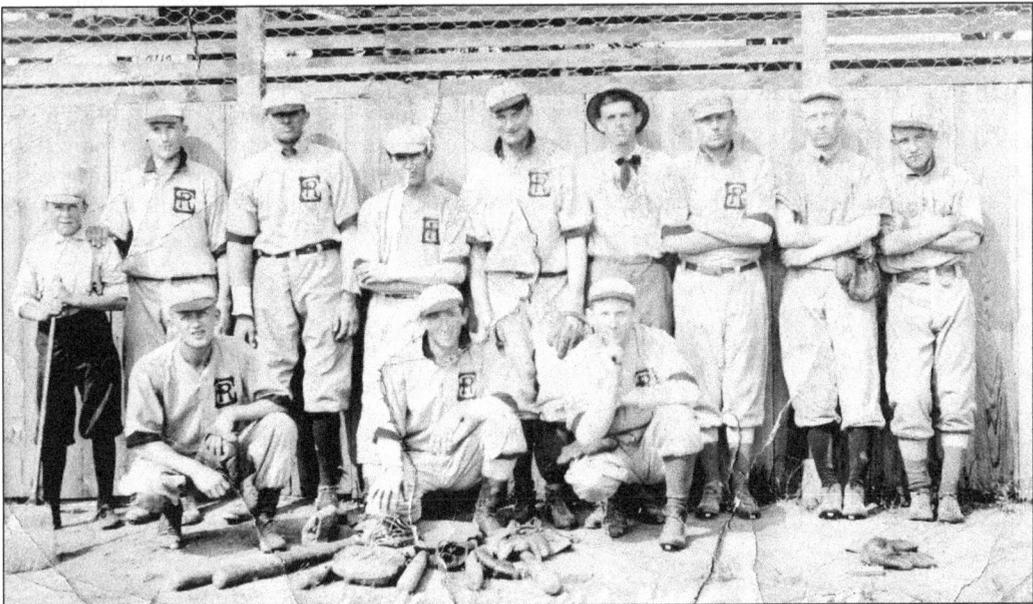

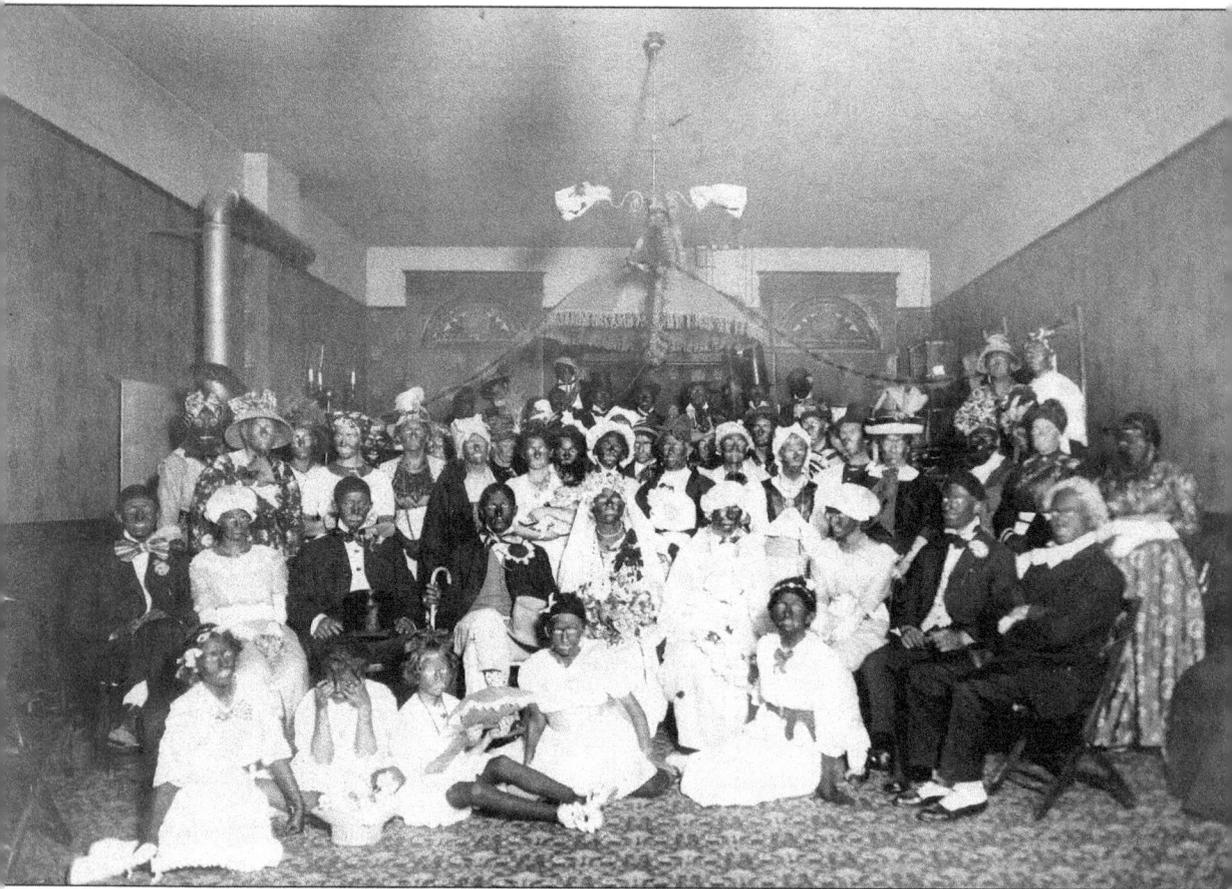

A Minstrels' Group in Earlville, c. 1910. Acting in blackface was popular before the Civil War up through the early 1900s, as this photograph above depicts. A bigoted form of art, a minstrel performance included white as well as black actors and singers. This photograph was taken in Earlville with the members of the D. A. Town Bank. In Streator, in the southern part of the county, there lived a well-known blackface comedian, who was also a songwriter, George "Honey Boy" Evans. He was born in Streator in 1870. Evans wrote the well-known song "In the Good Old Summer Time." It is thought to be written about his time spent working in Marseilles. Evans died in 1915 and is buried in the Riverview Cemetery in Streator. There is a memorial to Evans in Streator at the Elks Lodge of which he was a member. (Courtesy Earlville Community Historical Society.)

DRAMATIC ORDER KNIGHTS OF KHORASSAN. Ken Koehler and Fritzie Breuning were mascots of the Dramatic Order Knights of Khorassan. These fraternal organizations, founded 1864, received a charter by an act of Congress, approved in 1870. The order, inspired by the ideals shown in the myth of the friends, Damon and Pythias, who were loyal to one another, honors this myth by sponsoring humanitarian activities. (Courtesy Peru Public Library Local History Room.)

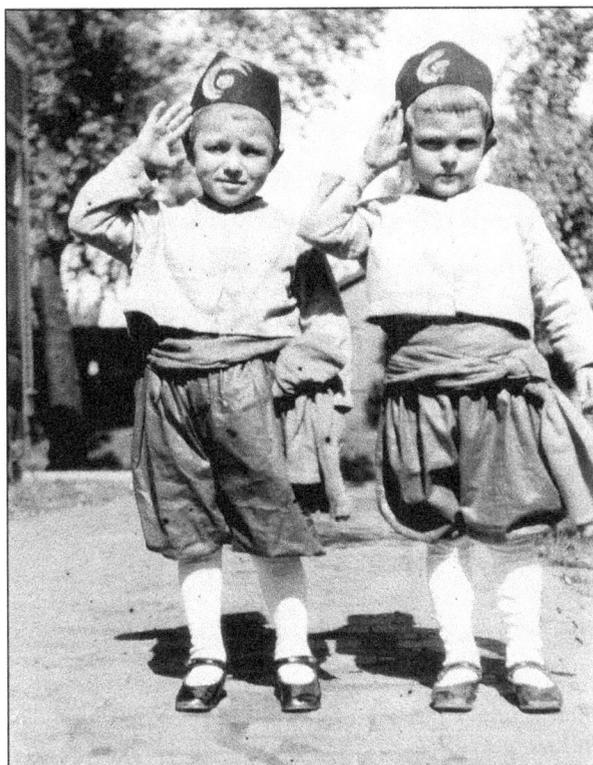

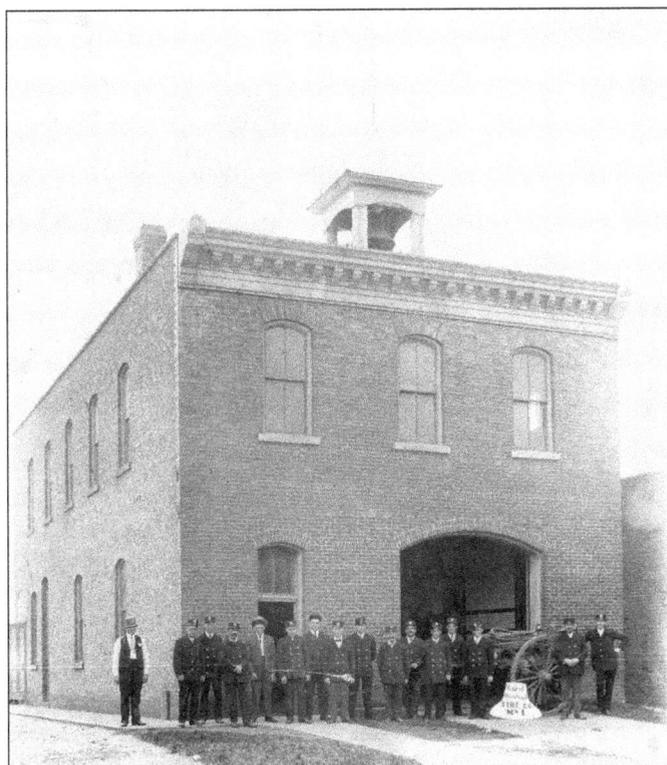

PORTLAND FIRE DEPARTMENT. Named Portland for the cement industry, this photograph was taken before 1913, after which the town's name changed to Oglesby. The names of the men of Portland Fire Company No. 1 are not known. This is a large brick firehouse with a large bell on top of the building. Notice the man on the far left, wearing a star on his vest. (Courtesy Oglesby Historical Society.)

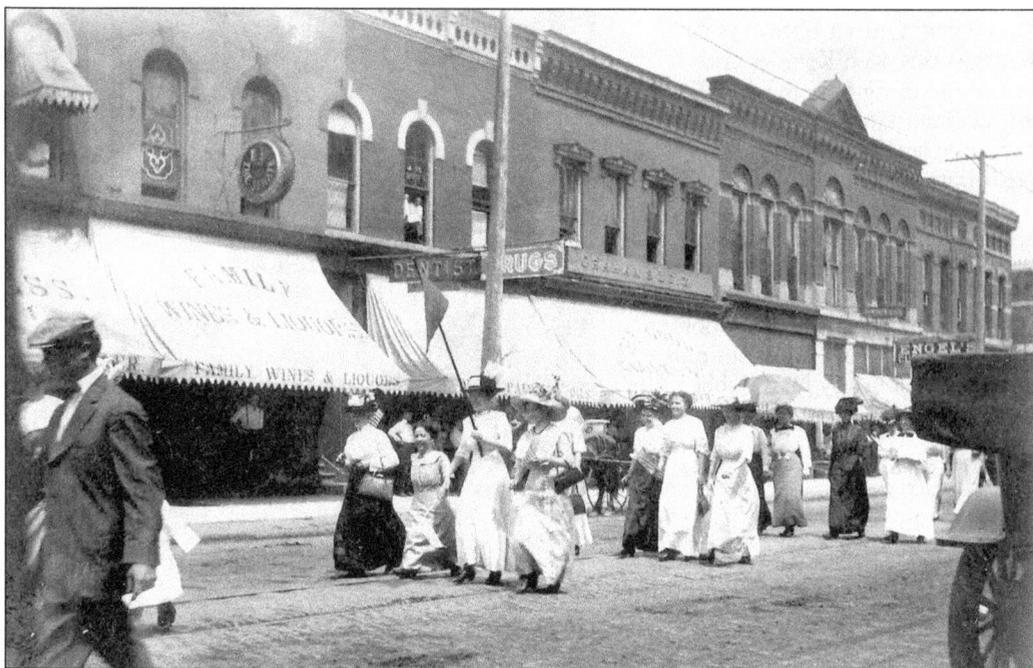

LADIES MARCH ON LASALLE STREET, IN OTTAWA, C. 1911. It is not known why the ladies march, but in 1911, aid to mothers with dependent children was given in Missouri, other states followed. In 1912, a minimum wage law for women and children passed in Massachusetts, other states soon followed. The ladies carry American flags and a pennant; possibly a championship for women's rights is being celebrated. (Courtesy M. Dorothy Clemens.)

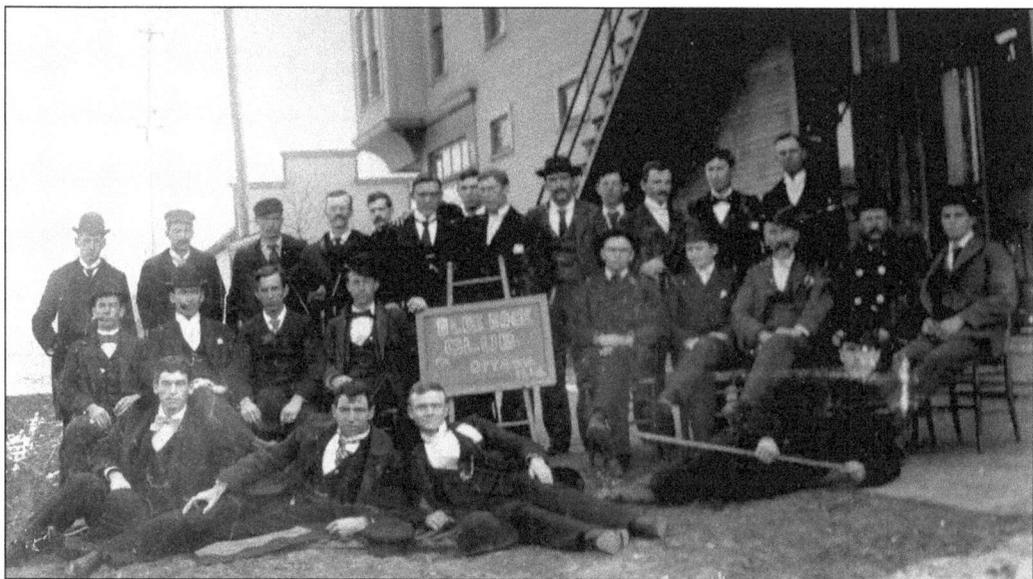

THE MEN OF THE BLUE ROCK CLUB, C. 1894. The club was listed in an 1894–1895 directory for Ottawa as the South Ottawa Blue Rock Club, under the category Social Clubs. Max Schultz is lying in front of the club sign. Noel Cooley is the club president and Henry Belk is secretary. It is not known where these men are among the group in the photograph. (Courtesy Helen Crawford.)

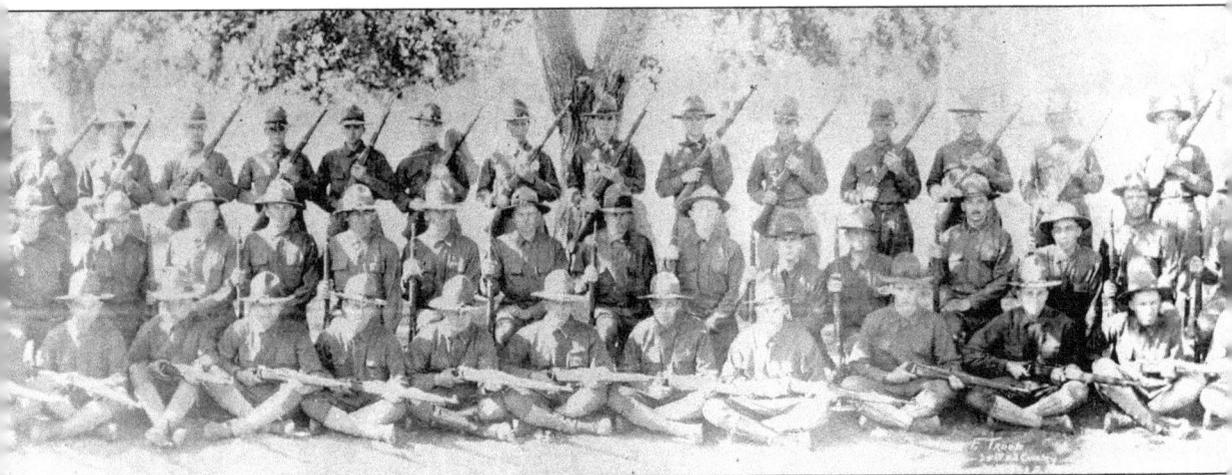

THEY WERE "F" TROOP. This group of men is the 25th U.S. Cavalry, F Troop, in July 1917. Theses young men were sent to Fort D. A. Russell in Wyoming, which was one of the largest cavalry bases in America. It was on November 6, 1917, that the F Troop was converted to the 83rd Field Artillery unit before being sent off to France, as part of the 8th Division, fighting in World War I. The war ended in November 1918. The fort was named for David Allen Russell who fought with the Union army in the Civil War. Russell successfully commanded many divisions and fought while wounded. He was further wounded, and when a piece of shrapnel pierced his heart he posthumously received further awards achieving the rank of major general. (Courtesy Mendota Museum and Historical Society from Leo and Norma Muhlach Collection.)

THEY WENT OFF TO WAR, 1917. These men served in World War I. Wilson E. Shaver (right) was born and raised in LaSalle County; the man on the left is unidentified. Notice their army service hats, the color of the cord on their hats would tell if they were officers or in training, going into the infantry, cavalry, or artillery. There were different cord colors to designate each area of service. These men were drafted and sent off to Camp Grant, named for Ulysses S. Grant, in Rockford, Illinois. Almost 60,000 troops were trained at Camp Grant, the largest camp in the Midwest, primarily for the infantry. The photograph below was taken at Camp Grant and is from the Auxiliary Remount Depot 321 Wagon Train. The camp was able to handle 5,000 horses. (Courtesy Wilson Everett Shaver.)

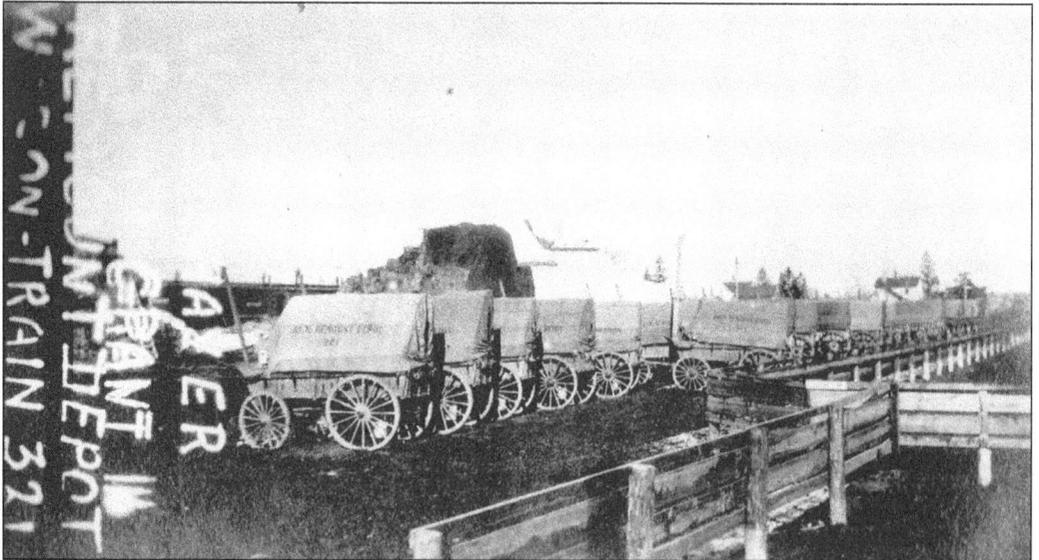

A SCOUTING CEREMONY AT THE CONGREGATIONAL CHURCH, 1920S. Marseilles Troop 96 is holding a ceremony on the grounds of the Congregational Church. Only five of these young scouts names are known. They are, from left to right, unidentified, Ed Coats, Dale Young, Bruce Linton, Keith Smith, Gerald Simmons, and three unidentified scouts. Below, a camp has been set up with tent and campfire and a board with samples of various knots. The three young men below are, from left to right, Bruce Linton, Dale Young, and Gerald Simmons. (Courtesy Marseilles Public Library.)

A CIVILIAN CONSERVATION CORPS CAMP, C. 1940. In 1933, Pres. Franklin Delano Roosevelt started a program to put men back to work. It was part of the New Deal campaign. In a time of vast unemployment, thousands of men worked making about $30 a month, $5 of which they kept and the rest was sent home to help out their families and the economy. Everything else these men needed was supplied for them, they had a five day work week, received three meals a day, a place to live, clothing, medical attention, and some education. These men worked planting trees, and building and restoring many areas around LaSalle County, especially around the Illinois River. Before this program was over in 1942, there were over 2,600 camps around the country, including Hawaii and Alaska, which later became states, plus Puerto Rico and the Virgin Islands. (Courtesy Marseilles Public Library.)

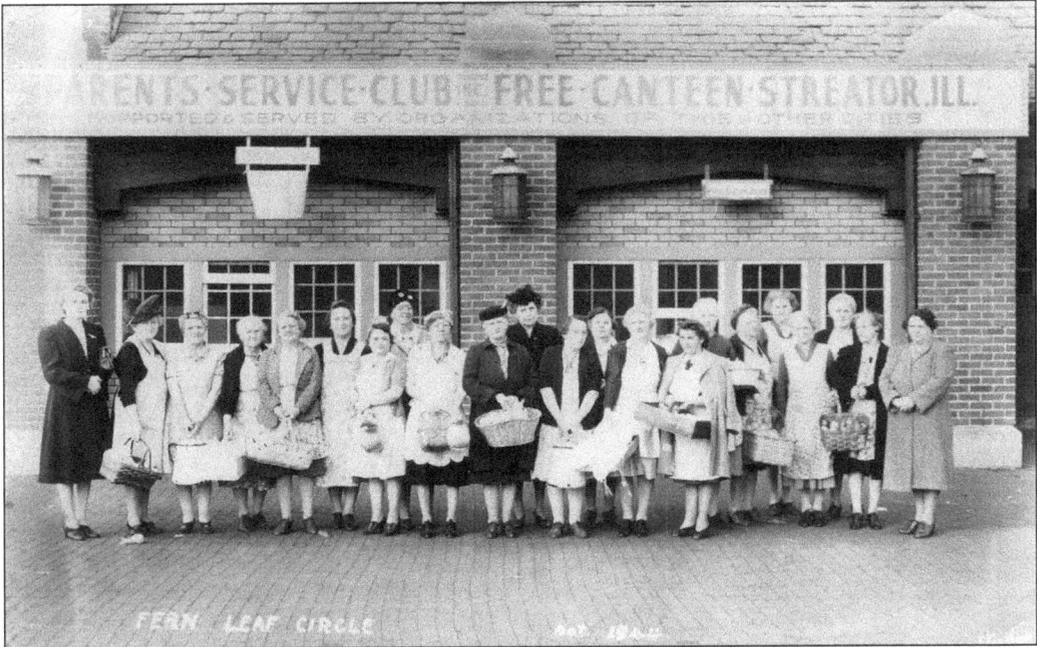

THE PARENTS SERVICE CLUB A FREE CANTEEN. Troops passing through Streator at the Santa Fe Railroad depot had a short time to grab a bite to eat, and most troops left hungry. The founders of the Parents Service Club saw the need and rushed to help the hungry troops by bringing food to the depot from their own homes. Local merchants, farmers, and townspeople were happy to volunteer and help out by providing coffee, ice, food and much more. This was all provided free of charge in a time when most items were rationed. The Parents Service Club grew from serving 300 hungry service men and women that first day, November 28, 1943, to 1.5 million by May 29, 1946, when they served the last troops at the free canteen. (Courtesy Streatorland Historical Society.)

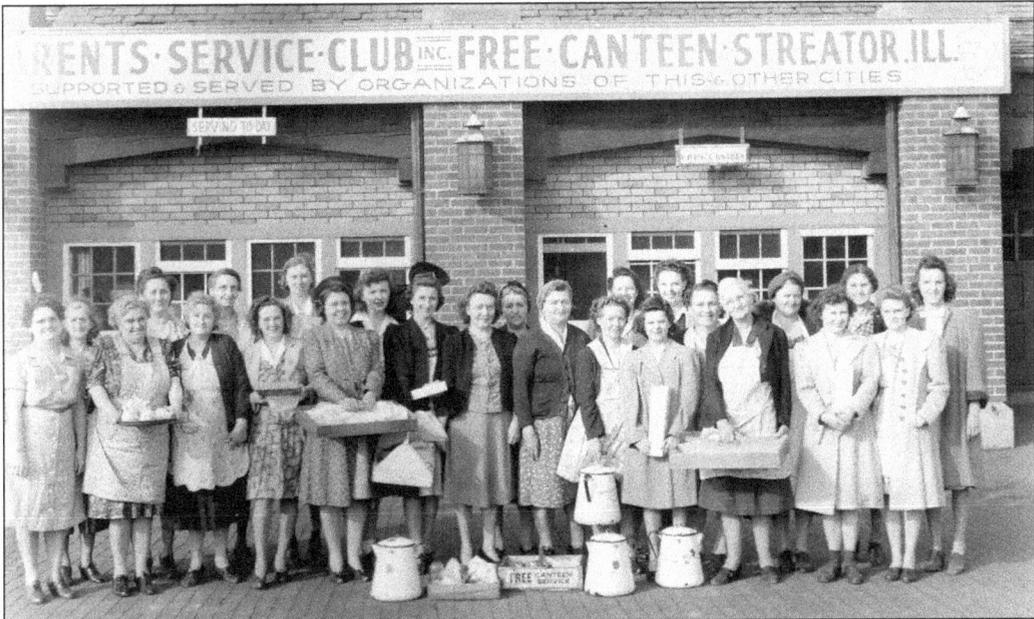

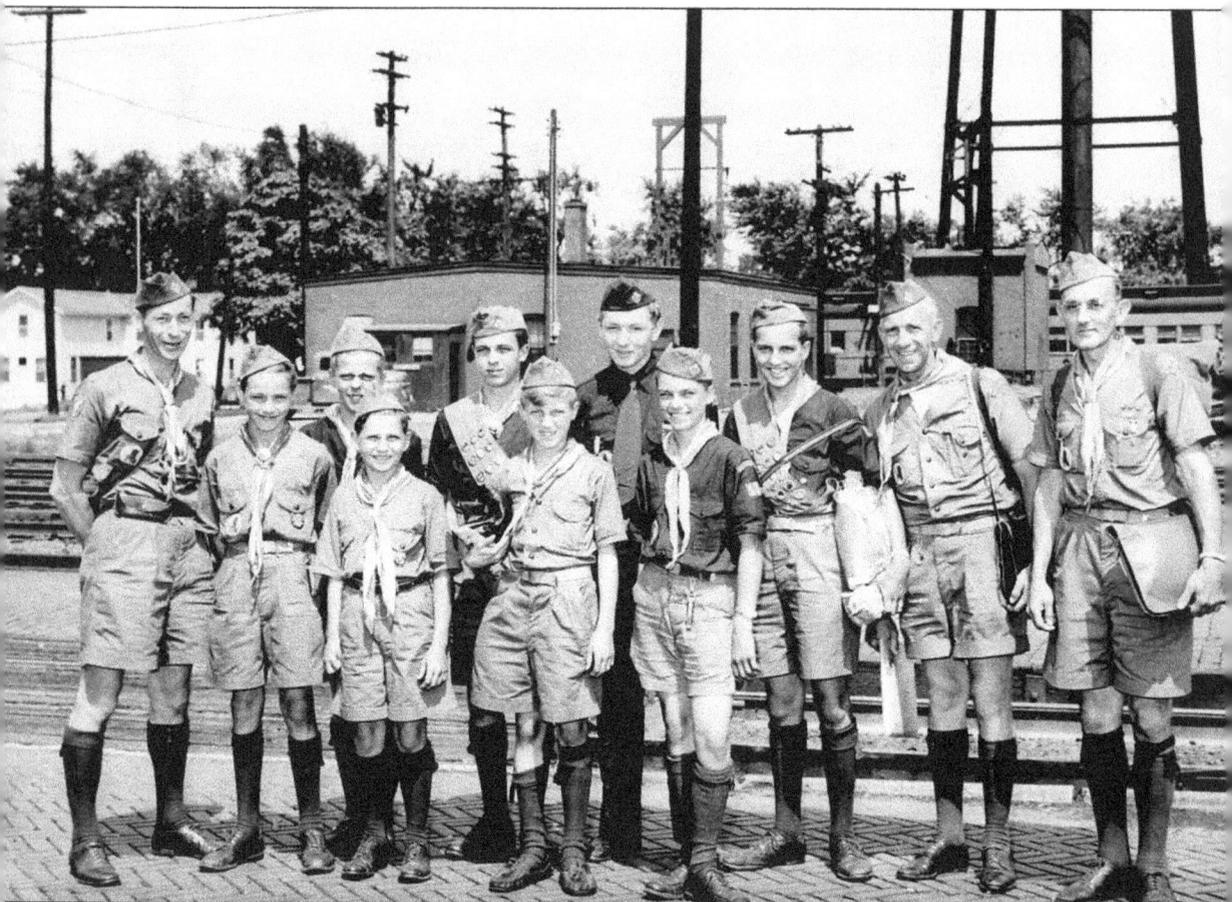

A SCOUTING TRIP TO VALLEY FORGE. In 1950, this Scout Troop, made up of boys from Ottawa, Mendota, Streator, Princeton, and other areas of the county, was able to visit the historic national park Valley Forge in Pennsylvania. The lucky travelers are, from left to right, Carl Sams, Gary Wolf, Jim Spanier, John Hood, Jim Eichorn, Bill Galloway, Francis Henkel, Tom Vickrey, Don Jones, Matt Wennemacher, and Bill Ashley. Jim Spanier recalls the trip being a great time, and he was able to meet with scouts from around the globe, as this trip was the site of the Scouts International Jamboree. He recalled 50,000 scouts gathered at the natural arena all held a candle, and when it was dark the site that all those candles created is still with him. On the weekend at Valley Forge, the visitors were in such numbers that the line of cars was bumper to bumper. (Courtesy Mendota Museum and Historical society from Leo and Norma Muhlach Collection.)

INDEX

Alberti, Hannah Jennings Clark, 13
Bailey Falls, 27
Bent, 84, 100
Boyce, 104
Brookfield Township, 13
Bruce Township, 12
Buffalo Rock, 35
Burlingame, Fanny M., 14
Deer Park Glen, 39
Deer Park Lake, 39
Dupee, 17, 117
Du Pont, 16
Eagle Cliff, 37
Earlville, 2, 13, 14, 17, 19, 21, 26, 44, 56, 57, 61, 62, 63, 65, 66, 67, 68, 70, 71, 73, 74, 75, 78, 83, 87, 88, 89, 101, 117, 118
Fort Johnson, 9
Fox River, 46, 78, 81, 105
Grove, 36
Harrington, 15
Hebel, 22, 64, 109, 113
Hickok, James Butler "Wild Bill", 10
Hogan Grain Elevator, 30, 97
Holderman's Grove, 9
Illini State Park, 46
Illinois and Michigan Canal, 10, 27, 30, 33, 35, 42, 97, 106
Illinois River, 27, 31, 35, 37, 40, 41, 42, 46, 49, 93, 103, 124

Kelly, 16
LaSalle, 33, 39, 68, 81, 93, 94, 100, 109
Lauber, 81
Lincoln, Abraham, 11
Lover's Leap, 31, 37
Marseilles, 13, 15, 30, 32, 34, 36, 37, 40, 46, 49, 55, 79, 81, 84, 88, 100, 103, 104, 110, 118, 123, 124
Matthiessen State Park, 39, 41
Mendota, 10, 23, 26, 28, 29, 30, 32, 43, 48, 50, 51, 52, 53, 54, 59, 60, 61, 66, 69, 70, 74, 82, 87, 89, 92, 95, 96, 101, 102, 109, 112, 114, 115, 121, 126
Mulford, 18
Oglesby, 37, 41, 75, 84, 91, 100, 119
Ophir Township, 28
Ottawa, 11, 25, 38, 45, 46, 47, 48, 56, 76, 97, 98, 101, 102, 105, 106, 107, 110, 120, 126
Parr, 36
Peru, 18, 20, 22, 23, 27, 29, 33, 47, 58, 62, 64, 68, 72, 81, 82, 85, 93, 94, 105, 106, 108, 109, 113, 115, 116, 119
Plum Island, 33
Plumb, 12, 24, 34
Rutland Township, 36, 88, 107

Seneca, 9, 15, 16, 20, 30, 55, 80, 86, 97, 111
Shabbona, 9
Spring Lake, 99
Stanislaus, 82
Starved Rock, 31, 33, 37, 41
Streator, 12, 18, 24, 34, 49, 90, 99, 100, 118, 125, 126
Sulphur Springs, 29
Tombaugh, 90
Tri-County Fair, 92
Triumph, 28, 82
Troy Grove, 10, 30, 32
Utica, 27, 42, 77, 86, 96
Vermillion River, 27, 39, 41
Washington Square, 11
Weir, Annie (Farley), 15
Westclox, 22
Widman, 18
Ziesing, 20

Visit us at
arcadiapublishing.com